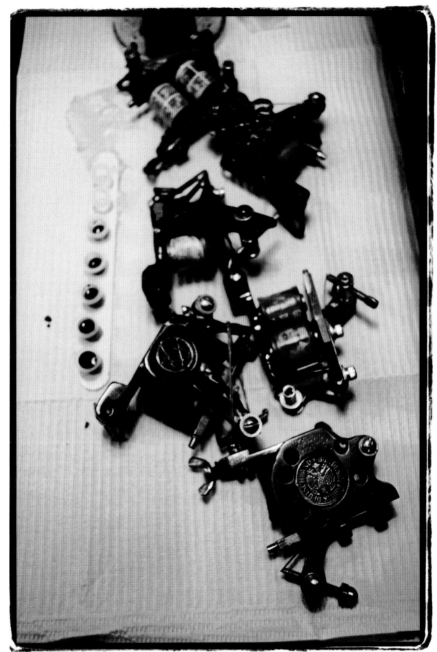

First Published in the United States of America in 2008
Fourth Printing

Gingko Press, Inc.
1321 Fifth Street
Berkeley, CA 94710, USA
Phone (510) 898 1195 / Fax (510) 898 1196
email: books@gingkopress.com
www.gingkopress.com

ISBN: 978-158423-288-9

Printed in China

Produced by: R. Rock Enterprises
Design by: Kim Groebner
Project Manager: Nicky Teri
Special Thanks: Caleb Neelon, Shawna Kenney
Special thanks to Henry Lewis for his invaluable support in realizing this project

Cover image by Estevan Oriol, Tattoo by Mister Cartoon
Image opposite of this page: Tattoo by Chris O'Donnell

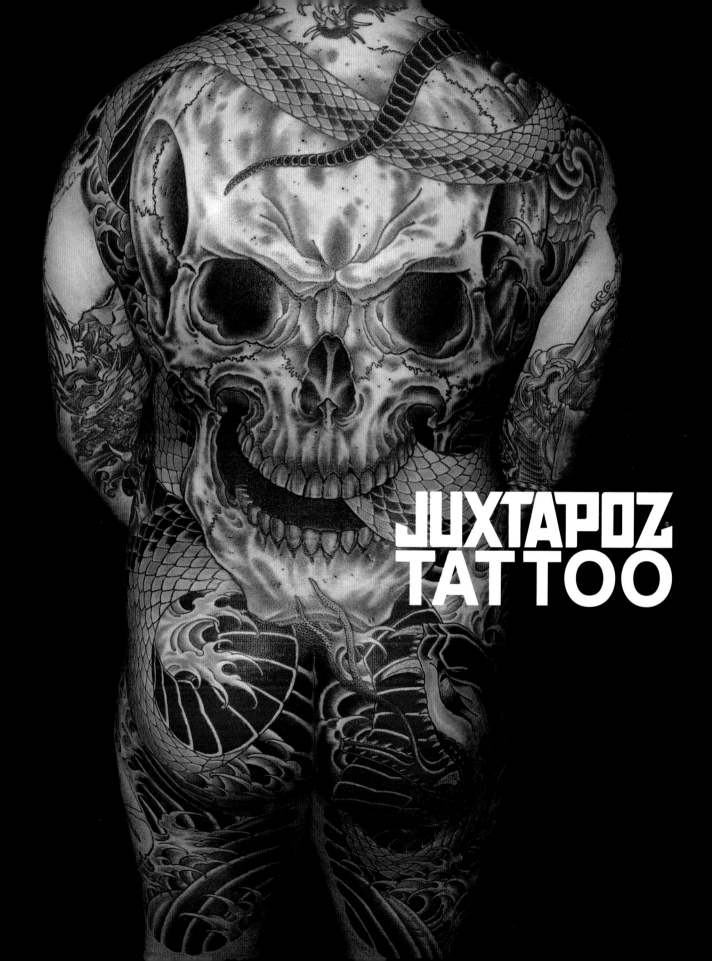

JUXTAPOZ
TATTOO

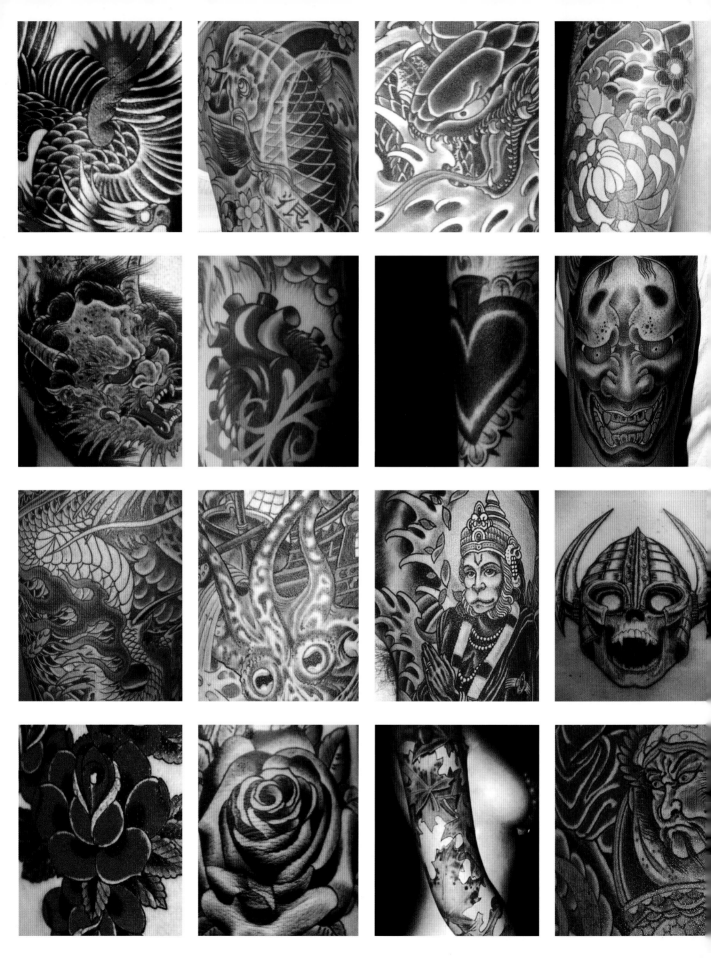

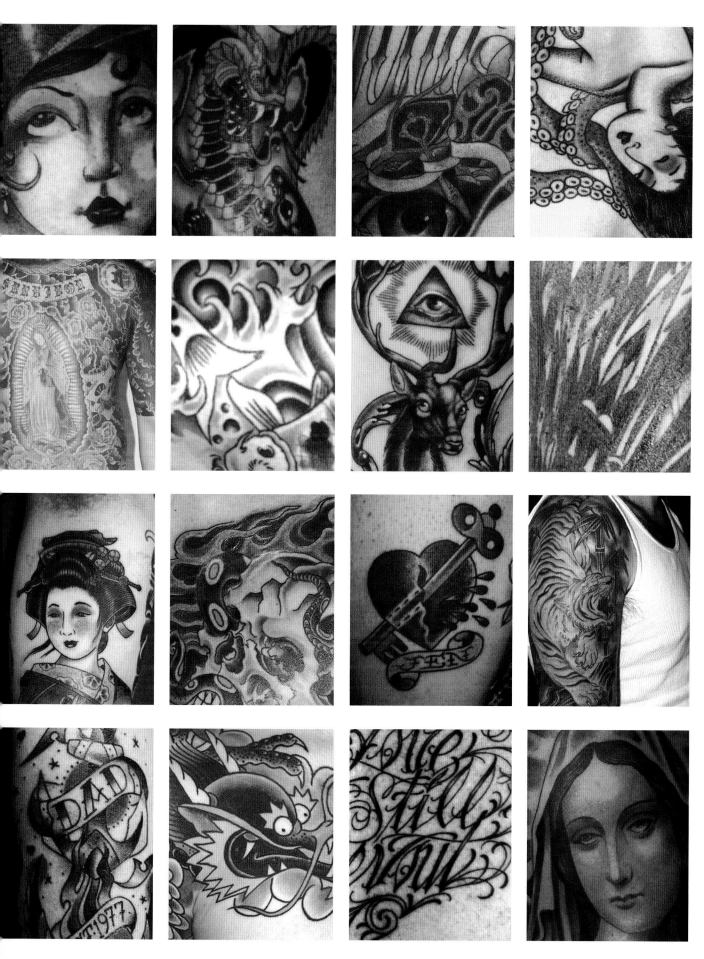

CONTENTS

Image Opposite Page: Mark Mahoney by Estevan Oriol

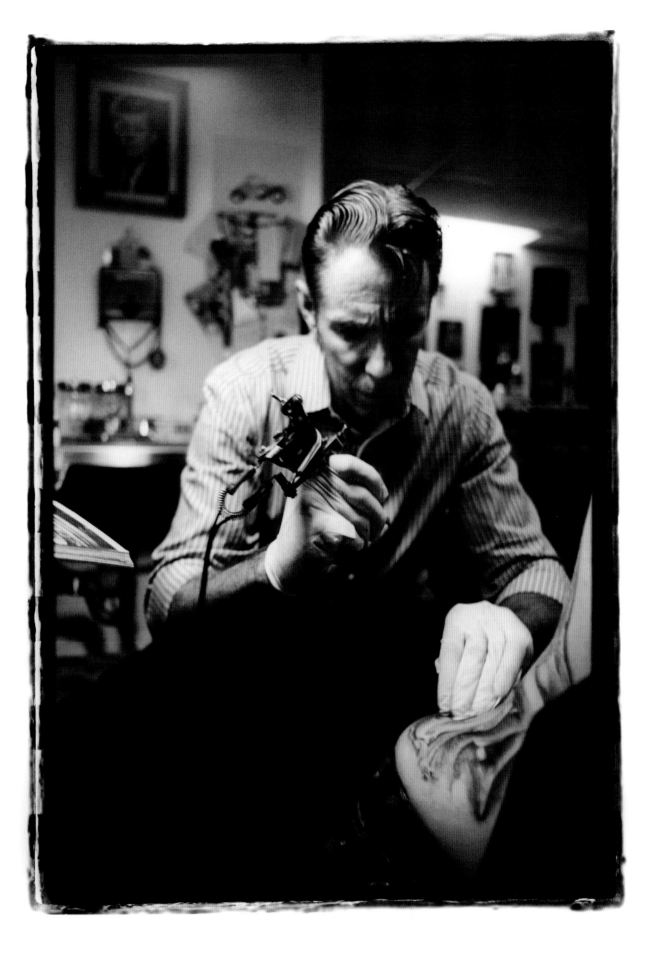

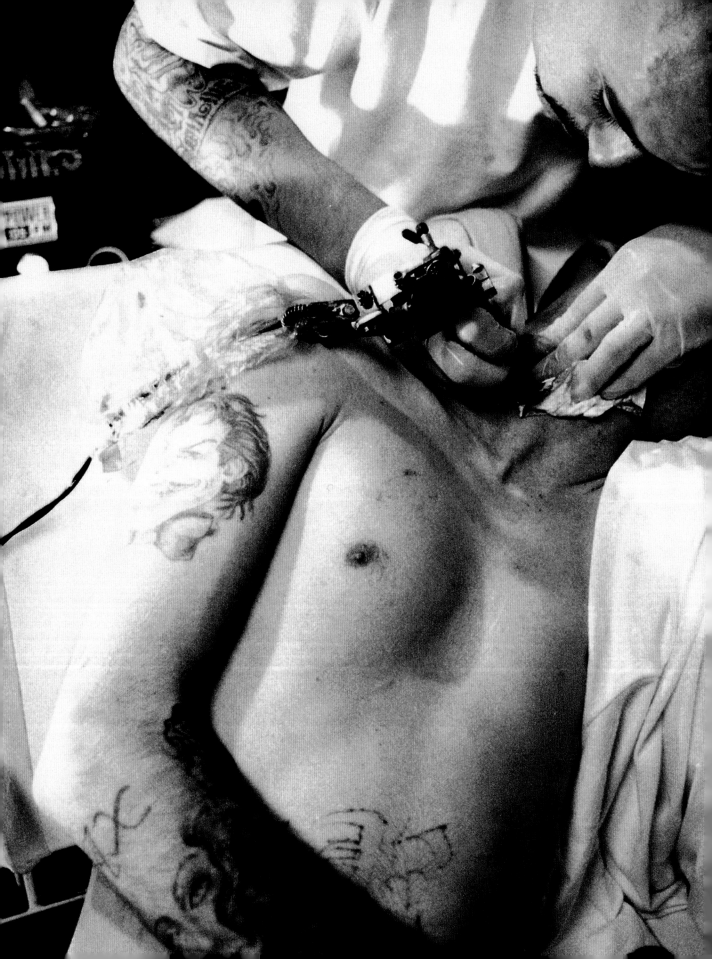

INTRODUCTION

*J*uxtapoz Tattoo, the second book in an ongoing series from the seminal West Coast art and culture magazine, focuses on a subject very dear to the inked hearts of *Juxtapoz* readers. When the magazine first appeared on the scene in 1994, the art featured within its pages was subversive. Over time, *Juxtapoz* artists have grown in popularity, and the underground sensibility of their work has transcended into the mainstream. Similarly, while tattoos were once icons of rebellion reserved for social outcasts, today they have become fully embraced by popular culture. People from all walks of life have inked their flesh—from soccer moms to sorority chicks to celebrities and beyond. Reality shows have even picked up on the craze; artist Kat Von D, for example, featured in the pages of this book, is the star of TLC show, *L.A. Ink.*

As the craft of tattooing crept out of the underground, the artists looked beyond the genre of tattoos to create an ever-evolving aesthetic. For this book, *Juxtapoz* approached tattooists who are masters of their field—they are artists with the same sensibility as the painters and illustrators featured in the magazine. These gifted inkers are creating a modern twist on a classic archetype, or pushing the boundaries of conventional tattooing. Most of the featured artists were there at the birth of tattooing's mid-90s modern Renaissance, hungry for a new approach, but steeped nonetheless in the traditions of their craft.

The artists featured include Daniel Trocchio, Jason Goldberg, Jason Schroder, Jeff Rassier, Jiro Yaguchi, Juan Puente, Julie Becker, Mario Desa, Mark Mahoney, Mister Cartoon, Time Lehi and Troy Denning, among many others. The art of tattooing is expanding and changing, and the artists in this book are at the forefront of the evolution—discover them here first.

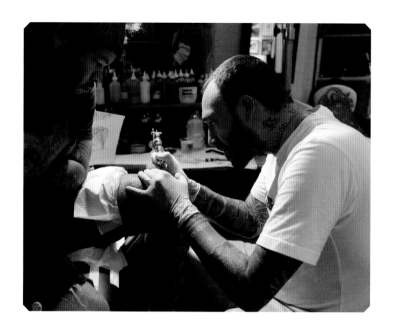

JOSEPH ARI ALOI

While attending RISD, Joseph Ari Aloi, aka JK5, got a ¾ sleeve. "The magic and power of all that tattooing embodied sucked me in like a tractor beam," he recalls. JK5 made it his mission to learn how to tattoo. Since then, he has developed a distinct, evolving identity. "It's all in perpetual flux, constantly, organically growing and changing, yet remaining consistent, distinct and unique," he says. "Uniqueness and sincerity are of paramount importance to me and my work." In '99, he published a 432-page monograph titled "Subconsciothesaurusnex." JK5's artistic sensibilities have led him to work in a wide spectrum of mediums–from sketching to sculpture–and he has exhibited work at a number of galleries around the globe: from Deitch Projects in New York to a Hello Kitty anniversary show in Tokyo. He currently tattoos at Saved in Brooklyn, N.Y., where some of his most memorable experiences have been created. While working there, he tattooed Adrock of the Beastie Boys, who made him four mixtapes in return. "It was one of the illest, most precious barter exchanges of my growing career," he says. He has also worked on Heath Ledger, Penelope Cruz and Marc Jacobs (who tipped him with a suit). "It's just an explosive community," he says, "and our shop is quite the destination."

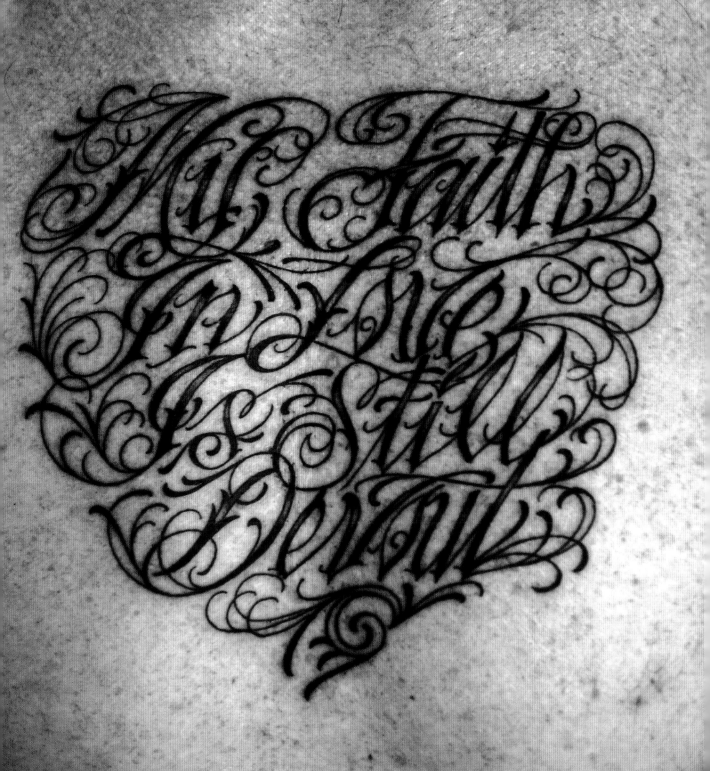

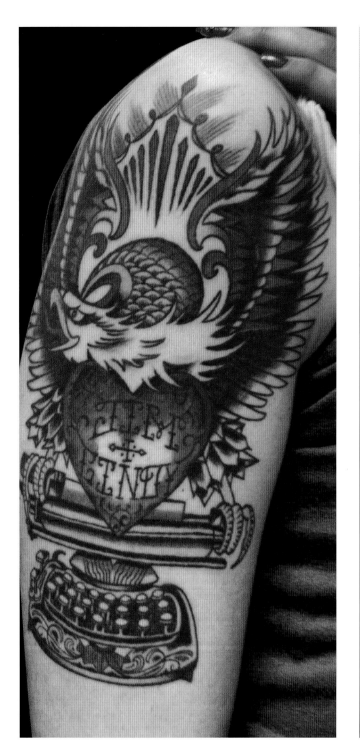
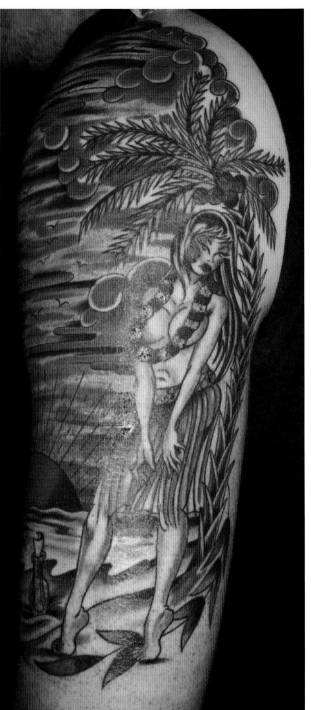

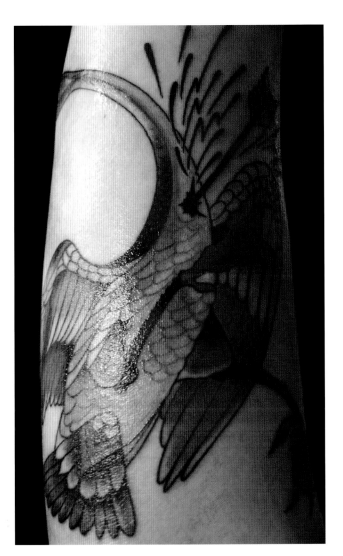
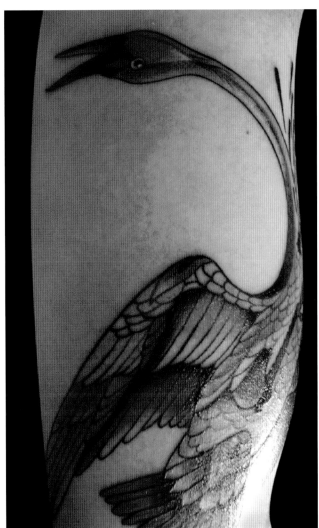

JULIE BECKER

Julie Becker prefers the comforts of home. "I'm a bit of a loner," she confesses. "I like to be home most of the time." Becker works out of a private studio in Los Angeles. The personal nature of her workspace allows her to connect with clients and create meaningful tattoos. Becker took an apprenticeship under Kevin Quinn, and did her first tattoo in '97. She explains, "Tattooing was a natural choice for me because you never get bored." She has been tattooing now for 11 years. Inspired by emotional highs and lows—like "love and misery"— her work is often bright and bold. She employs a traditional approach, favoring solid color, clean lines, and longevity, while applying a distinctly feminine sensibility. "I think my work stands out because I have a unique design quality," she explains. "I think I have a good feel for the body's shape and movement, and I design with those shapes, not around them." Becker works in pencil, oil, pastels, jewelry, and clothing as well—surprising for someone who "hated art class" when she was 7 years old. Today she cherishes her work and ability to create from home. "To me," she concludes, "anything that makes me or my clients happy is noteworthy."

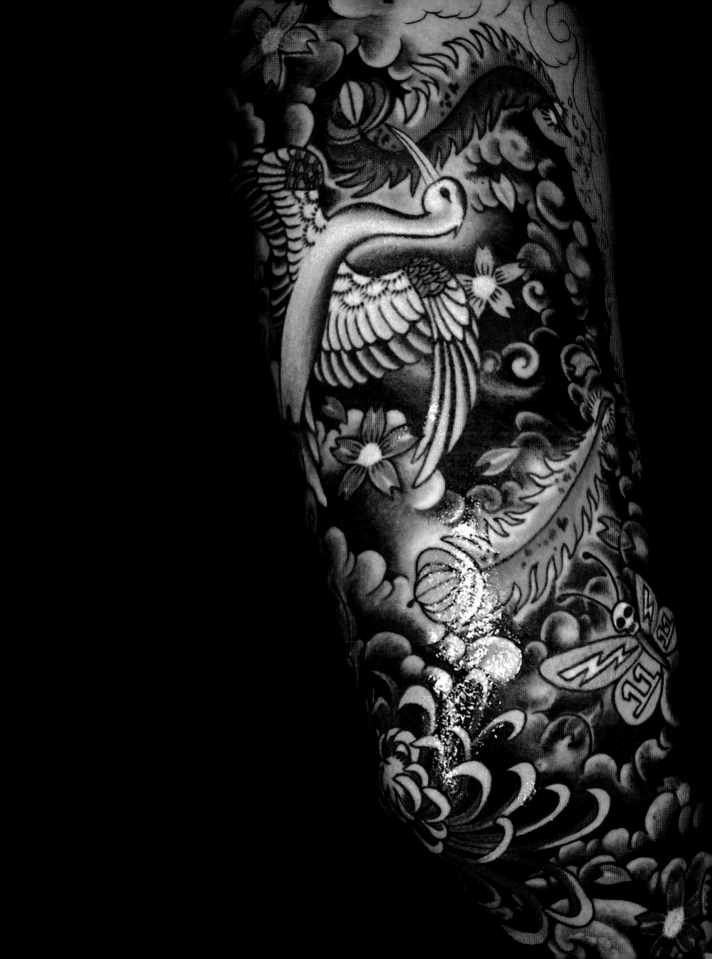

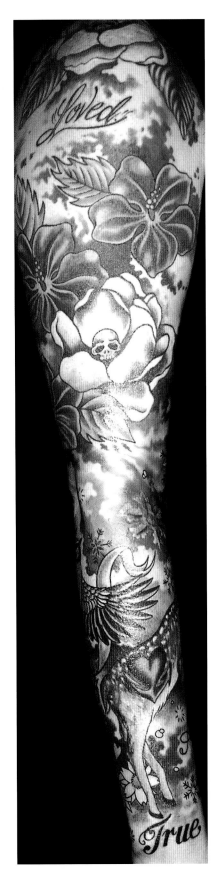
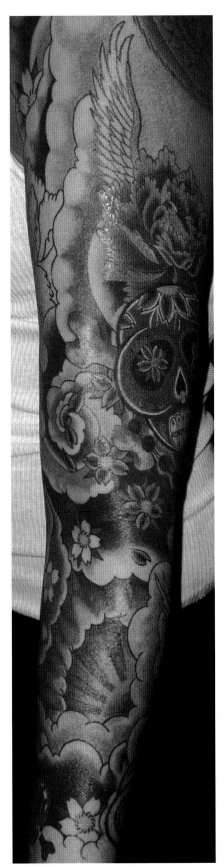
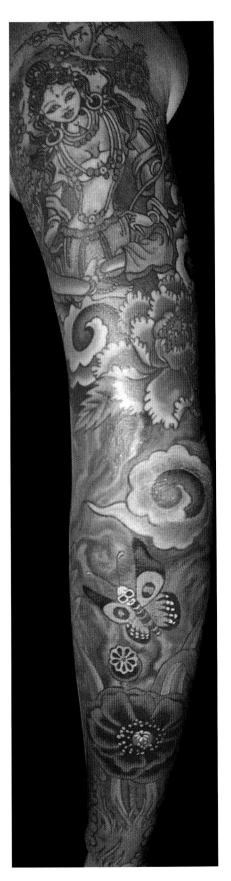

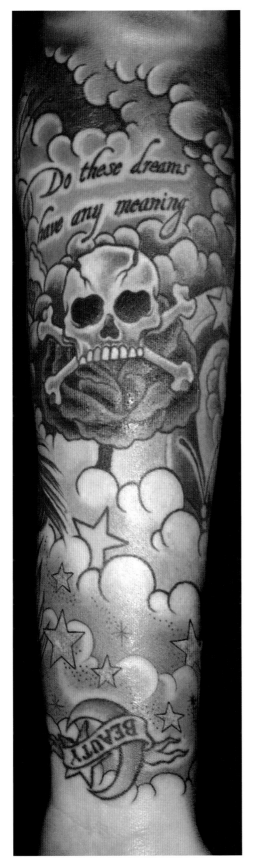
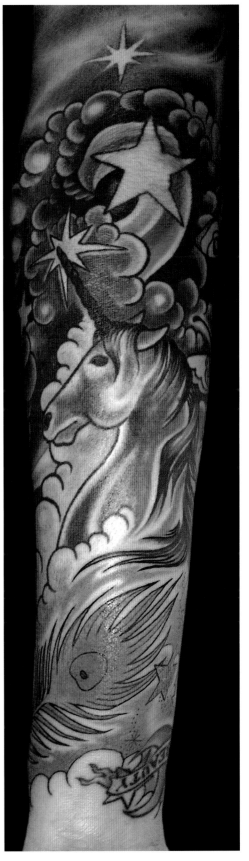

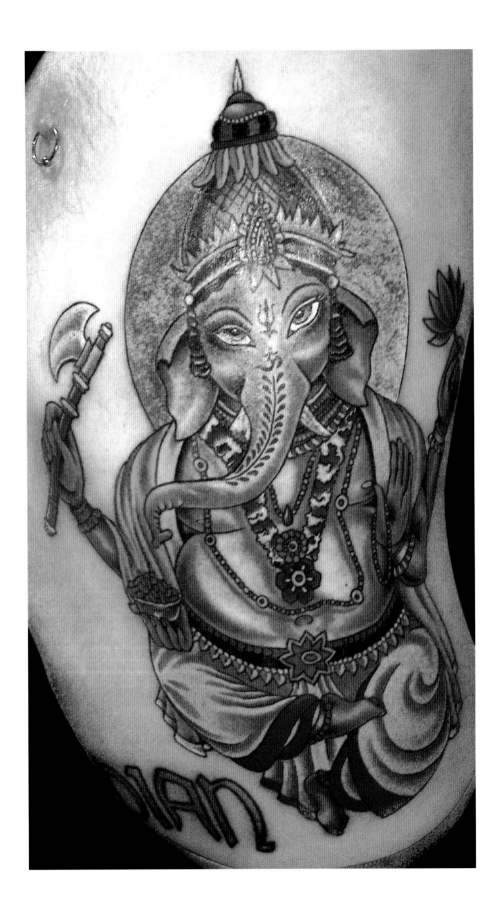

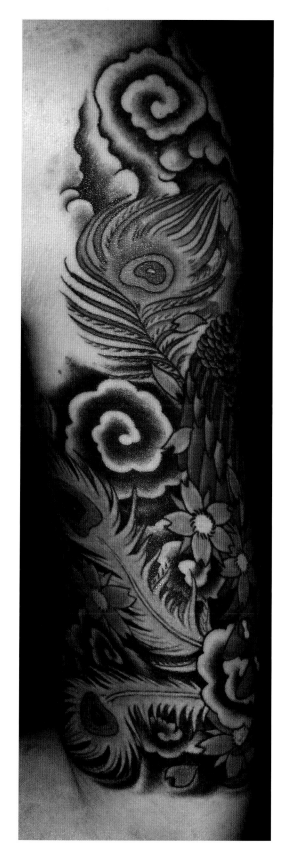
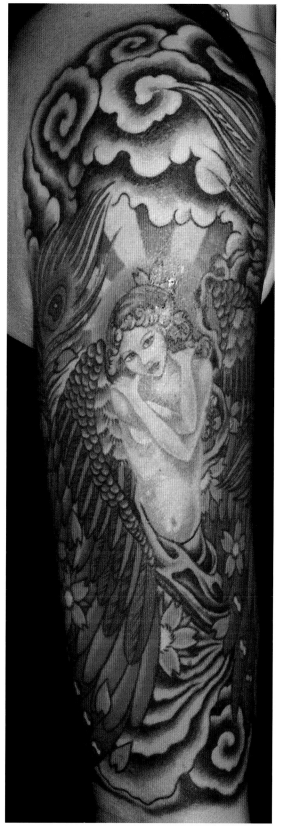

STEVE BOLTZ

Steve Boltz is a self-described street-shop tattooer at heart. In other words, he likes tailoring his work to fit the customer's needs. "I think that having confidence in your work will in turn make your customers confident in your ability to give them what they want," he explains. "I think just being reliable and available to your customers can go a long way in building and keeping loyal clientele. And I'm down to do whatever the client is after." Boltz has been working at Daredevil Tattoo for the past two years. Prior to moving to New York 10 years ago, he worked in Lancaster, PA, under local tattoo artist Jeff Slaugh. He recently published a book with Bert Krak titled "Revisited: A Tribute to Flash from the Past." The book includes 93 contemporary tattoo artists, each re-interpreting a sheet of flash from the original work. This was a fitting project for Boltz, who uses a dualistic approach in his own work, smudging the lines between the classic and modern. Boltz also paints with watercolors, producing hand-painted tattoo flash, which he sells regularly. "I don't do much outside of tattooing and painting," he admits. "I can't seem to go on a vacation without lining myself up to be in a tattoo shop for a good portion of the trip. I really wouldn't know what to do with my time if I weren't tattooing or painting."

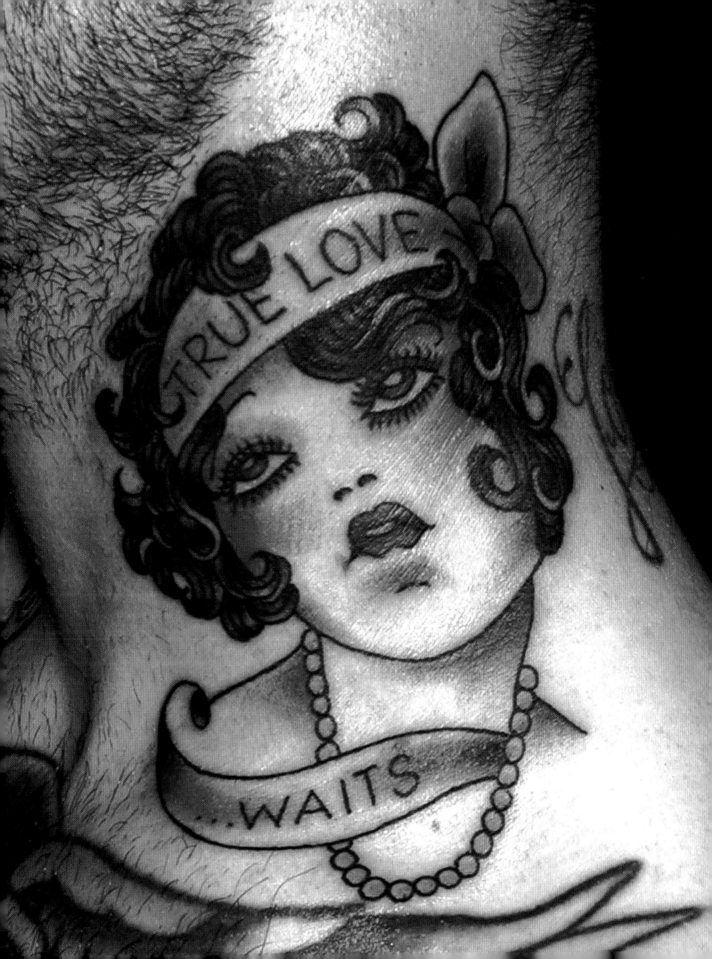

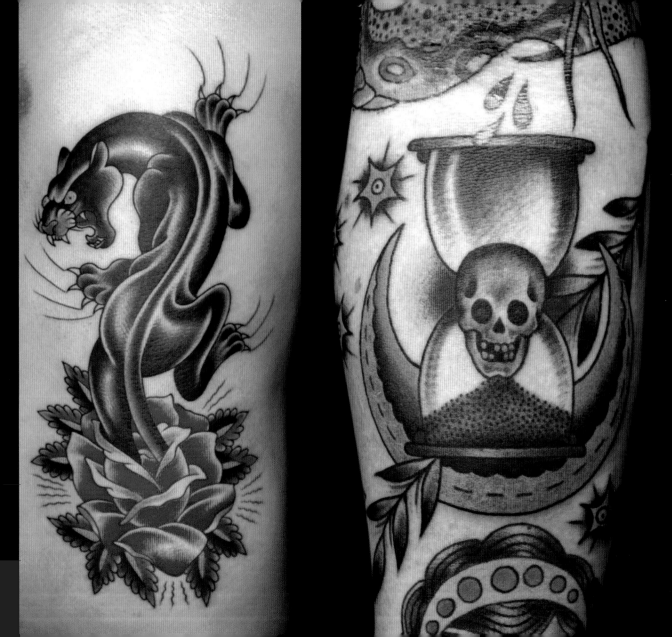

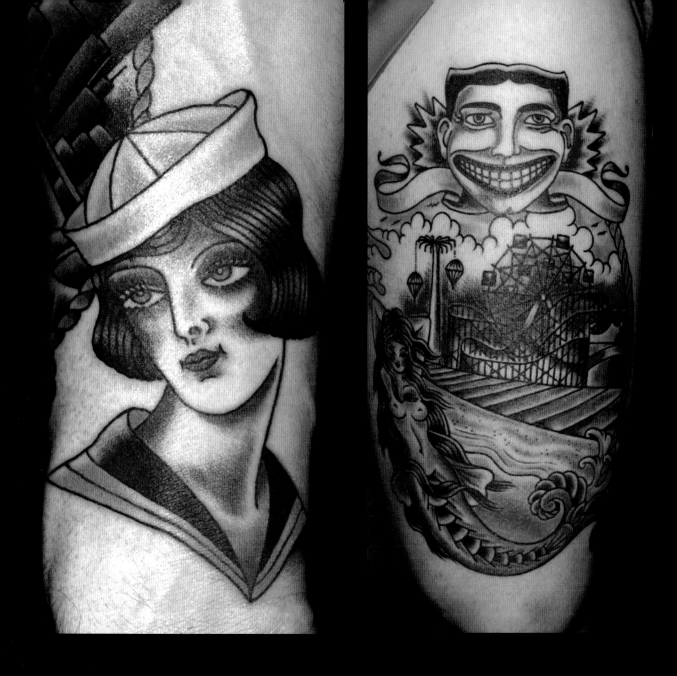

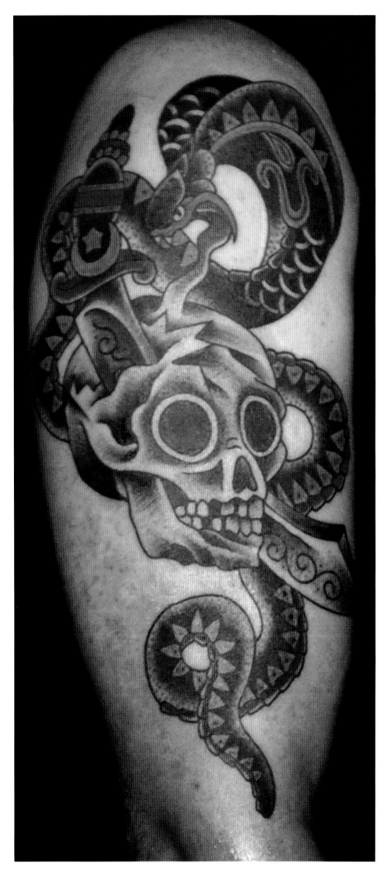

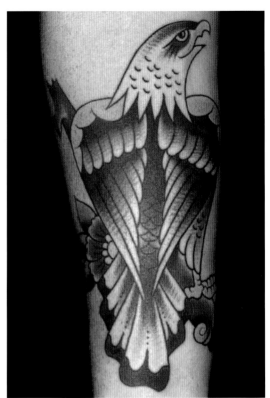

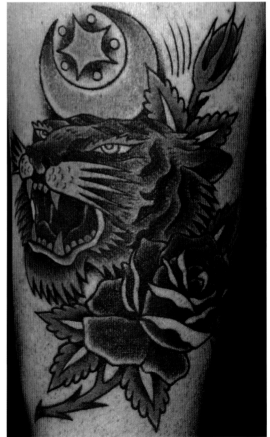

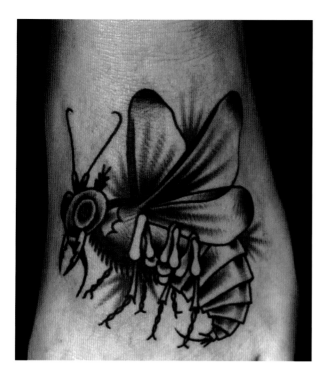

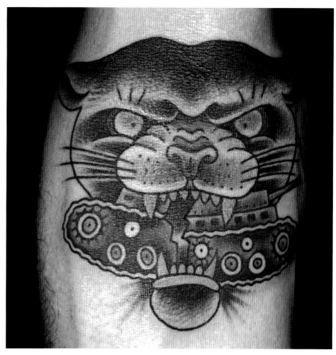

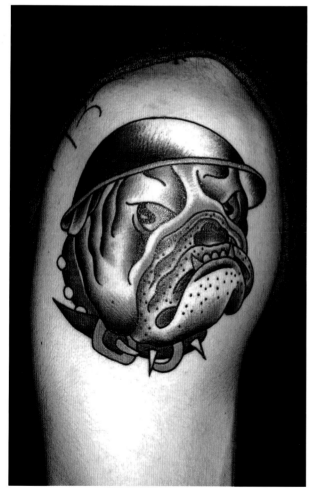

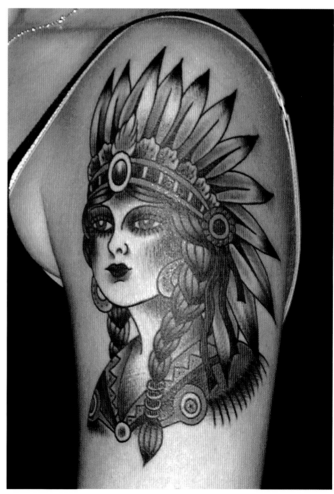

SCOTT CAMPBELL

As legend has it, Scott Campbell was raised on gunpowder and Louisiana swamp grass. After tiring of the South, he moved to San Francisco and took up tattooing. "All I really wanted to do was sit around and draw pictures," he explains. "My landlord kept nagging me for money. It seemed like a solution that made us both happy." Campbell began tattooing out of his house, and once he had a few photos of his work, he took them to Picture Machine Tattoo. "I swindled them into letting me tattoo there a couple days a week," he says. "I was the creepy lurker kid that would hang around scavenging any scraps of knowledge that the artists were careless or generous enough to drop." In '04, Campbell opened Saved Tattoo in Brooklyn, New York. "I love tattooing," he explains, "but sometimes the recipients of the tattoos make me crazy. At no point in a consultation is there any reason why a client should divulge what trauma their parents put them through as a child. I don't need to know that." Campbell also works in "watercolors, acrylics, laser beams, blood, sweat and tears." He has done illustration and design work for clients such as Nike, Maserati and Volkswagen, among others.

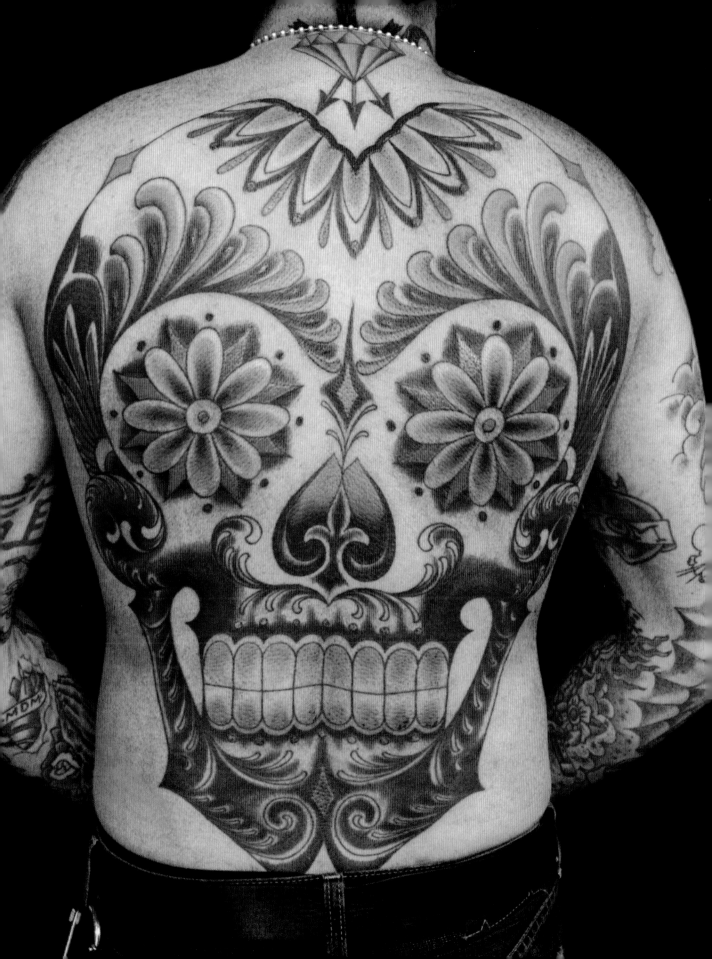

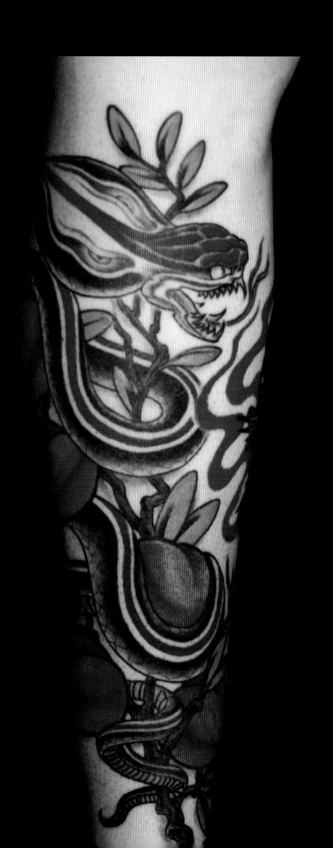

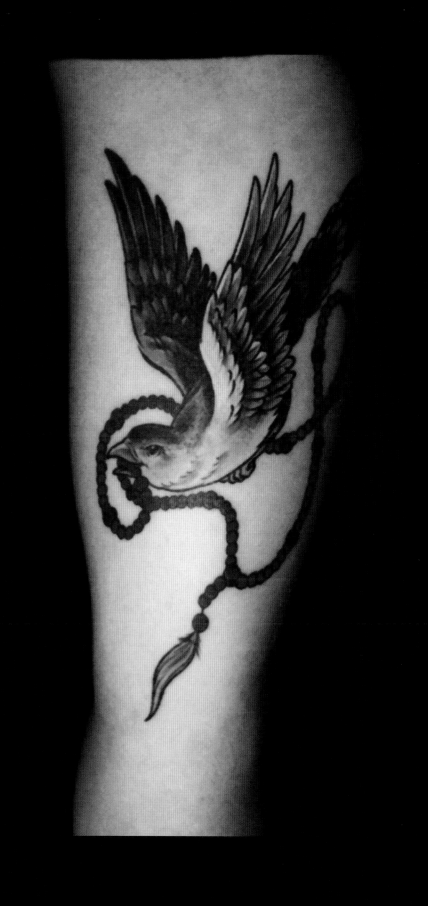

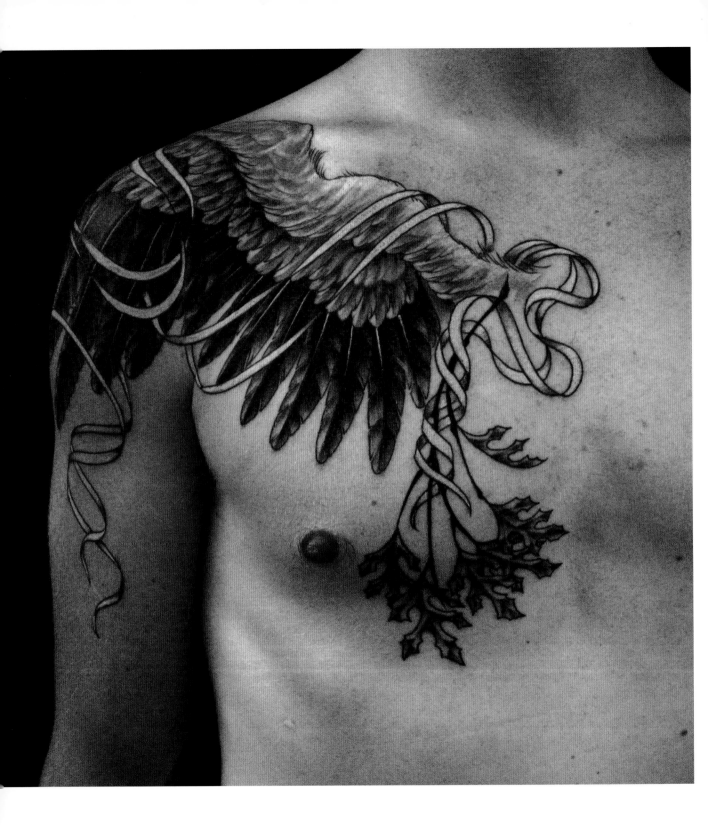

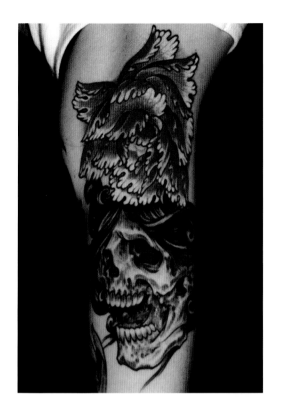

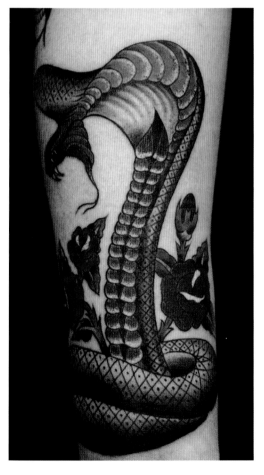

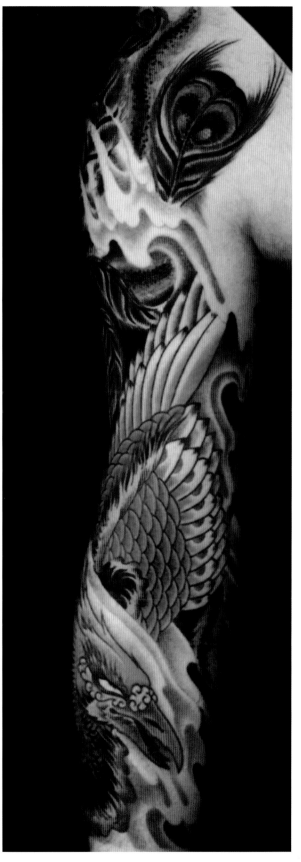

GEORGE CAMPISE

As a young man, George Campise fell in love with the idea of making a living drawing the same images he was always told would get him nowhere. "What I originally found appealing about tattooing I now realize was an incredibly naïve view of it," he says. "I saw only the rewards of tattooing and none of the hours put in to obtain them." The hourly rate "seemed pretty fucking awesome," too. But that rosy view was enough to get him started. After high school in southern New Jersey, he left for San Francisco, where his friend Nick Hoffmann took a look at his sketchbook, helped him order equipment and taught him about sterilization. Hoffmann also let Campise do his first tattoo on him. He set up shop in his house in the Lower Haight, where he worked for a year and a half, as well as at the Davis Tattoo Company in Sacramento and Erno Tattoo in the Fillmore District of San Francisco. He later began a nine-year stint at Everlasting Tattoo, followed by Seventh Son, where he works today. He's not a specialist, though he likes his work to be bright, easily read, and flattering to the body it adorns. "My clientele keeps me on my toes," he says, "always mixing it up as far as subject matter goes." As for that rosy view of tattooing, he says, "What I now know is that for every one hour you have on the clock you have three where you're not. Between the time put in on the illustration for the tattoo, to mixing your pigments, making needles, etc., there's way more time off the clock than on."

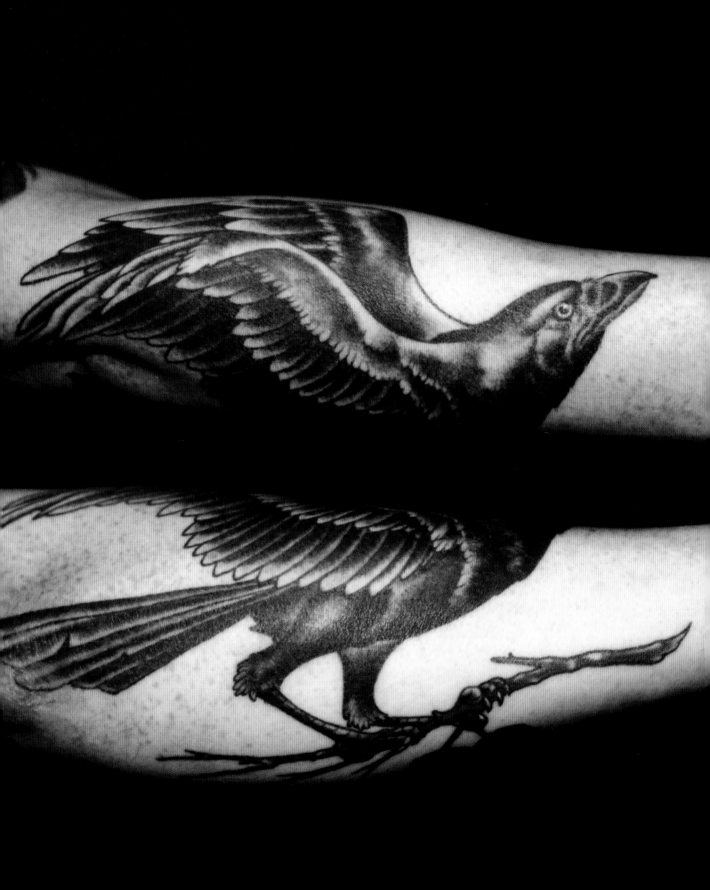

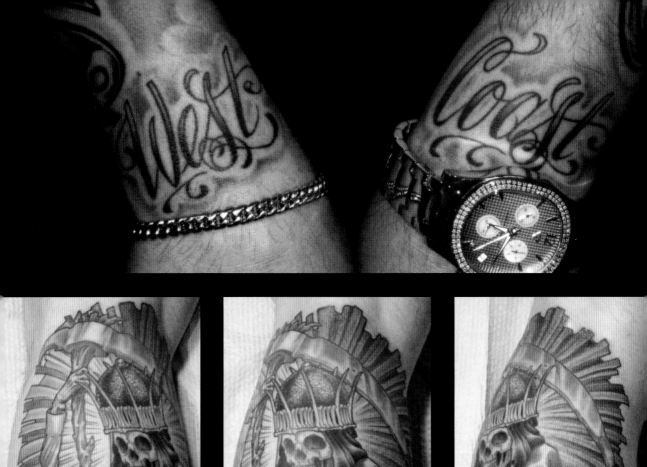
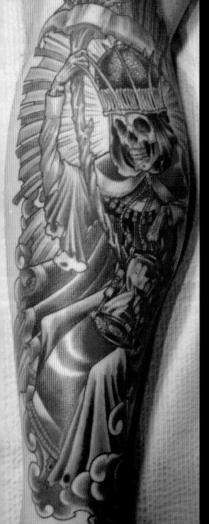
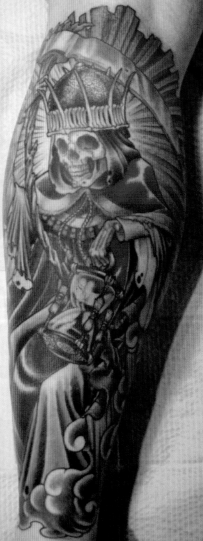
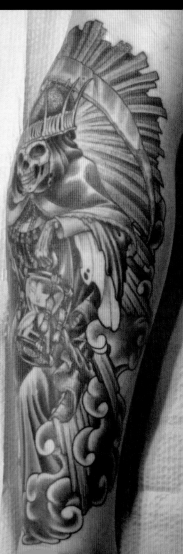

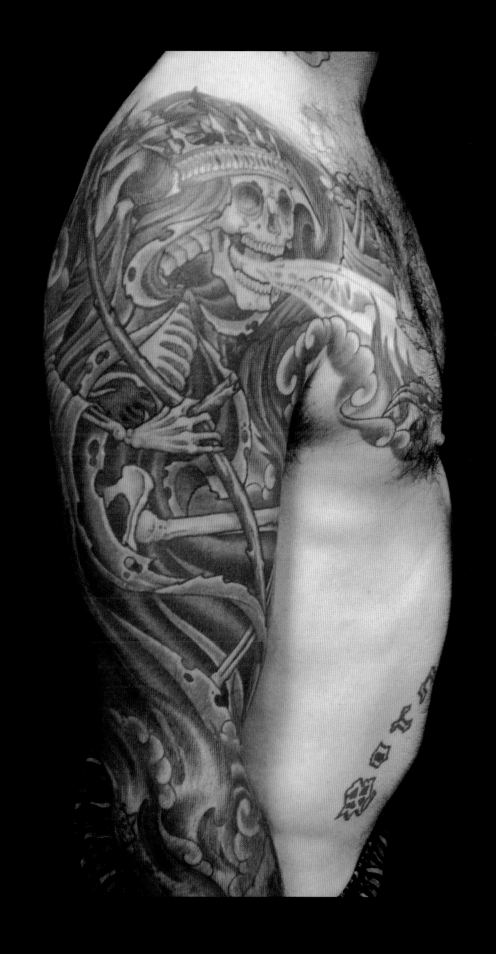

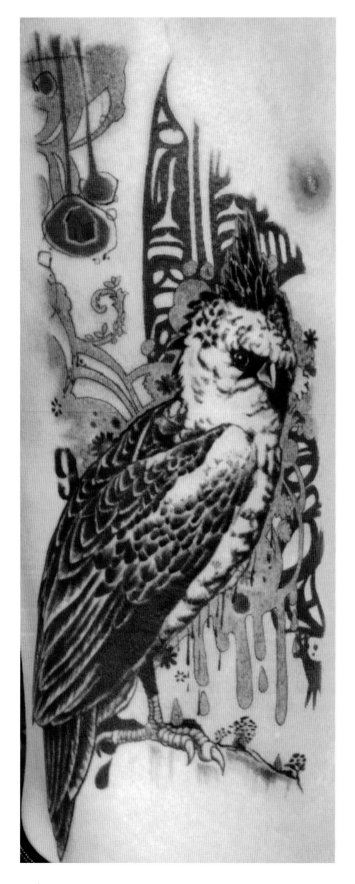
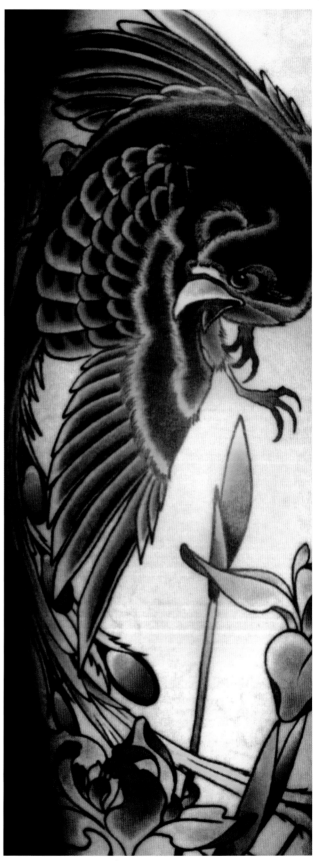

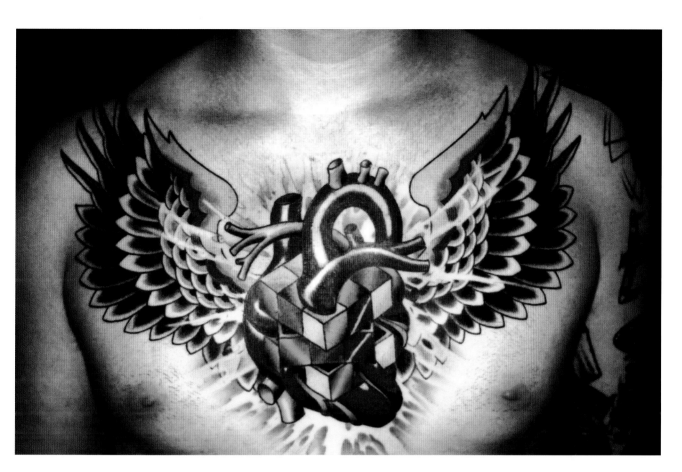

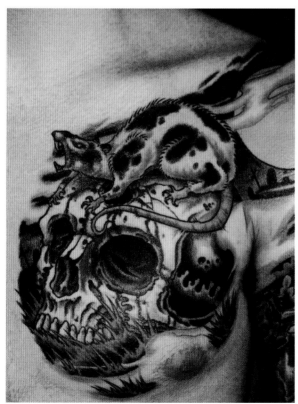

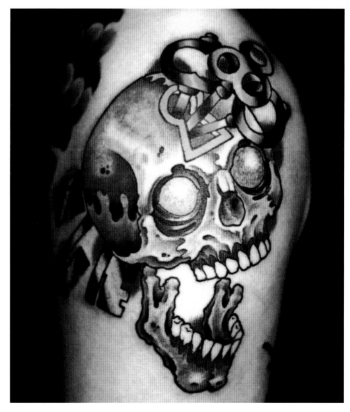

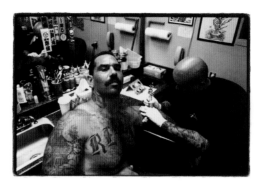

MISTER CARTOON

Los Angeles-native Mister Cartoon began his career as a graffiti artist, and gained local notoriety as a lowrider muralist. After painting Larry Flynt's limo, he was offered a job as an illustrator for Hustler. Although he was already a semi-established artist, Cartoon had to start tattooing from scratch. He began working out of a kitchen, where he learned the careful skill of applying ink to skin. In '98, after getting sober, Baby Ray apprenticed Cartoon at Bob Roberts' Spotlight Tattoo. "I already knew how to tattoo," he says, "but I was starting over in a real shop." After his apprenticeship, Cartoon continued to work hard at his craft and developed a deeply original style. But he largely credits his popularity to friend and business partner Estevan Oriol, who brought him celebrity clientele. Today Cartoon has tattooed top musicians and hip-hop artists such as Dr. Dre, Travis Barker, Eminem, Beyonce and Kanye West. "Tattooing celebrities captured the attention of the masses," he explains, "but the heart and soul of my art comes from the L.A. streets." Cartoon's black-and-gray tattoos collage street life and fantasy, rendered in an acute photorealistic style; his distinctive lettering pulls from hardcore gang graffiti and traditional Old English. "I don't focus on how much I am getting paid," he says, "but how to do the greatest tattoo I've ever done on every client that walks through the door." Cartoon has collaborated with companies such as Nike and T-Mobile, and his work has been exhibited in places such as New York, Tokyo and London. He is currently working on "The Lost Angel," a graphic novel, and has a shoe and lifestyle store opening soon in the heart of downtown. Through it all, Cartoon has remained humble: "You must always maintain loyalty to the godfathers of the art," he concludes, citing Jack Rudy, Freddy Negrete and Good Time Charlie. "You have to have ethics, even in the tattoo world."

All images for Mister Cartoon by ESTEVAN ORIOL

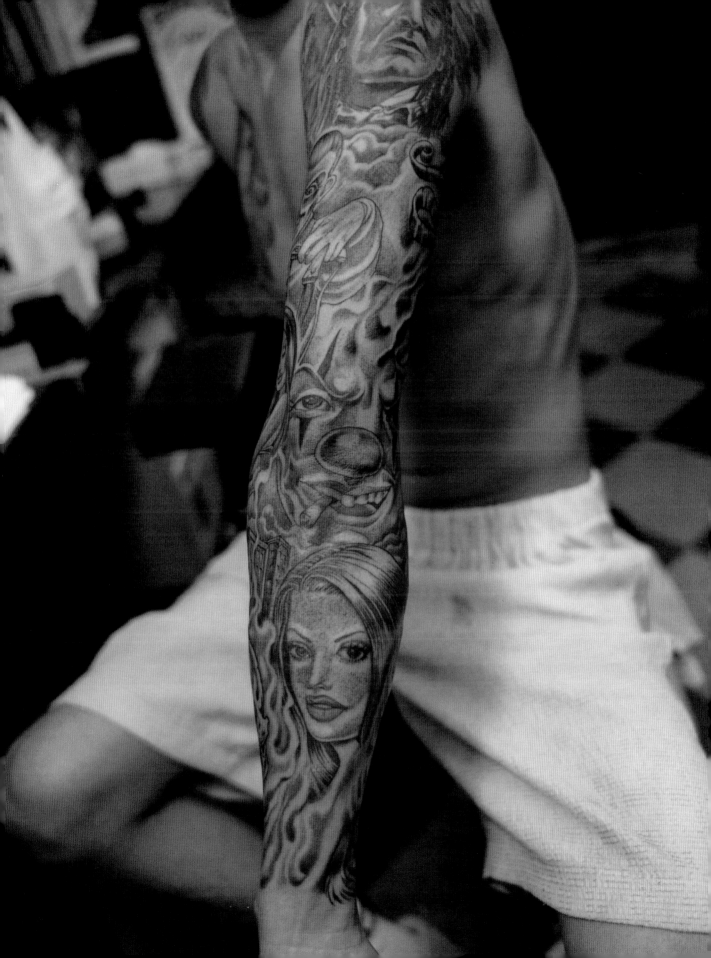

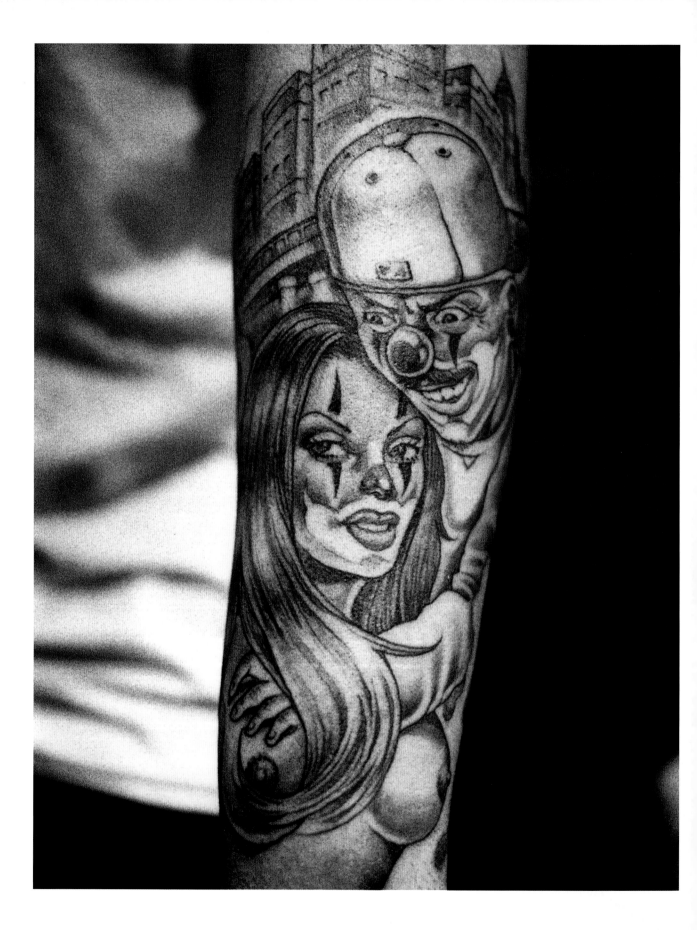

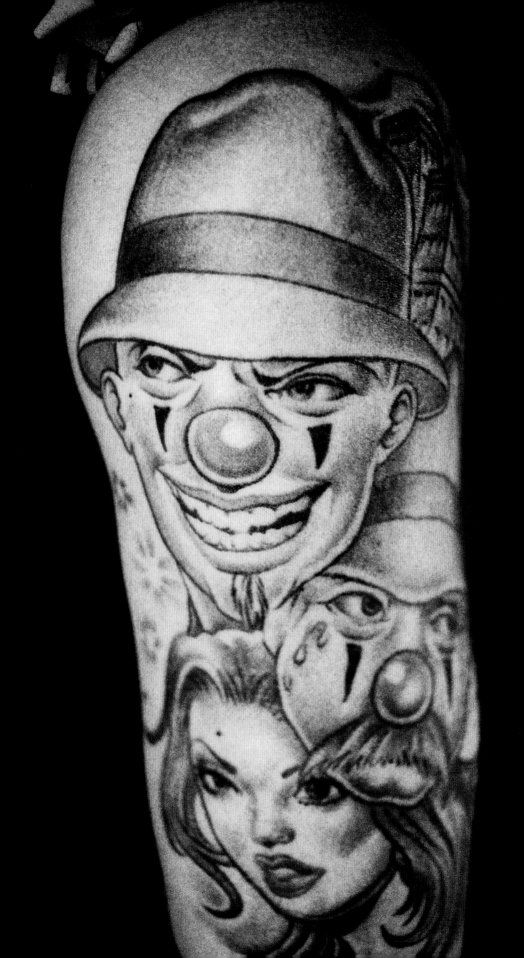

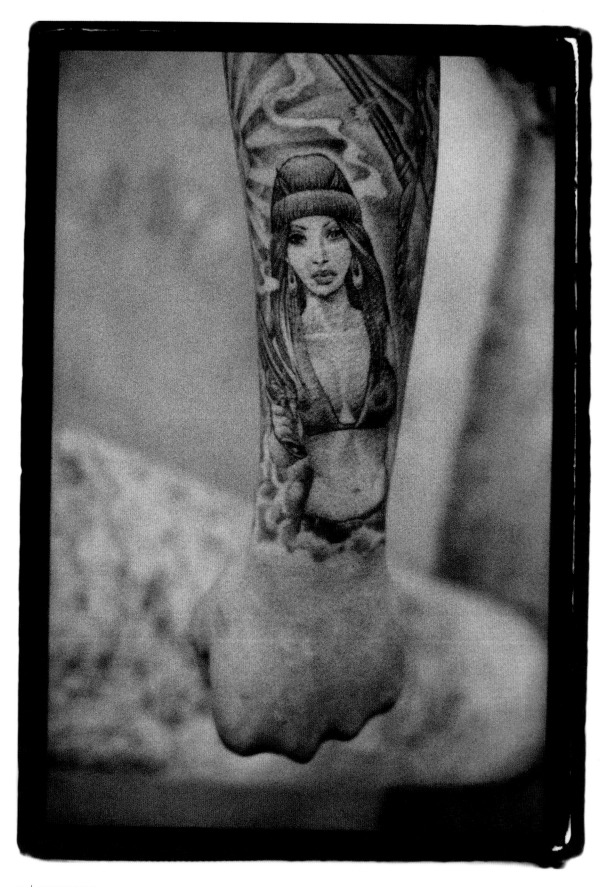

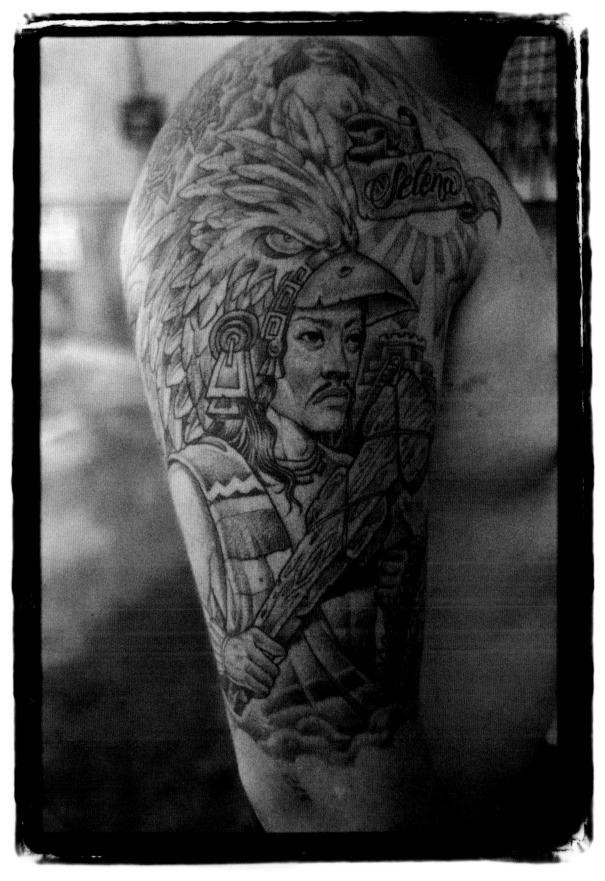

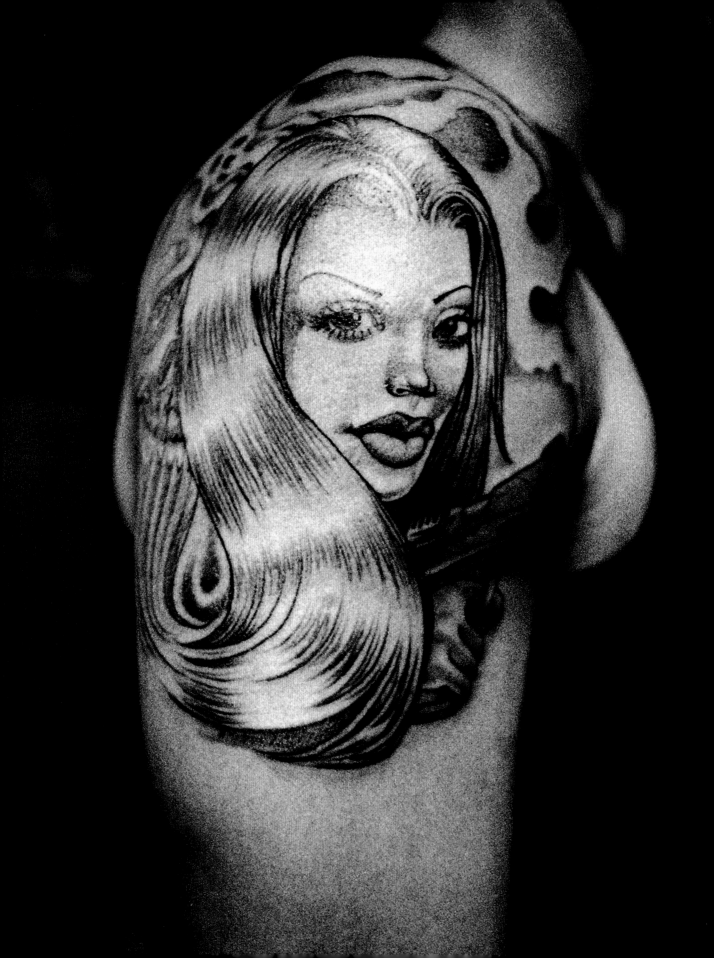

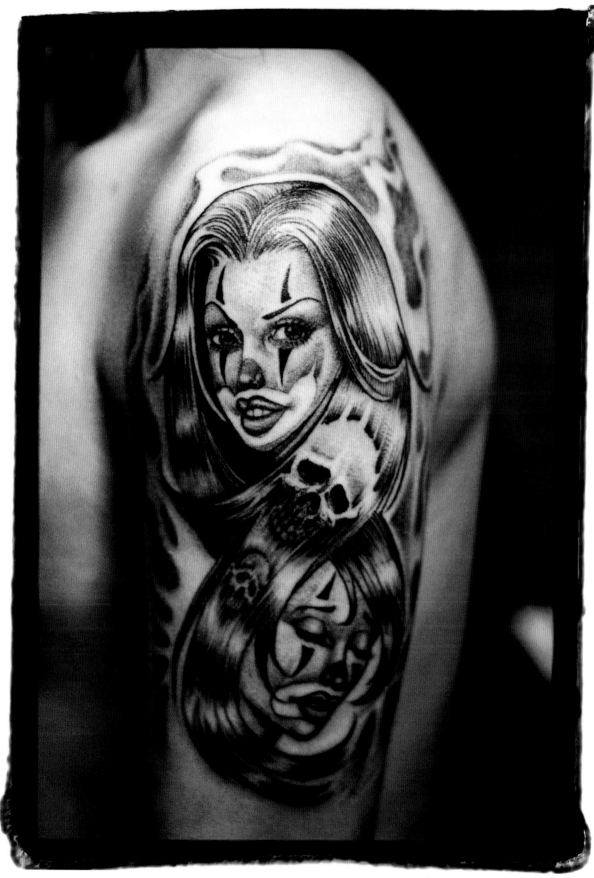

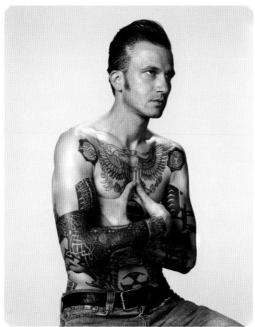

PATRICK CONLON

Patrick Conlon grew up in a coastal New England town. "I always loved the romanticism of the sailor's life," he says. "I've always associated it with tattooing." After moving to San Francisco to attend the Academy of Art College, he started tattooing at Erno Tattoo in '91. "I never had a formal apprenticeship," he explains. "I considered my co-workers and boss my friends, and they showed me what to do. Nalla Smith, Greg Kulz, Mandy Flynn, Jaime Trujillo and of course the late, great Erno are responsible for how I work today. I would say my greatest influences are my peers." For the last four years, Conlon has worked at West Side Ink in the West Village neighborhood of New York. He inks figurative, one-of-a-kind tattoos. "I create original, custom illustrations," he says. "I specialize in the female form and will use 'reference' as reference—no tracing. The result is a unique, form-fitting tattoo just for you." Conlon also paints and illustrates graphic novels. He created the erotic series Swarm, has collaborated with artist Michael Manning on Tranceptor, and has two more graphic novels on the way. He concludes, "Earning a living while creating unique illustrations is my dream come true."

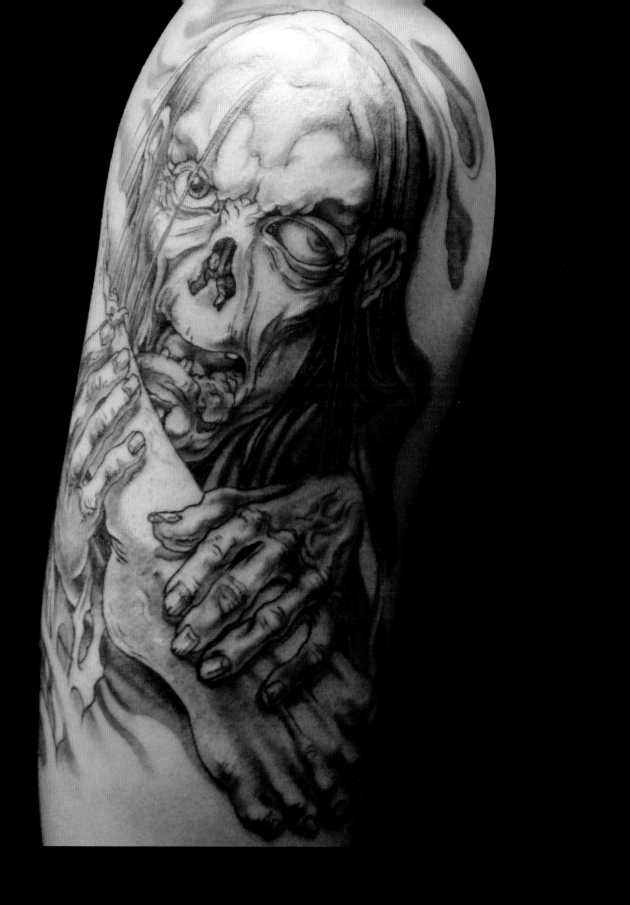

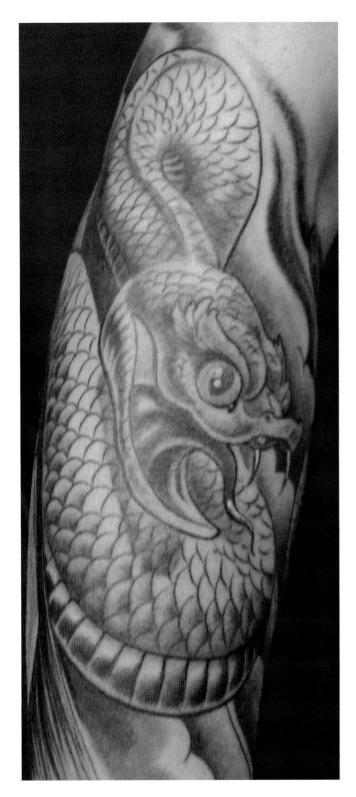
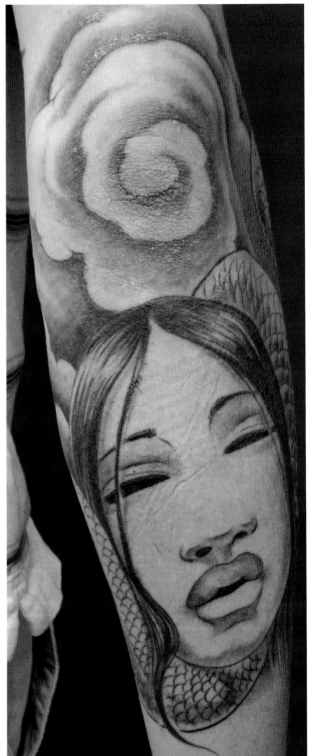

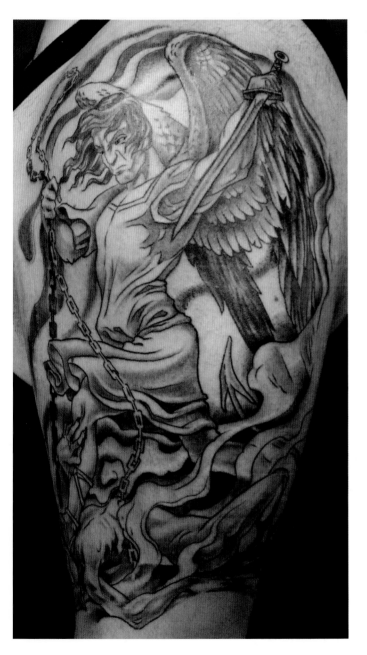
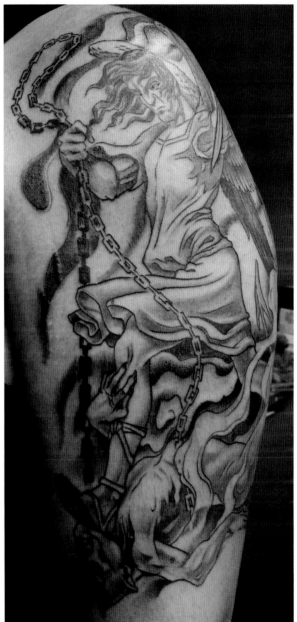

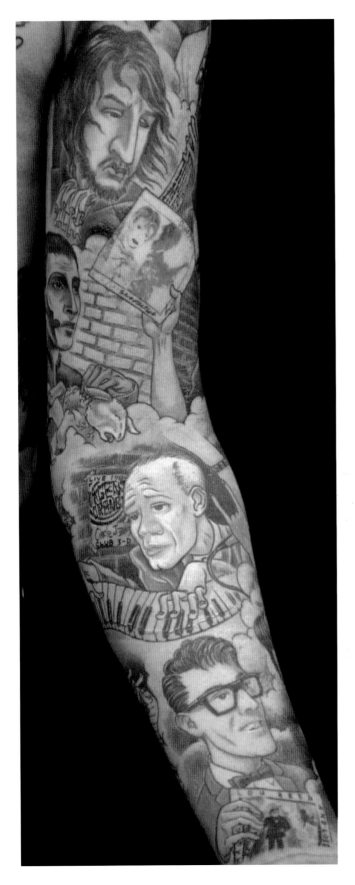
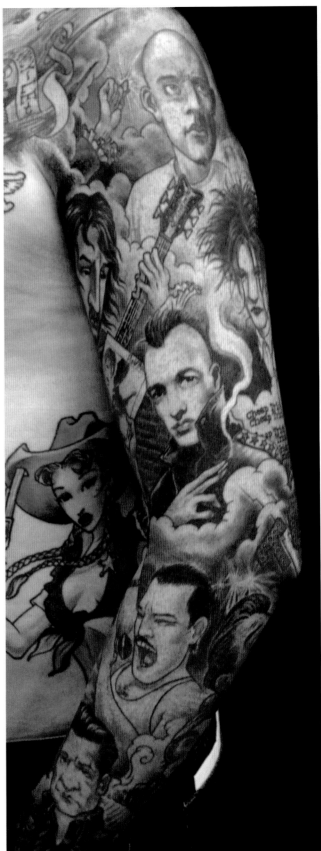

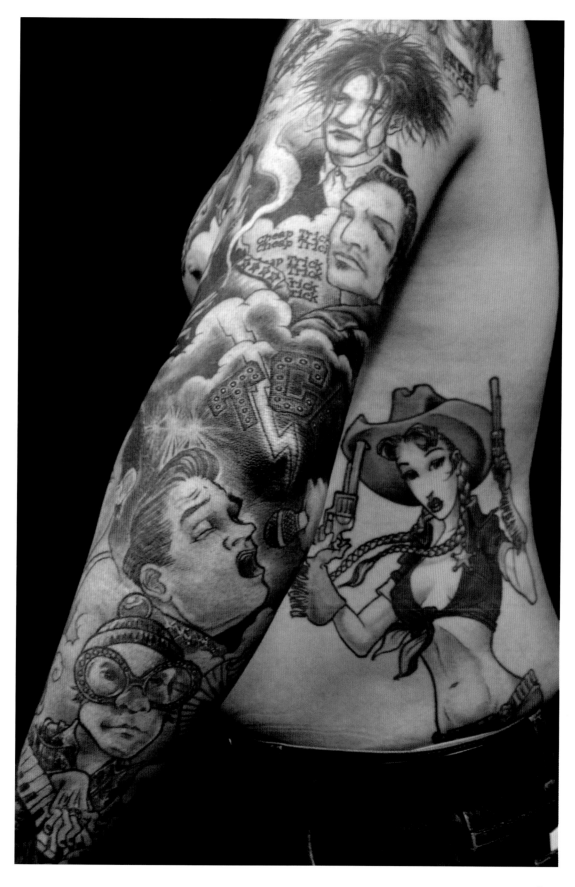

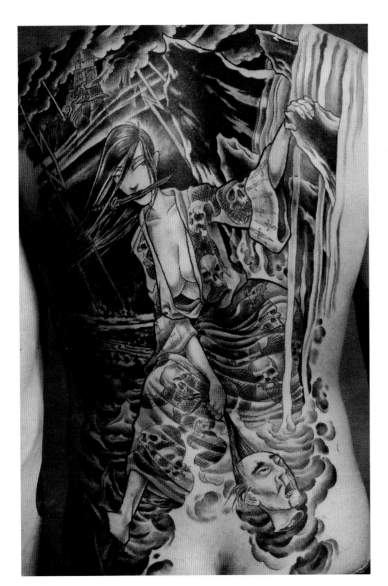

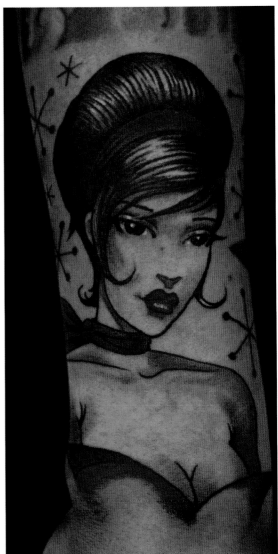

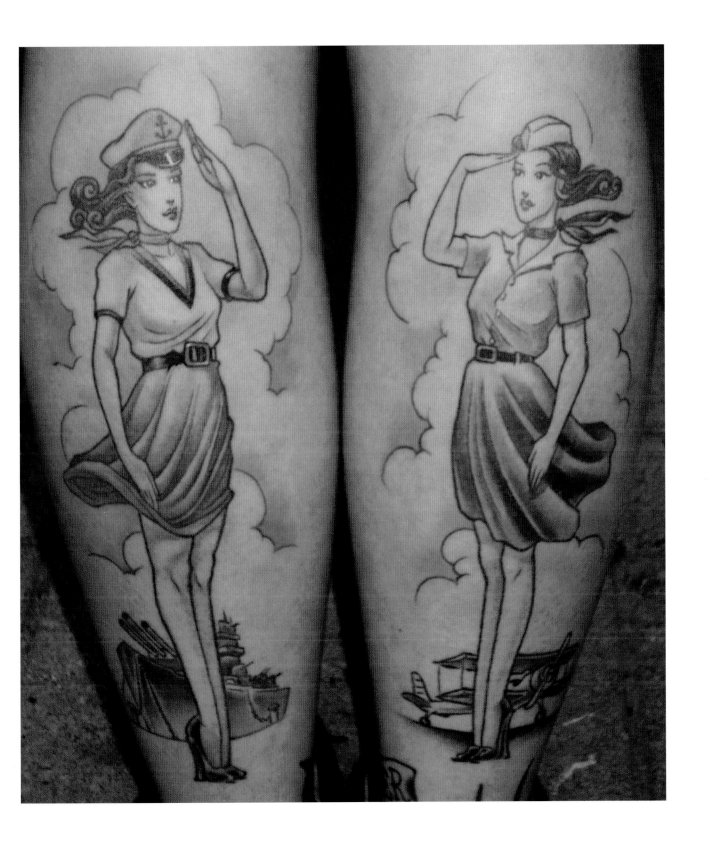

MIKE DAVIS

"I got a tattoo and thought it would be fun to make them on other people," Mike Davis explains. While working as a theatrical and movie set designer in the late '80s, he began tattooing at home in his spare time in Cincinatti. In '92 he moved to California and worked at Everlasting Tattoo, which he bought two years later. Davis says he has no tattooing specialty, but his work is recognizable by a clean graphic style rendered in vivid colors. He has been tattooing for 20 years, and his work has been featured in numerous books. With no formal training, the autodidact educates himself via reading, museums, and travel. He began painting in '98 and has since enjoyed a number of successful gallery shows. "Right now I am working on a second career as a painter," he explains. "I love traveling to Europe and studying old paintings and archaeological sites." He finds inspiration in his wife and mother, and says, "I love tattooing because it has given me everything I have."

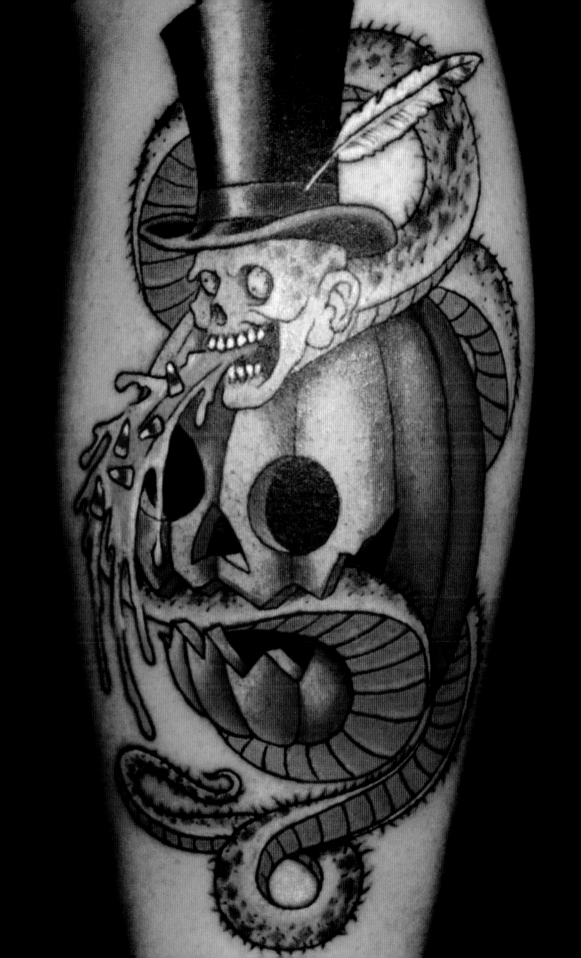

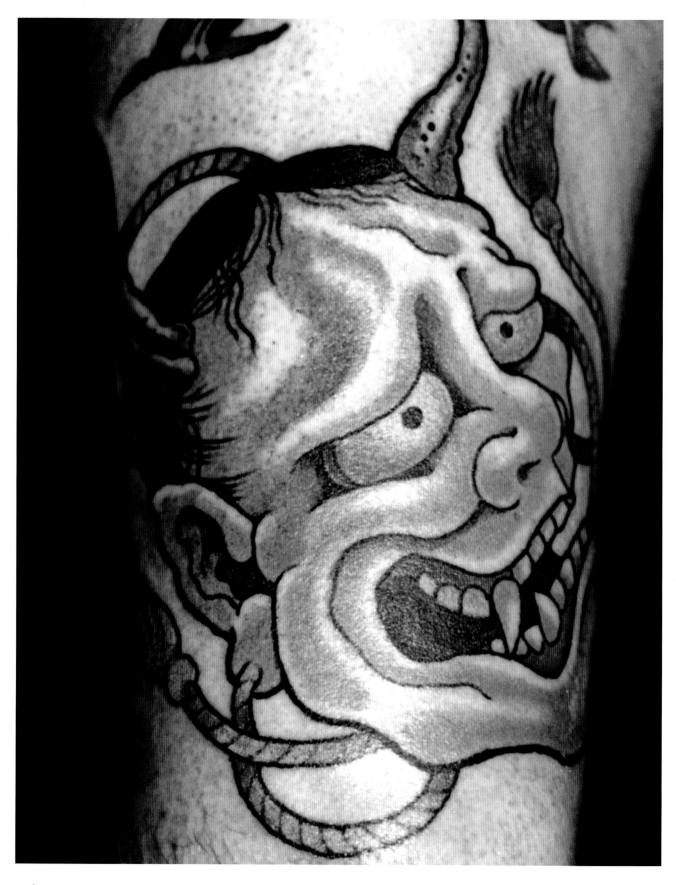

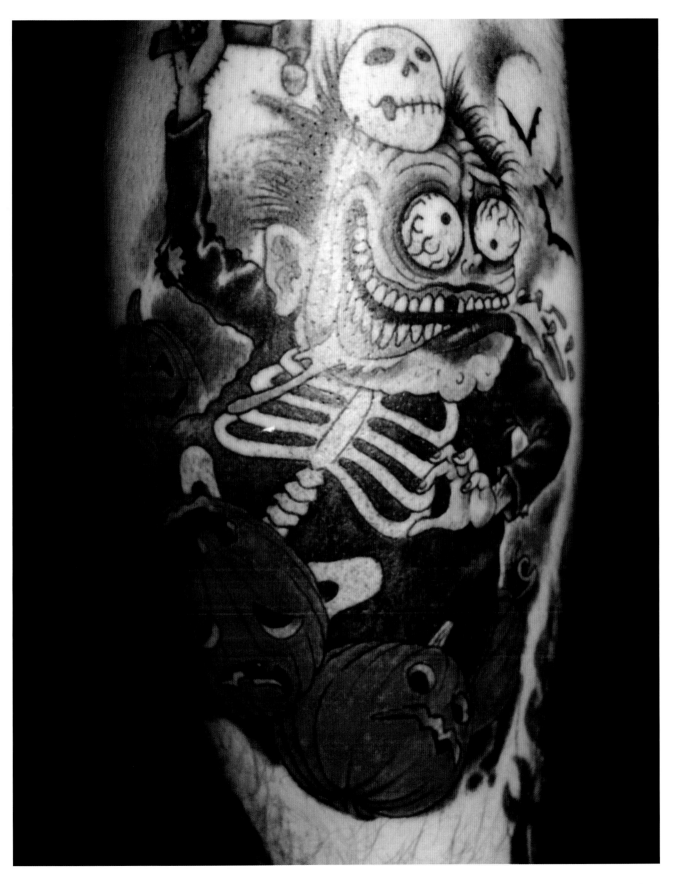

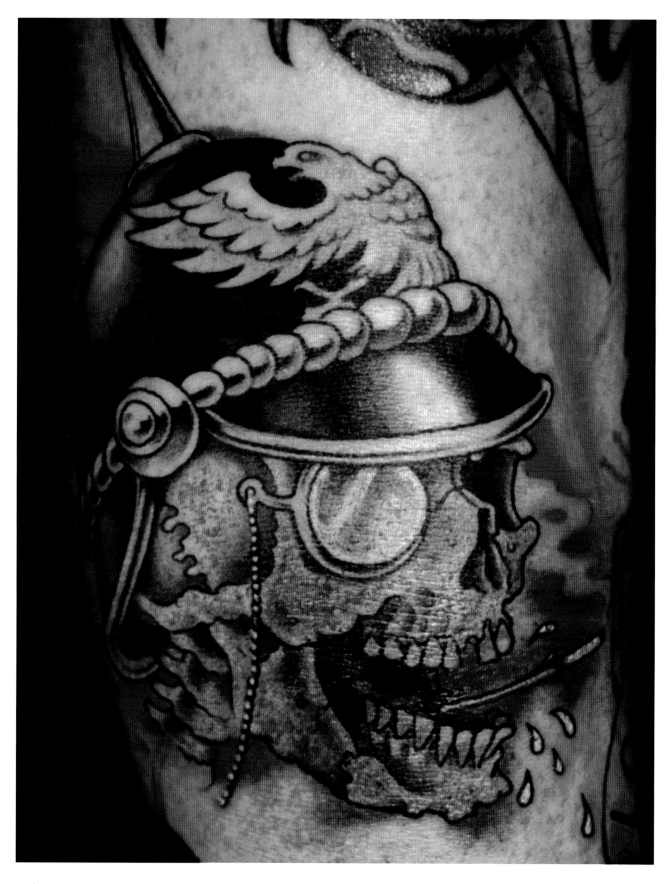

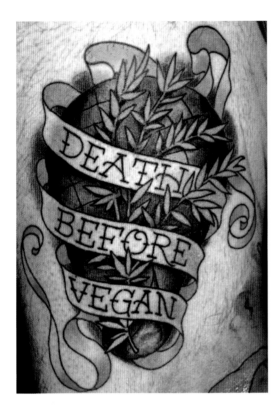

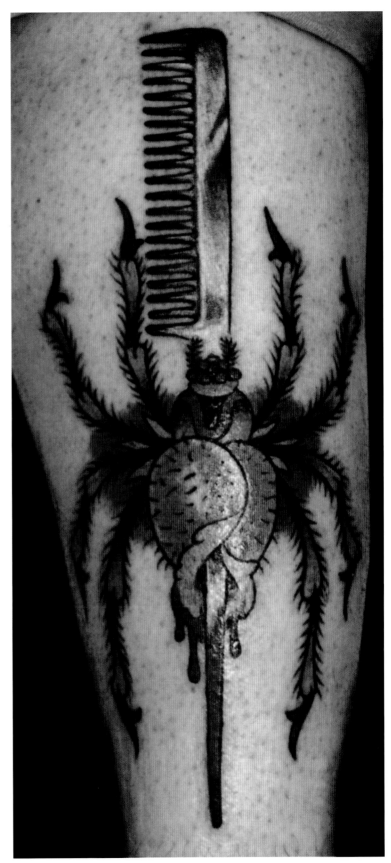

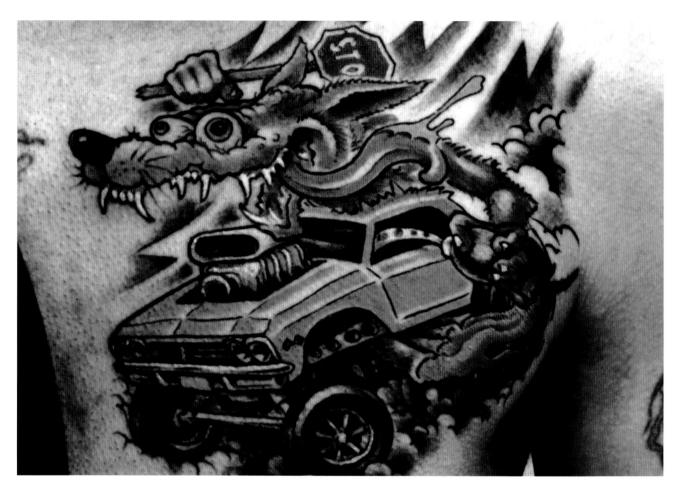

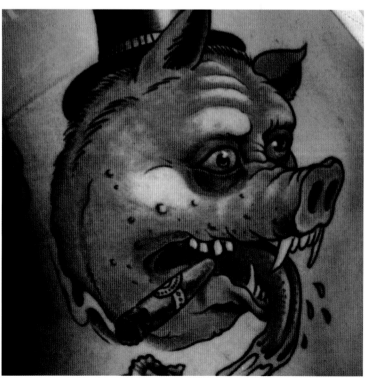

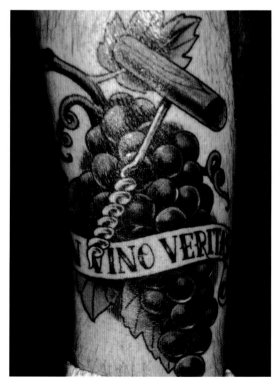

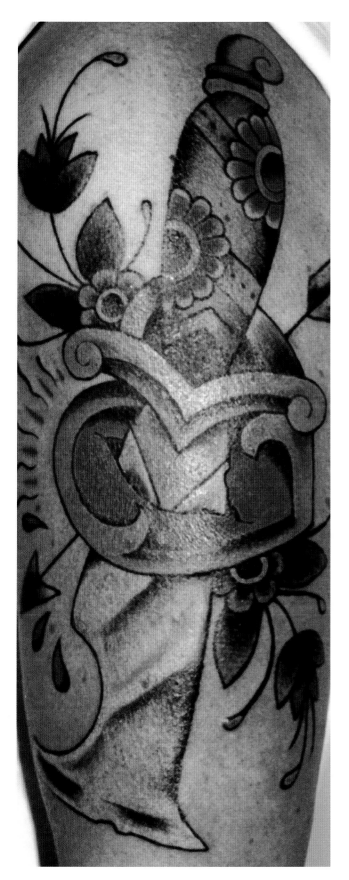
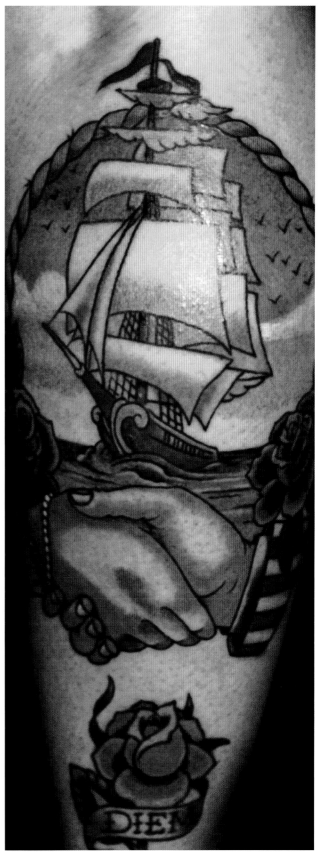

TROY DENNING

"I have no formal art training," explains Troy Denning. "I just drew a lot as a kid as a form of escapism." Growing up in Oakland, that was enough to get him started, and by '92 he was tattooing professionally in San Francisco. Besides, he says, "the tattooers that I've worked with throughout my career have all been the best teachers I could ever have hoped for." Troy and his wife, Jesse Lee, relocated to New York and opened their shop, Invisible NYC, on the Lower East Side. "The fact that my wife and I were able to open a shop, not knowing what to expect, and within a year have the most talented crew of tattooers—their growth and progress, as well as the growth and development of the shop—is the greatest accomplishment I can think of." Troy himself is a specialist in large-scale Japanese-influenced work, having been drawn especially to how its particular imagery and technique "contrasts with the modern world around us." Now 17 years into his professional tattooing career, Troy is still a student of the trade, though he now has an apprentice and, most importantly, a strong client base at his shop. "I think people enjoy my approach to the tattoo process as well as my deep understanding of the subject matter," he explains. "I also think that Invisible NYC as a space and as a whole offers people a completely different tattoo shop experience."

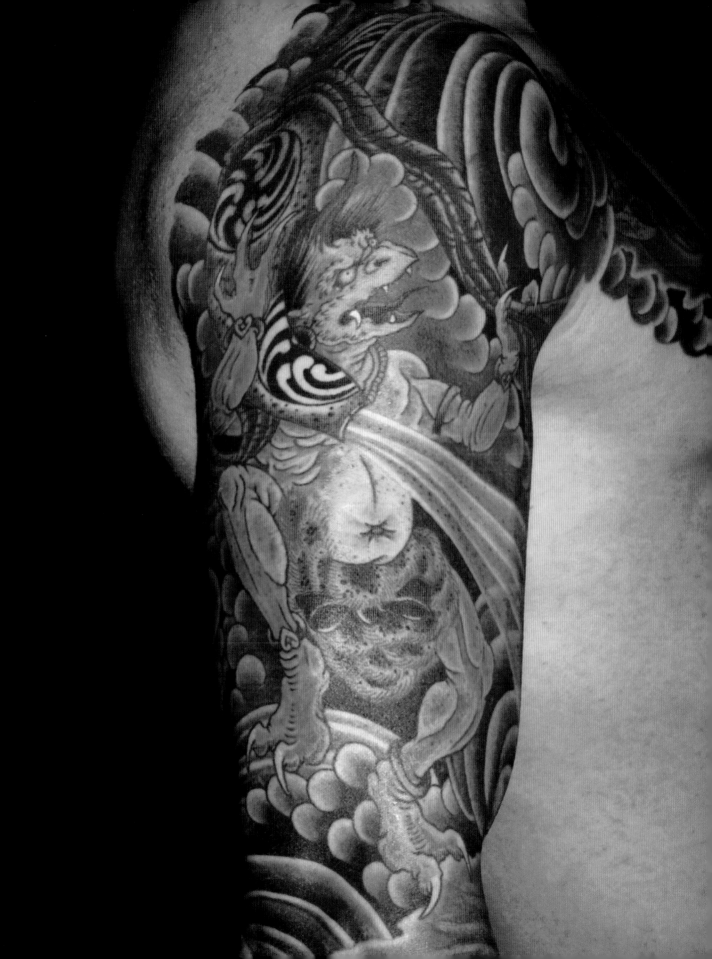

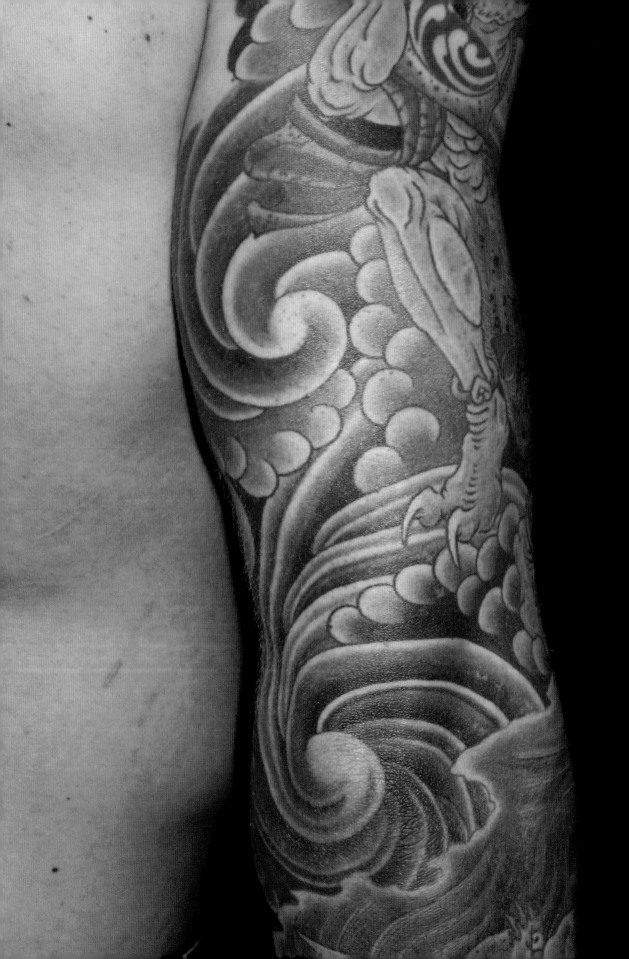

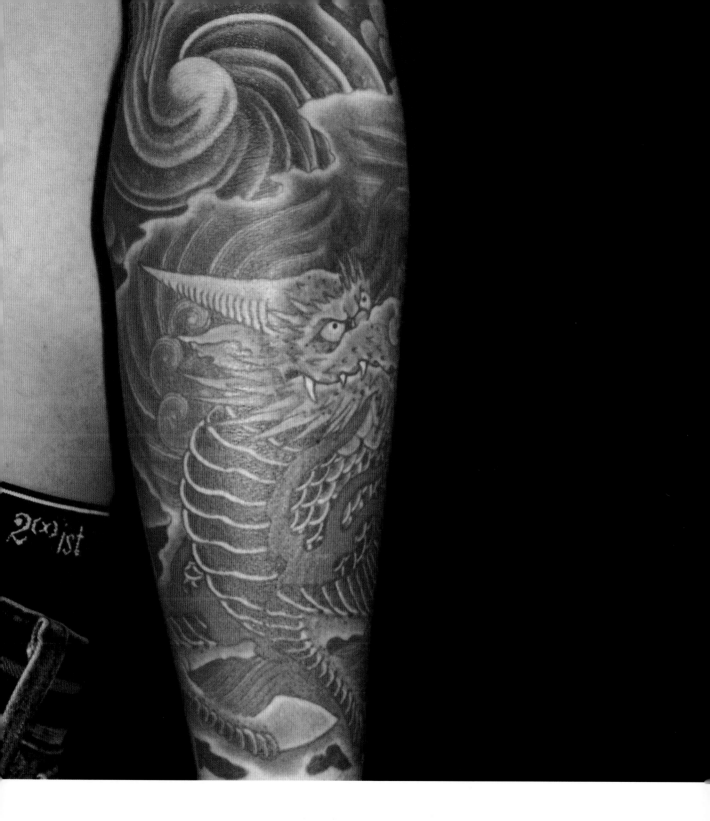

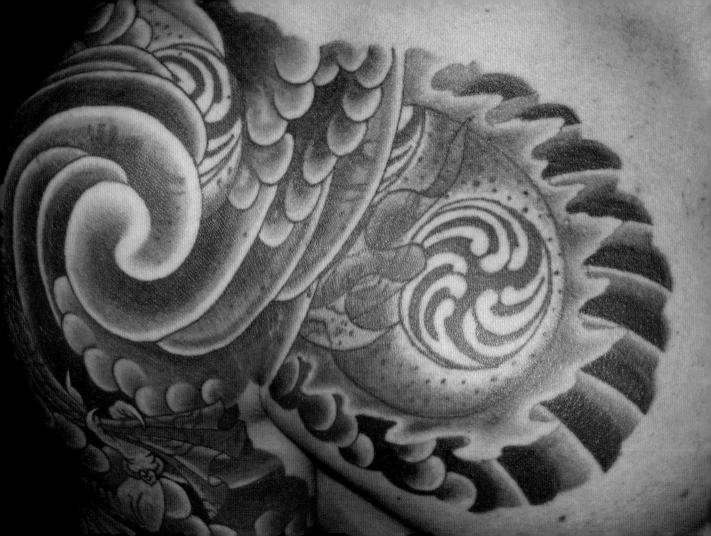

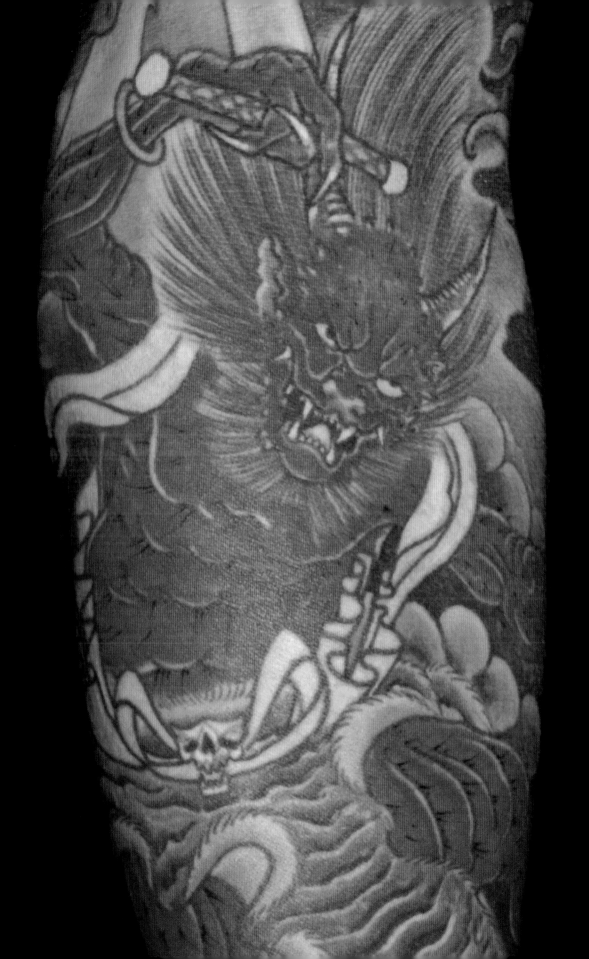

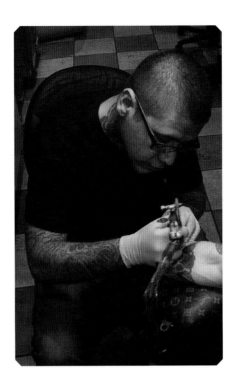

MARIO DESA

Mario Desa grew up drawing, but it was graffiti that honed his skills. "I did go to art school for a year, but I don't think I really learned anything," he says. "I learned much more under bridges and in freight yards." A few years later, Desa began getting tattooed. "I really liked being in the tattoo shop and was intrigued by the process and lifestyle," he explains. "I liked the 'pirate' aspect of it, similar to the graffiti lifestyle. I thought I'd be good at it and it was a way I could actually earn a living with artwork." In '97, he started tattooing under the guidance of Daniel Trocchio in Milwaukee. Today he works at Chicago Tattoo Co., an Illinois-based shop where he has been since '04. "I love the freedom I feel as a tattooer," he says. "I don't feel like I have a 'job.'" Desa's tattoos are done in a classic American style, inked with exotic color combinations. His work has been featured in a number of art shows and magazines, but Desa doesn't claim those as his most noteworthy accomplishments. "I'm just glad to come to a job I love everyday and do tattoos for people," he says. "I came from nothing and made my own way, and my mom is proud. That's what it's all about, right?"

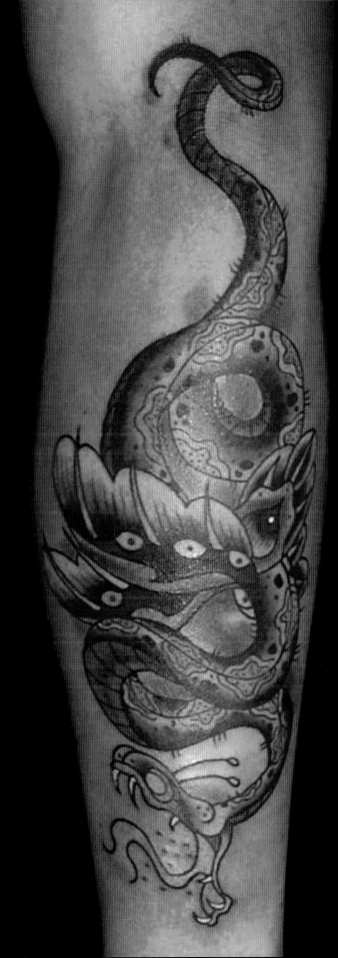

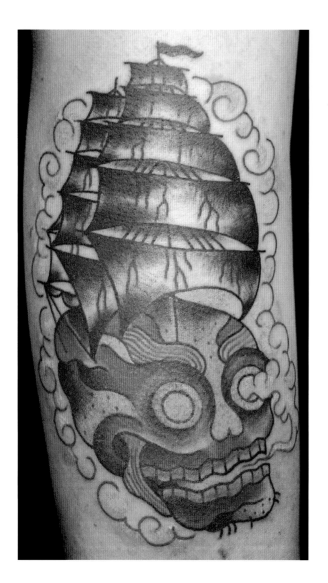
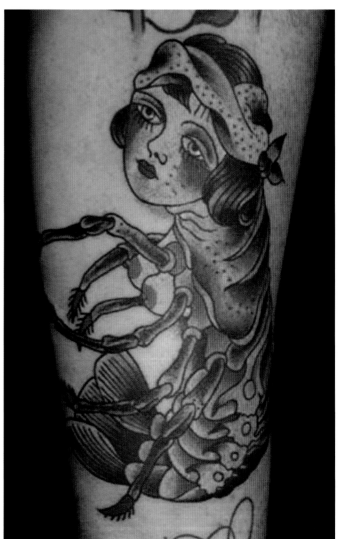

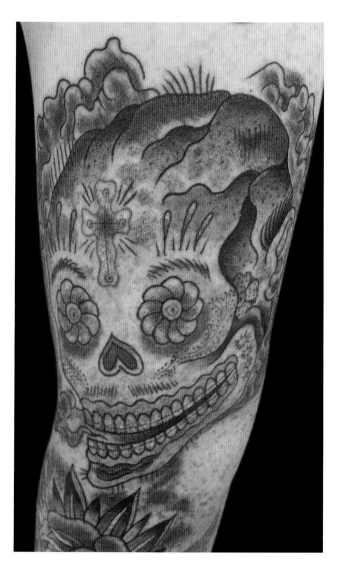

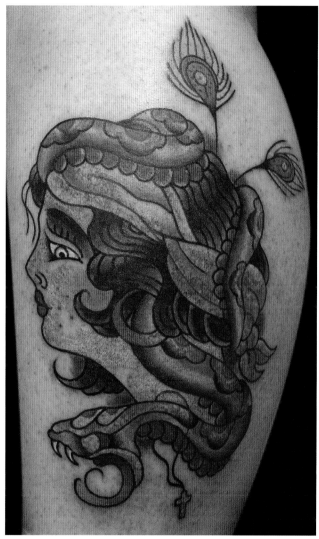

KORE FLATMO

Cincinnati tattooist Kore Flatmo has a commute that lights a fire under him. "Fucking walking past a Taco Bell everyday on my way to work—there's no better inspiration than my desperation to avoid that kind of life." Yet for all that desperate drive, tattooing was a happy accident for Kore, who grew up in Pasadena and Glendora, California, and began to tattoo in 1990. "I fell into it, no real intention—just got very lucky," he explains. "What was appealing for me then and is stronger now is the tattooing itself, just being there doing it. The money, drugs and women were just a wonderful bonus." Another bonus is people seeking him out for tattoo work, whether he's visiting Los Angeles or home at Plurabella, the Cincinatti shop he opened in 1999. "I don't exactly know why people like what I do but I am grateful they do. I hope it's a response to the style, craft and effort." Between running Plurabella with his wife Brenda and friend Kim, he's been accused of not having enough balance in his life. "But," he offers, "that's not something that bothers me too much. My preference is to focus on work." "What I love the most about tattooing never changes," he adds, "it's just being a part of it and having a place in something so meaningful."

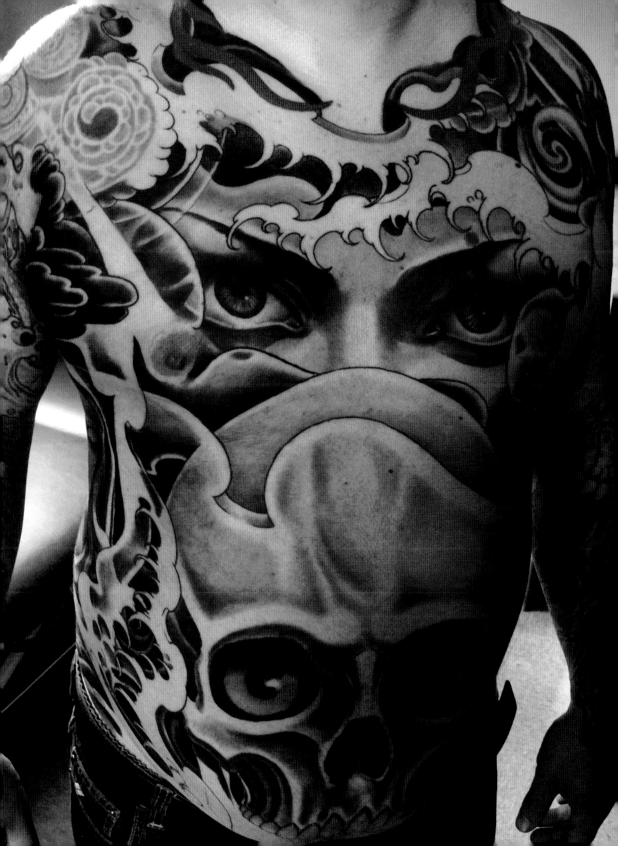

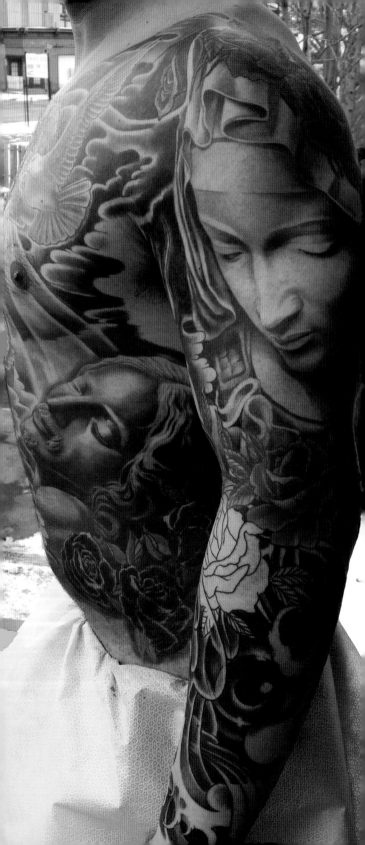

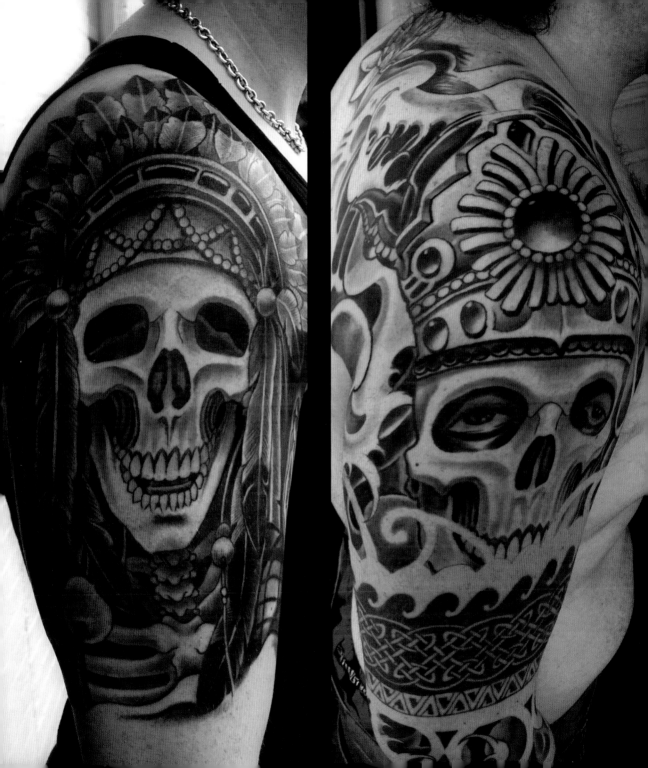

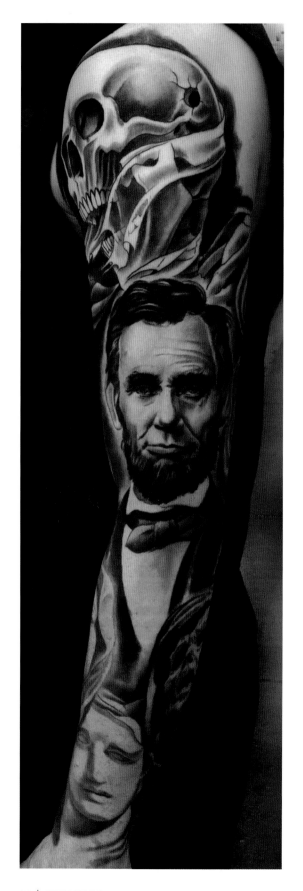

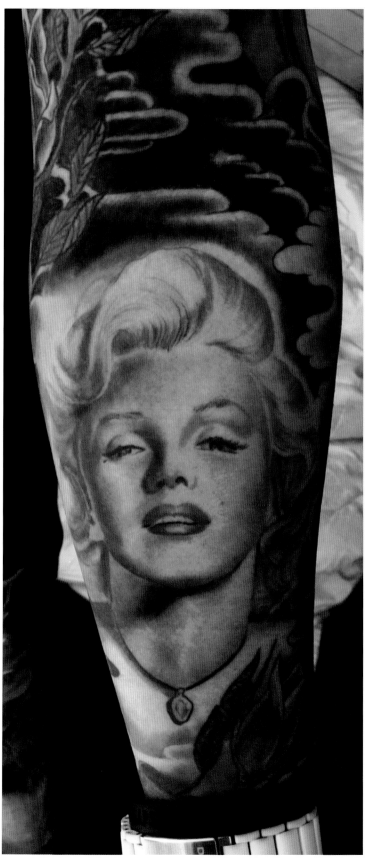

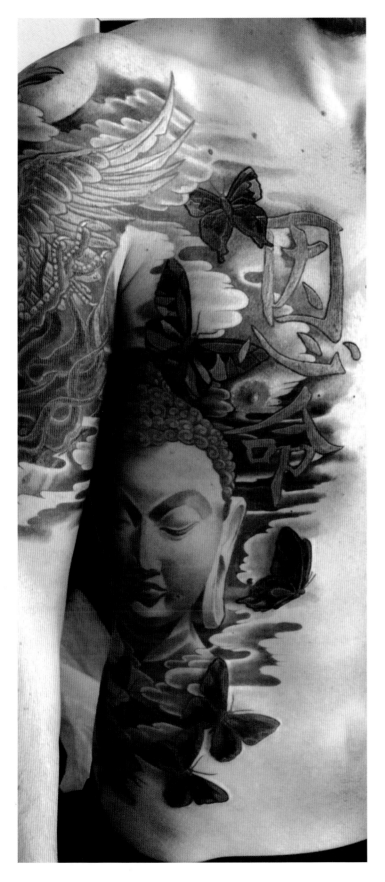

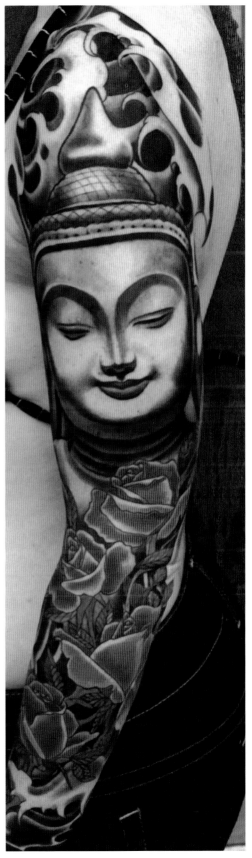

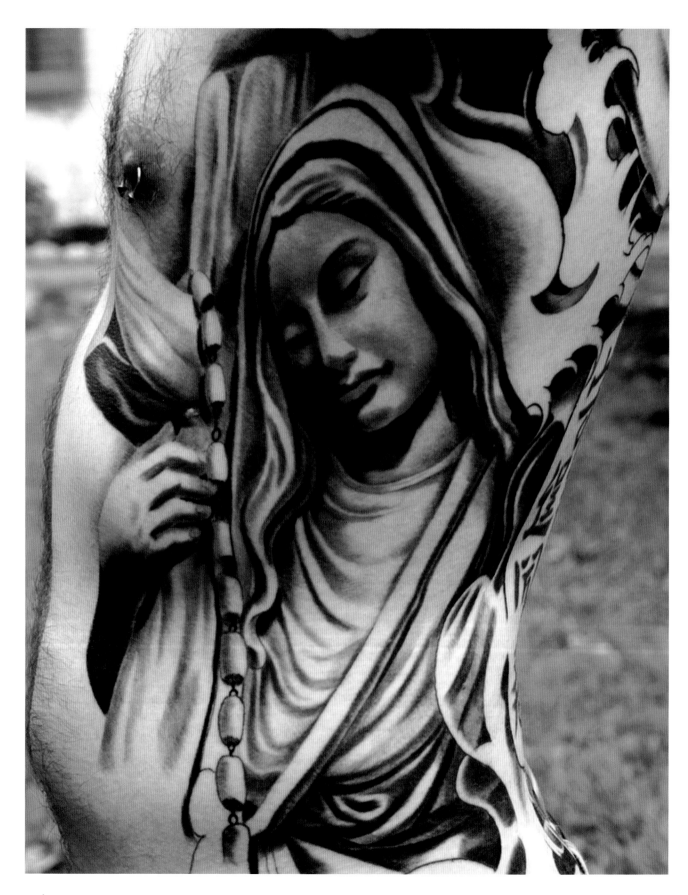

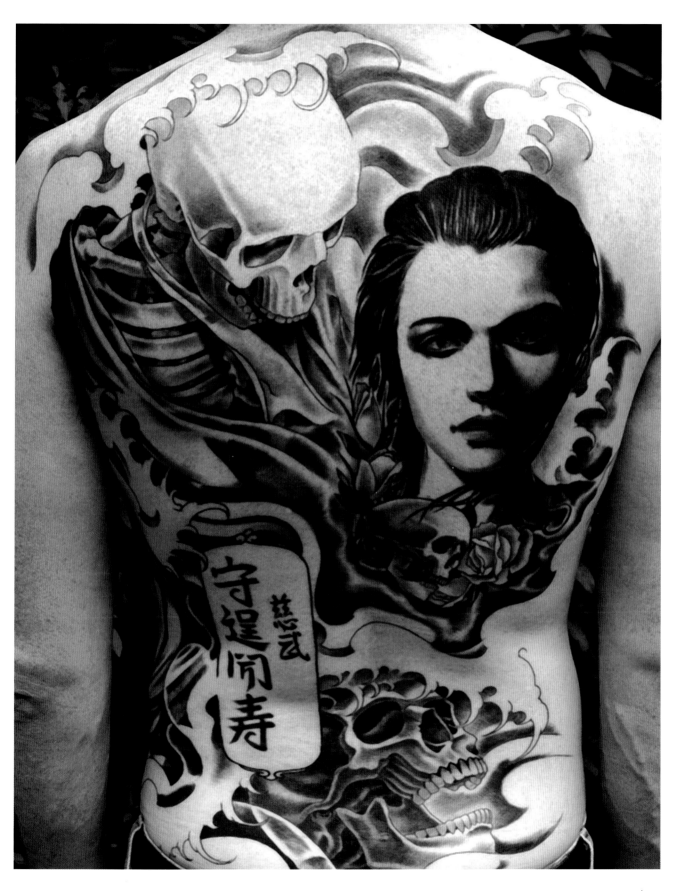

ADAM FORMAN

Adam Forman applies what he learned in art class to his tattoos. "I went to a state college art program, but I was tattooing while I was in school," he explains. "So I really looked at tattooing from the perspective of someone who was also learning to paint, illustrate, photograph, sculpt and make prints." He started tattooing out of "desperation." "There are not a lot of ways for someone to make a living as an artist in southeast Michigan," he says. "At least not as far as a kid like me could see at the time." After working out of his kitchen for a few months, a local shop owner gave him a job and threw him "into the ugly mix that was mid-'90s Midwestern-style tattooing." For the past two years, he has worked at Incognito Tattoo in Pasadena. When he's not tattooing, Forman works as a concept and storyboard artist for film and television. He worked on Frank Miller's movie "300" and as an illustrator for Disney's "Enchanted." Forman's work is beginning to develop a recognizable aesthetic. "I come from a pretty hard street shop background that discouraged specialization," he explains, "but the longer I work the more I am discovering what is important to me visually in tattooing and I am moving more and more into those spheres." Of his career choice, he says, "I think there is no quicker way to the center of one's self than through what inspires them—I am simply on that path."

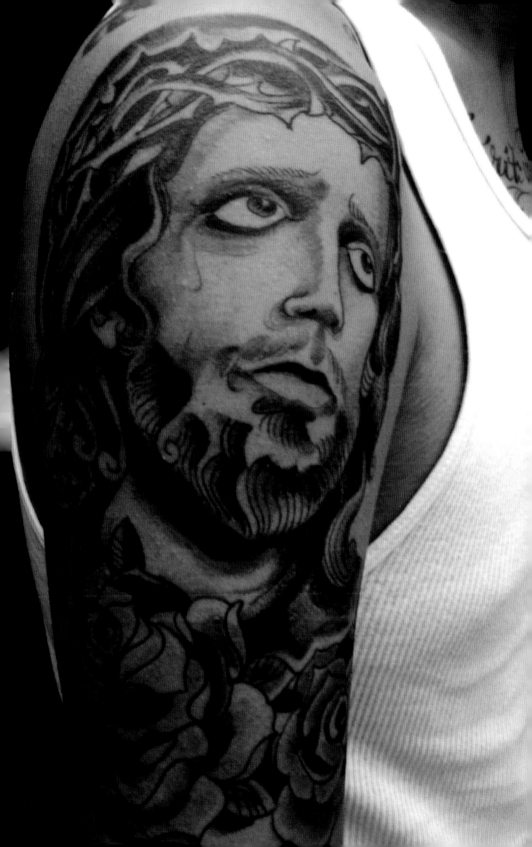

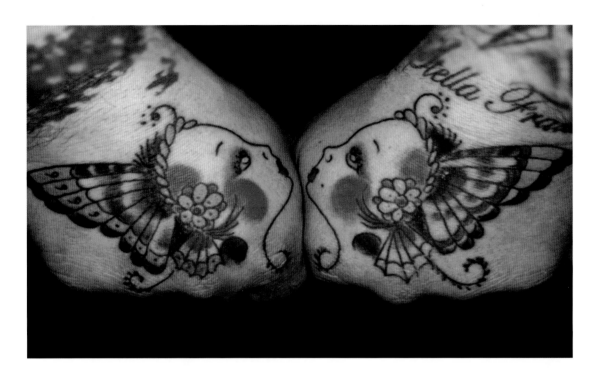

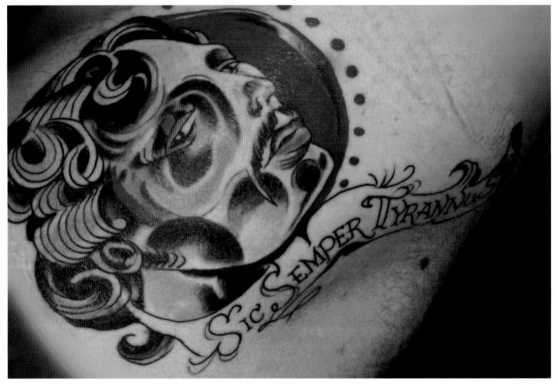

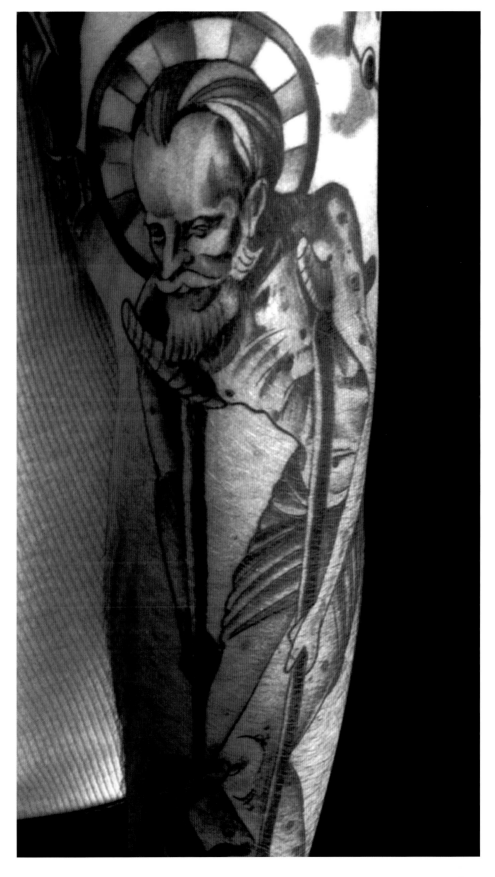

JASON GOLDBERG

Jason Goldberg is based in Philadelphia, a city rich with tattoo history. "I'm inspired by the people around me every day, all the people I work with, and the old-timers from Philly," he says. In 1991, Goldberg hung around established tattoo shops such as Maine Line and Damien City, where he began to learn the craft. Goldberg's macabre style may be pulled from the punk and hardcore scenes he grew up in, or by touring as a member of the band Bad Luck 13 Riot Extravaganza. Goldberg also works with watercolors, acrylic and "the blood of my enemies," he says. In '99, he opened Philly-based shop, Olde City Tattoo, and more recently Baker Street Tattoo. "I love everything about tattooing," he says. "It truly is a different lifestyle than most people are used to. Somehow it's an art and it's social at the same time."

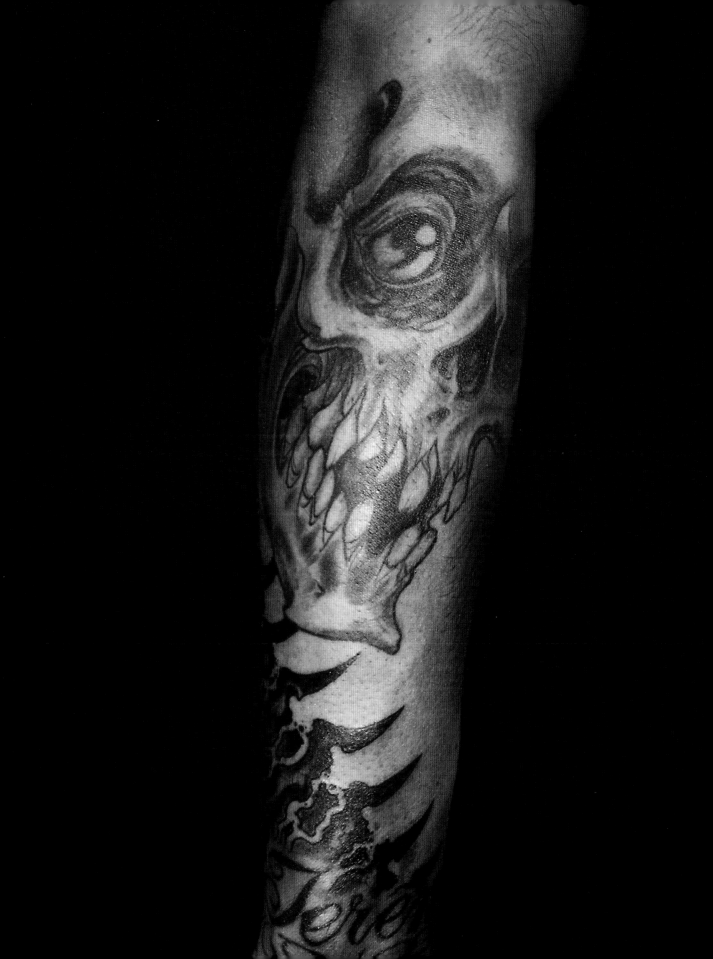

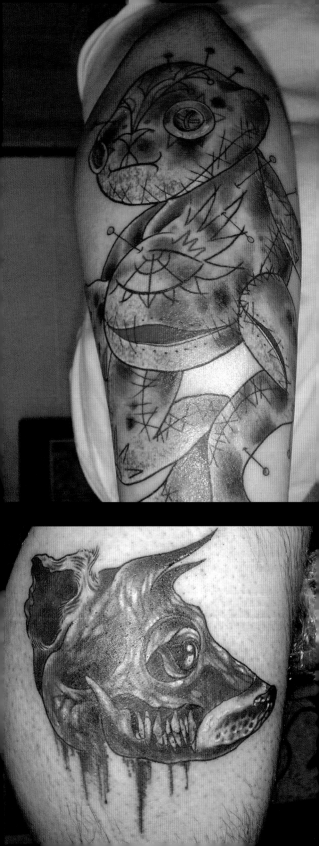

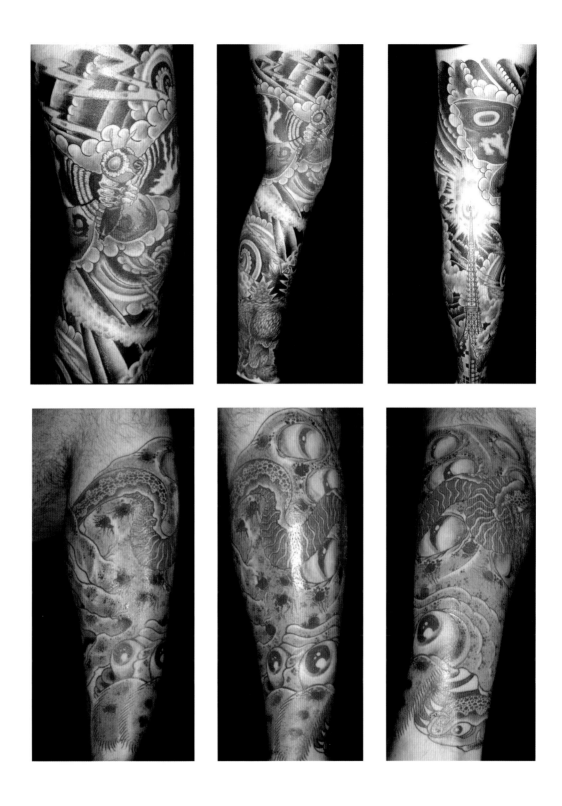

REGINO GONZALES

Growing up in California, Regino Gonzales was fascinated by the Chicano-style tattoos he saw around the neighborhood. "I was completely mystified by how the tattooers achieved subtle gradations of gray and beautiful line work with homemade equipment," he explains. "I wanted to figure out how it was done." One of his friends had some needles and ink, and Regino decided to give tattooing a try. "I was bored and inclined to drawing, and it seemed like a good idea," he says. "We really didn't think our parents would mind." In '95 he began an apprenticeship with Daniel Adair, and three years later he moved to New York to attend the School of Visual Arts. For the past few years, Gonzales has been working at Invisible NYC. He is known for his bold designs with impossibly intricate detail. Inspired by everything from gang graffiti to Flemish paintings, Gonzales can easily work in any tattoo style. "I think this came from working in a street shop for a long period of time," he says. Gonzales also paints with watercolor, acrylic and oil, and also does graphic design. His work has been shown at galleries such as White Walls and 111 Minna in San Francisco, and he has done commercial work for Iisli, Atlantic Records and Image Comics, to name a few.

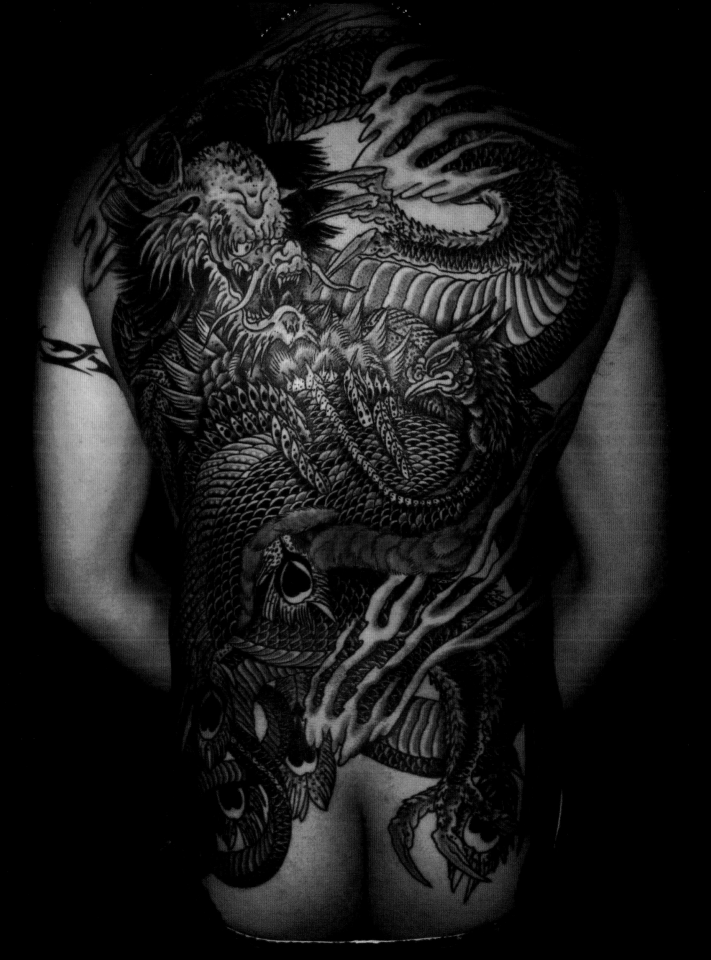

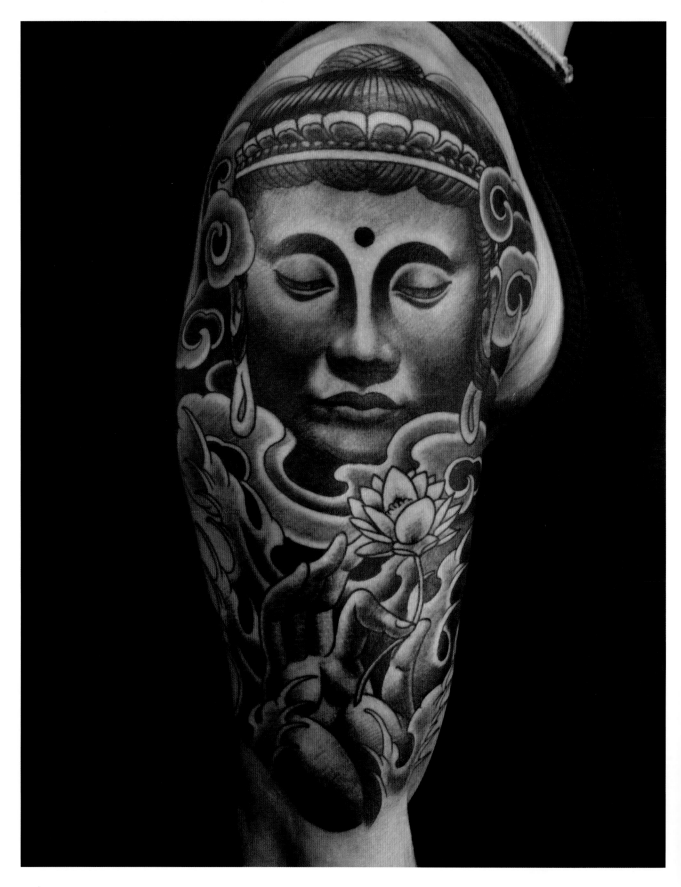

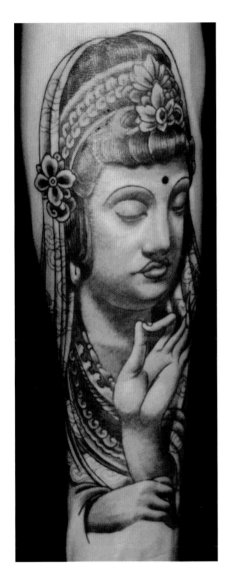
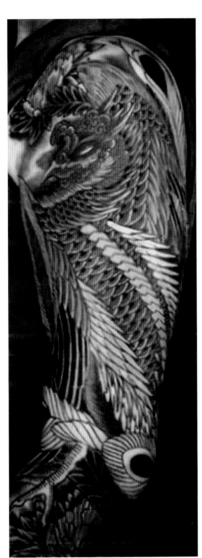
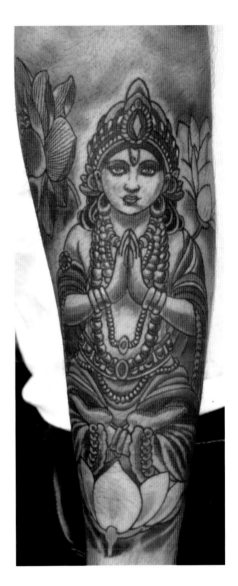

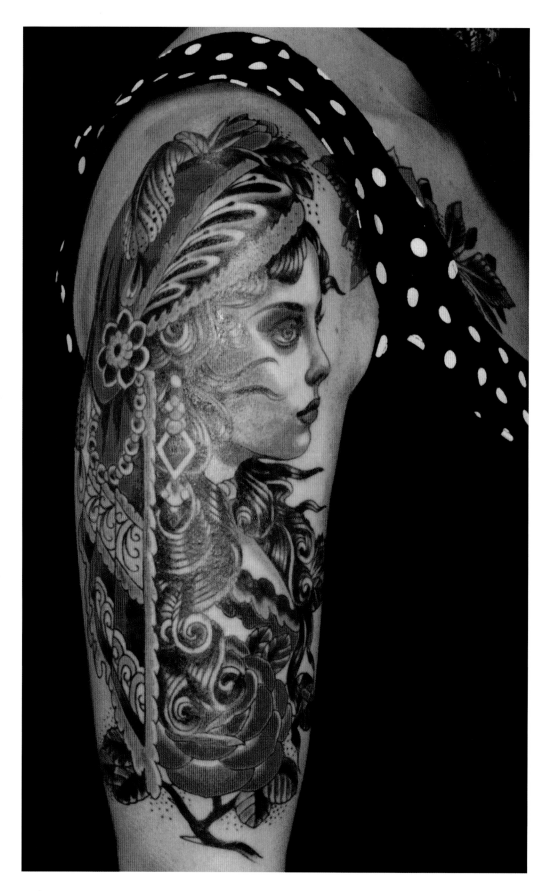

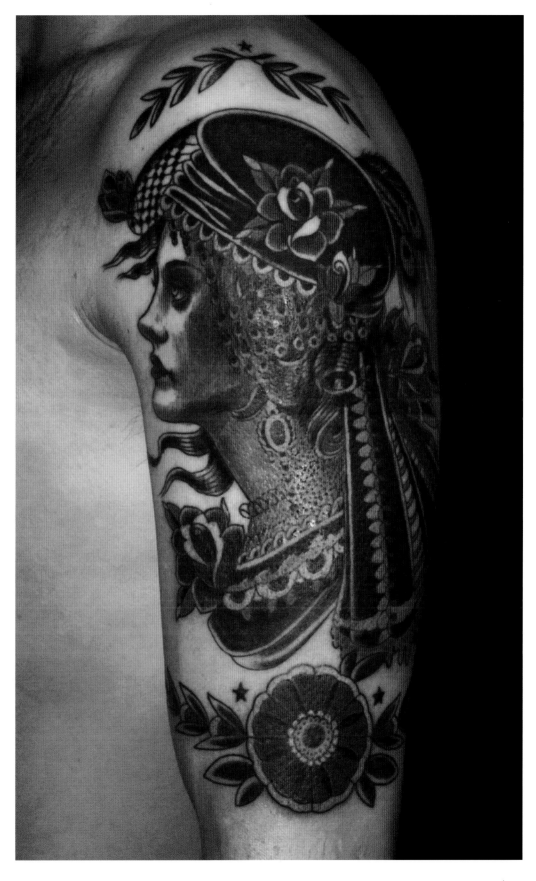

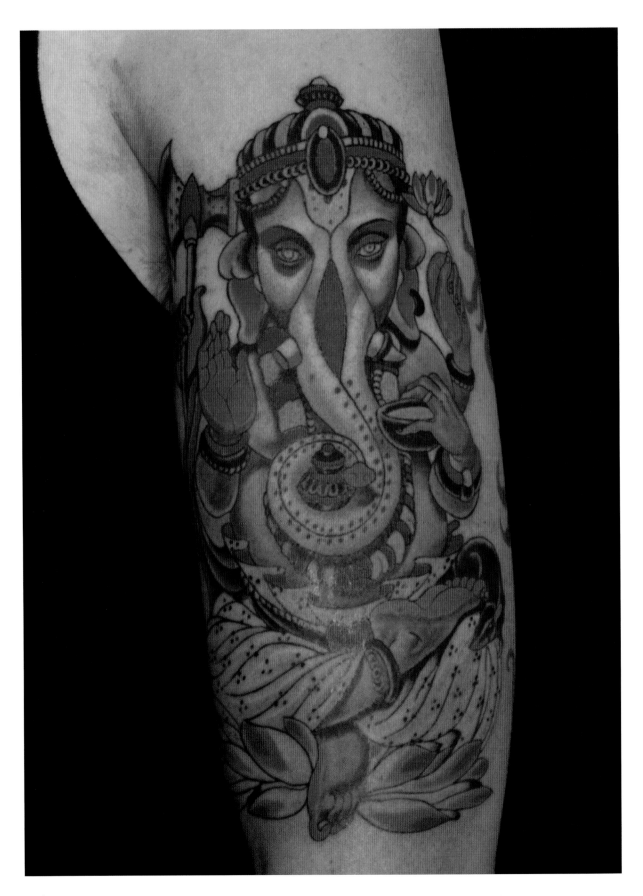

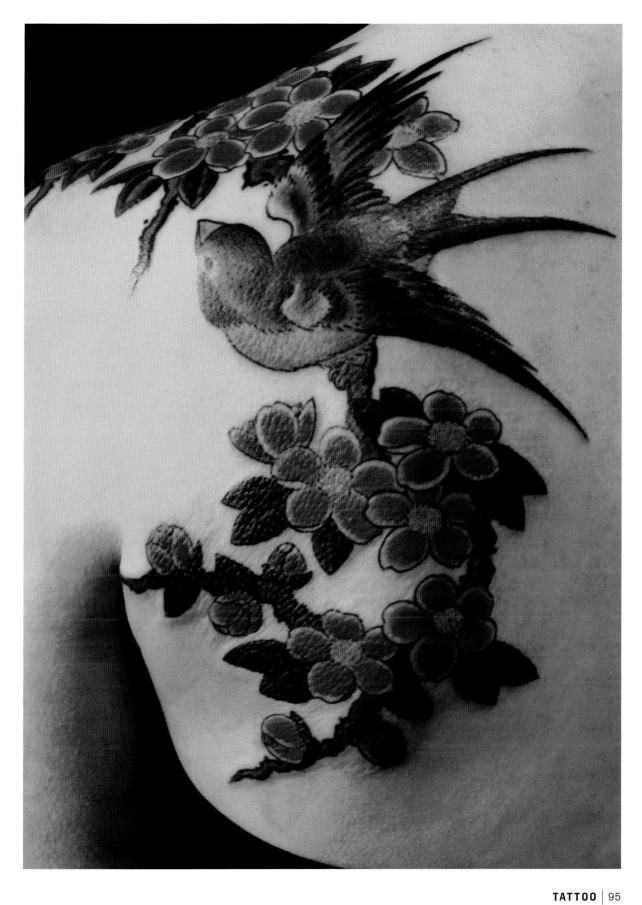

DENNIS HALBRITTER

Dennis Halbritter grew up in rural Michigan, near Michael Moore's hometown. He tried college for a year, but decided it wasn't for him. "The day I got my first tattoo I fell in love with the whole magical art of it," he explains. "I decided that day that I would be a tattoo artist do or die." Halbritter started tattooing in '94 at a shop in Downriver, Detroit. Now he lives with his wife in Los Angeles, and recently started working at "High Voltage," a studio owned by Kat Von D. "The most recent leap in my career is having the wonderful opportunity to work at Kat's shop along with an amazing group of artists," he affirms. Halbritter describes his tattoos as "rich in color, illustrative and fun to look at." His work has been published in a slew of tattoo and mainstream magazines. For GQ, he applied temporary special-effects tattoos on the bodies of models who posed with Quentin Tarantino. "I got to where I am now through a simple love of drawing," he says. Halbritter also paints, sculpts and builds tattoo machines. "I love tattooing," he explains, "because I am free to express my art, make a living and go to work everyday with a smile."

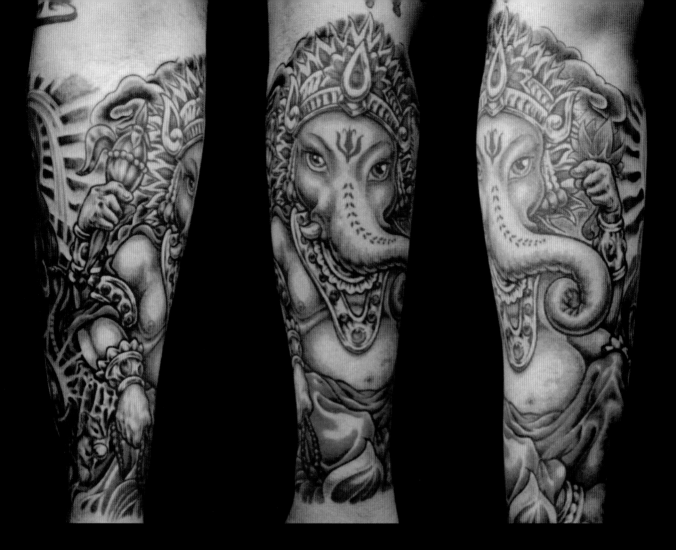

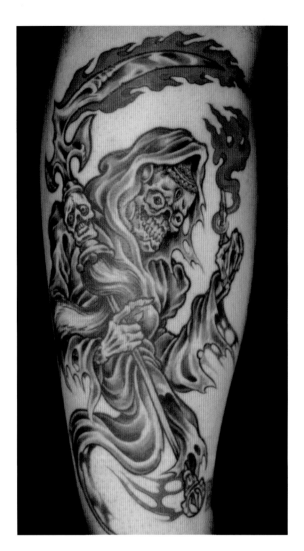

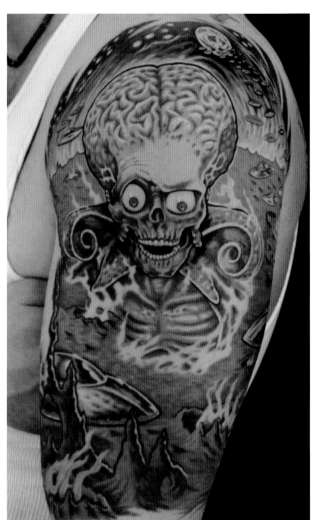

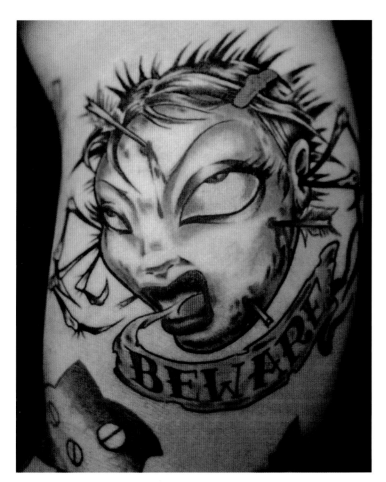

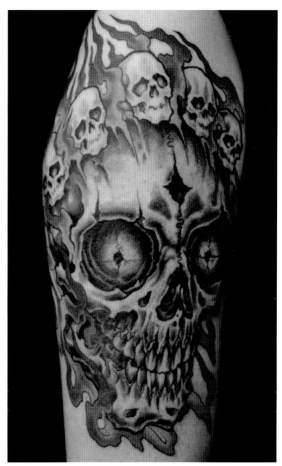

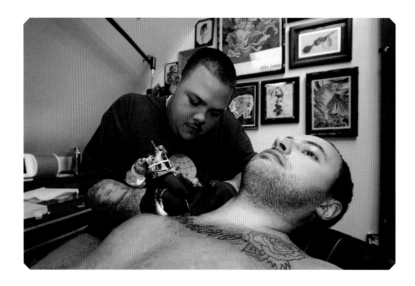

BERT KRAK

When he's not doing one-armed pushups, Bert Krak is stacking chips at Top Shelf Tattooing in New York. Six years ago, he started his career at Rock-A-Billy Tattoo in Lauderhill, Florida. "I got into tattooing because I've always wanted to be a pirate," he says. At the shop, he worked as an apprentice for Dave Poole. "Dave and many other artists that were around taught me not only how to tattoo, but how to be a gentleman, businessman, and craftsman," he explains. While he was apprenticing at night, he also worked a full-time day job and raised a family. He currently co-owns and operates Top Shelf, where he's been for four years. "I got where I am today by working hard and having a great wife who supports my every move," he says. Among the greatest accomplishments he lists are being a shop owner, having three kids and a book he recently published with Steve Boltz titled "Revisited: A Tribute to Flash from the Past." Krak's own work combines an old-fashioned aesthetic with bold lines and black-whip shading. "Tough stuff," he says. "Tattoos that look like they were applied by a man."

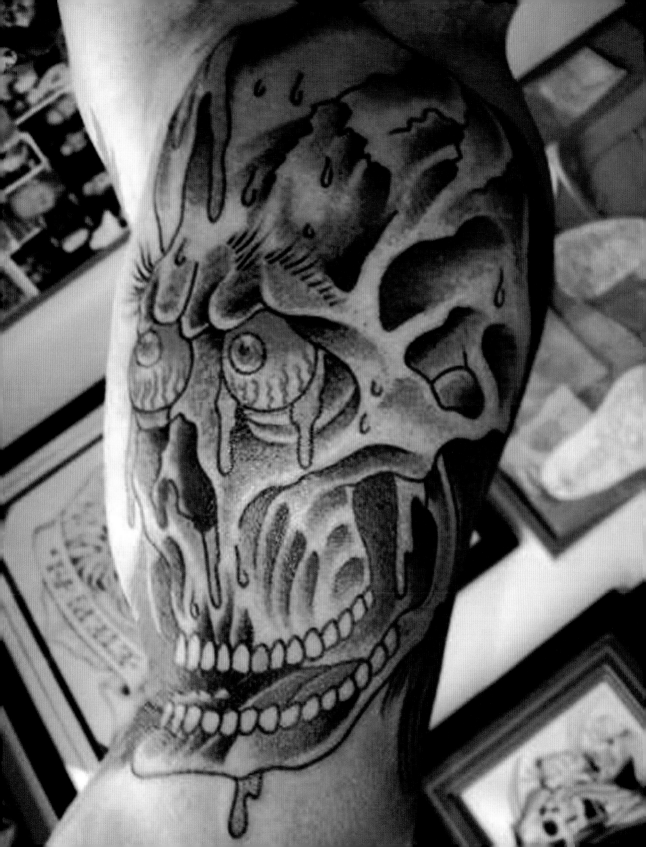

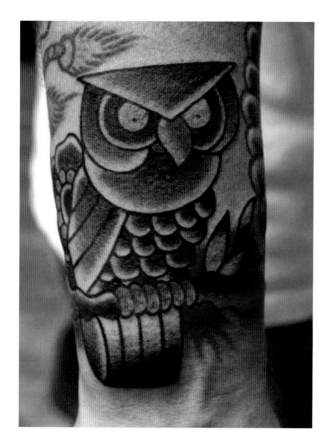

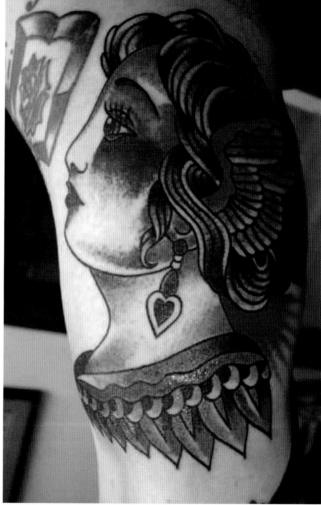

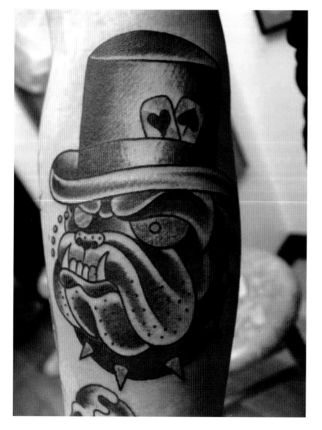

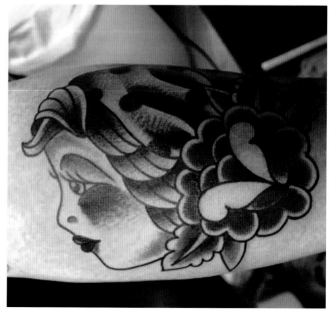

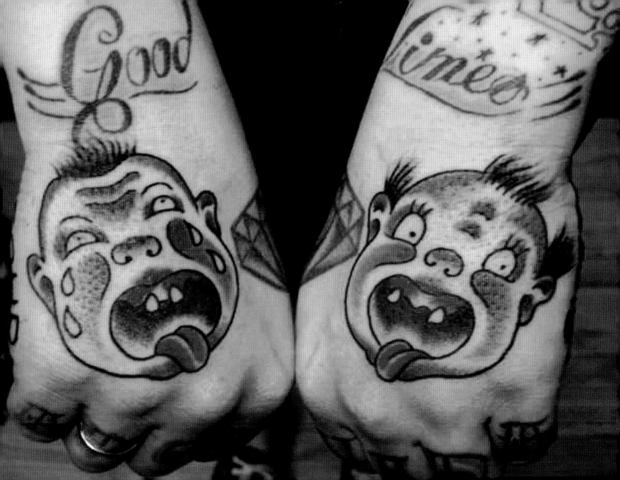

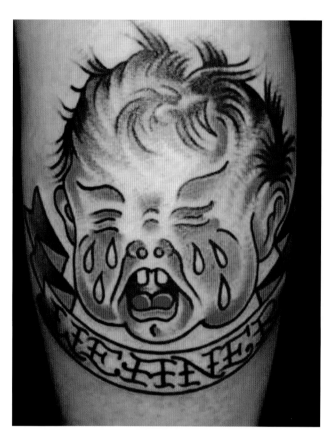
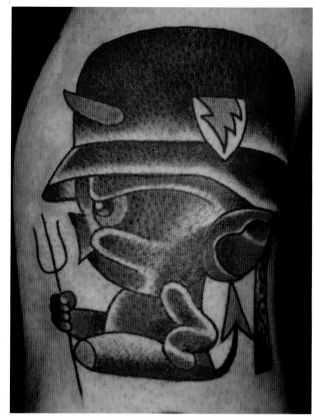
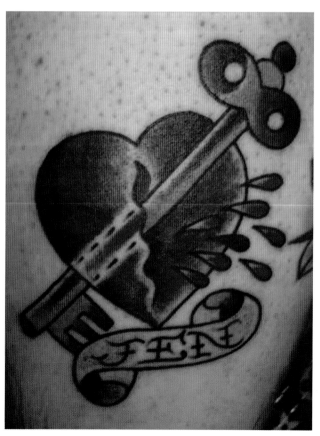

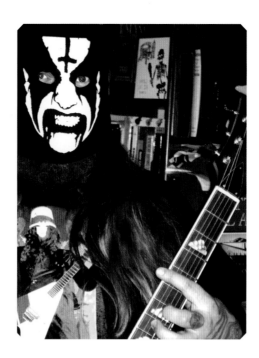

TIM LEHI

Growing up in Kansas, Tim Lehi had all the encouragement he needed, crediting, "My father and a few others are artists, art teachers, and fine artists." At a young age, he wanted to get tattooed, and as soon as he could, he took up the practice himself. He didn't have an official apprenticeship, but at age 16 began tattooing, and was soon able to support himself as a teenaged tattoo artist. He moved to San Francisco 10 years ago, and is now co-owner of Blackheart Tattoo on Valencia Street in the Mission District. He appreciates that his work enables him to sustain things without "having to sell myself to an obnoxious degree to be busy or 'known.'" He tries to strike a similar balance with his designs, as well, "trying to avoid grandstanding or copying others' styles, but making something with good visual impact, naturally, and unforced." He thinks of it as "showing something without showing everything, keeping it hard, ongoing, and beautiful." A skilled musician, he loves guitars, plays them well, and occasionally will trade a tattoo for one. While there's plenty he dislikes about tattooing's current wave of popularity, the creativity and satisfaction of wrapping up big projects keep him coming to the shop every day.

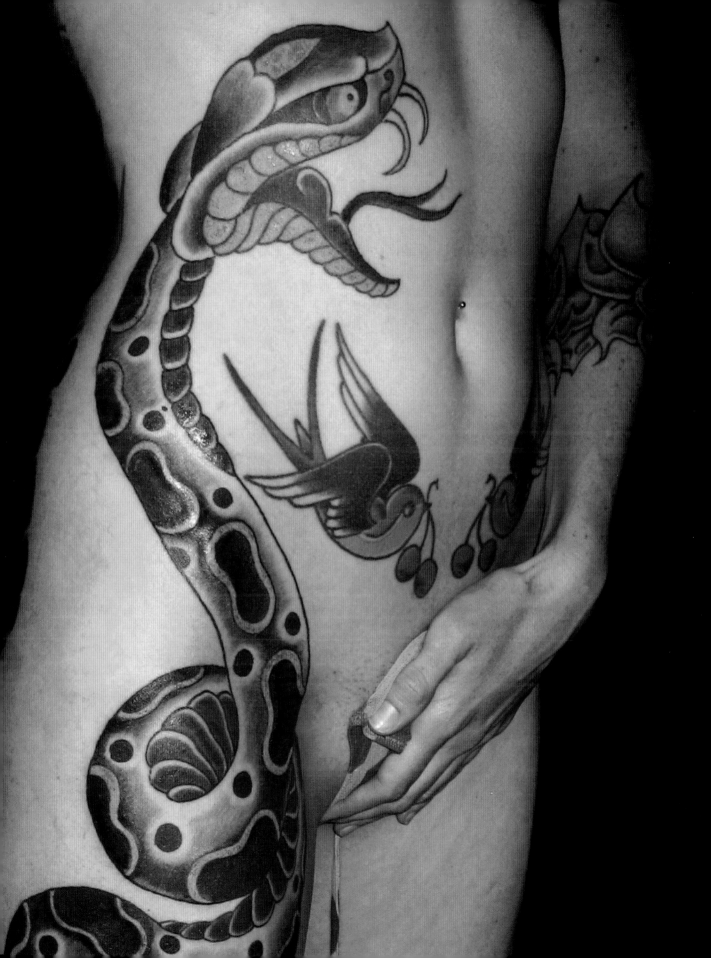

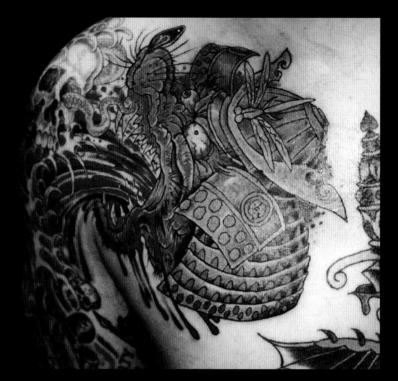

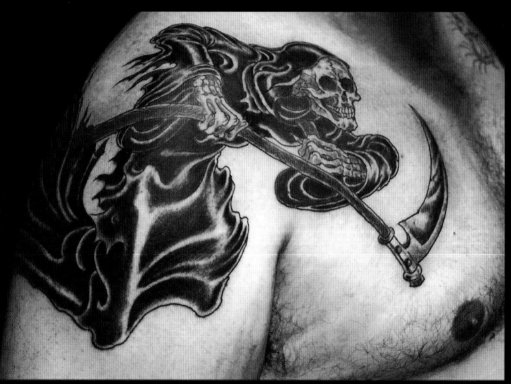

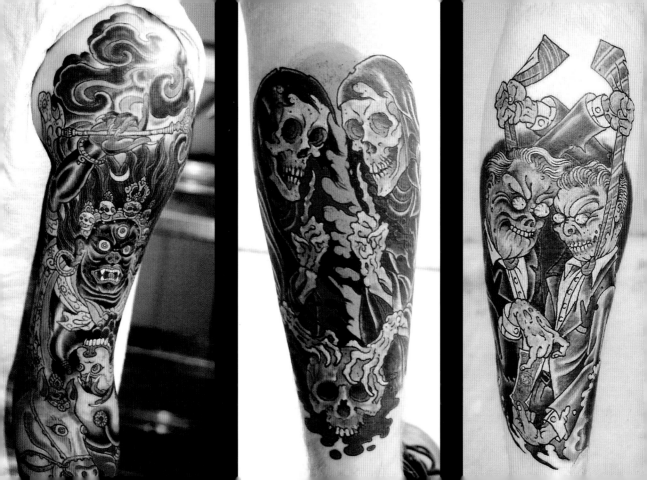

HENRY LEWIS

Henry Lewis was born in Pasadena, California, the 4th of 14 children. He began creating at a young age and throughout his teens, ultimately evolving into a tattoo artist and painter. Much of his work, conceptually, is born out of the ashes of loss, memory, and time. His interest in the human condition and all its complexities continues to pervade his work. Death, birth, love, uncertainty and truth are constant thematic elements of both his paintings and tattoos, often rearing their heads through sinister imagery, livid characters, and his penchant for a limited palate. The connection between his environment and mediums, during a time when many artists choose ready-made, redundant, and easily-digestible media, is most evident in the motifs of light and detail used throughout his work. Drawing from the Baroque period, his style uses exaggerated motion, clear detail, and dark shadows as counterpoints to shafts of light. He lives and works in San Francisco.

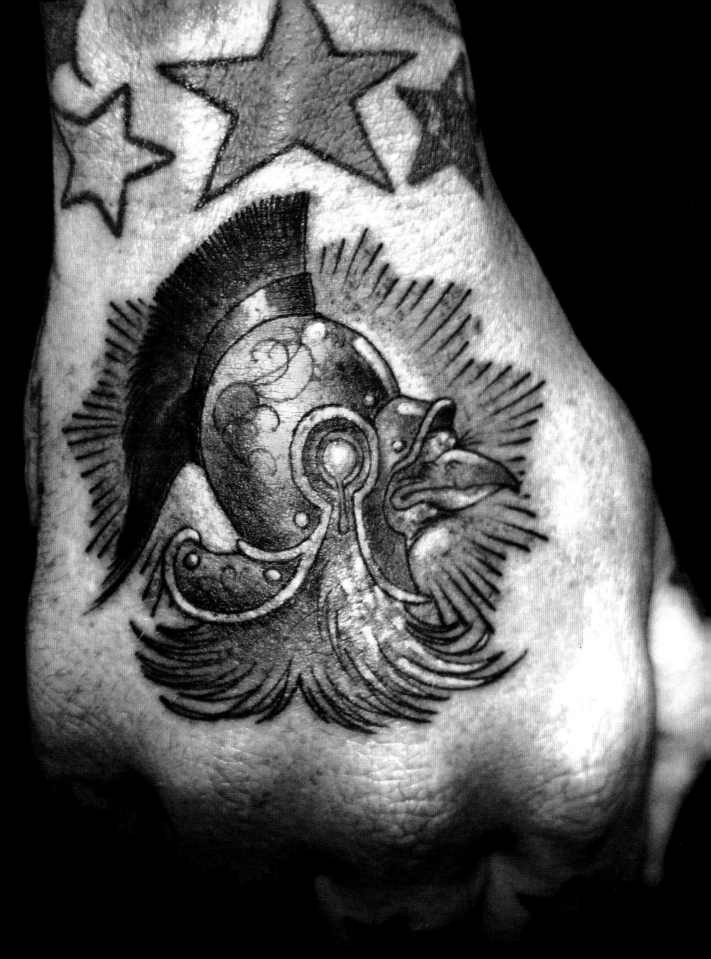

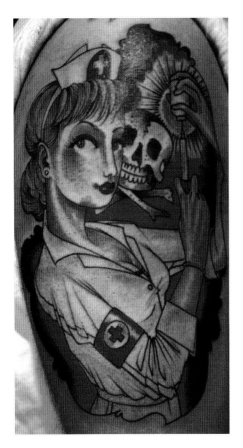
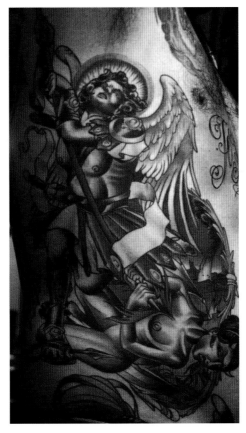
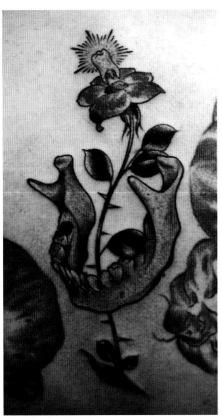
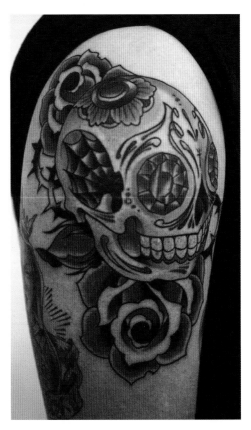

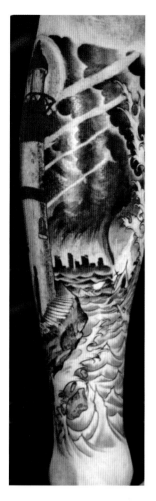
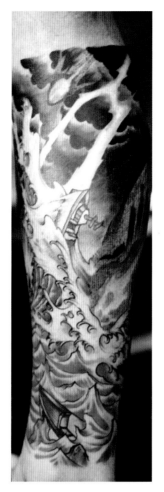
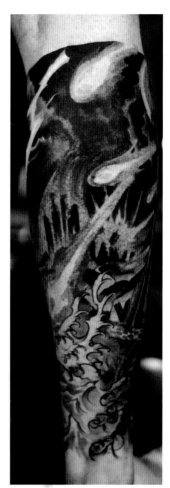
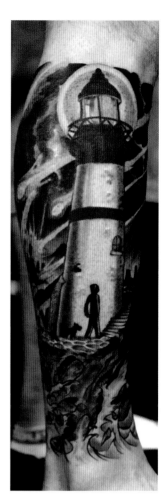
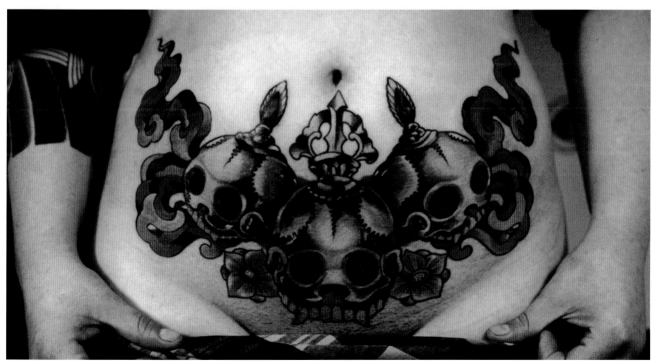

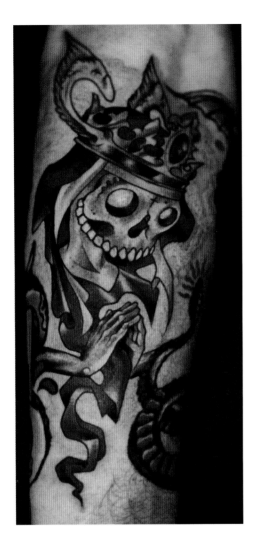
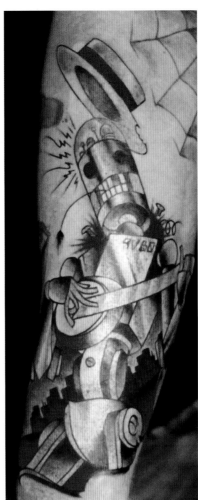
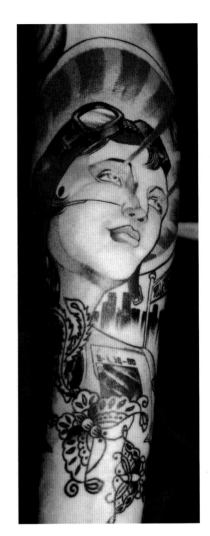

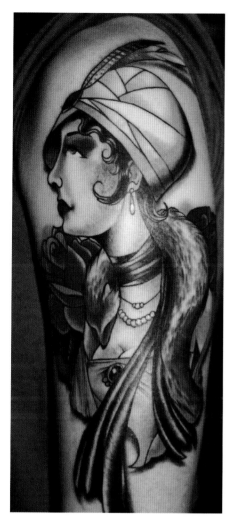

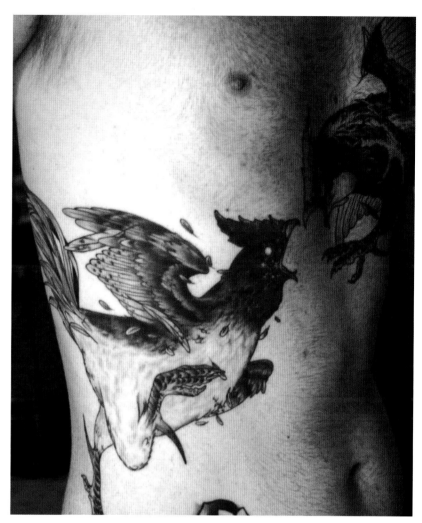

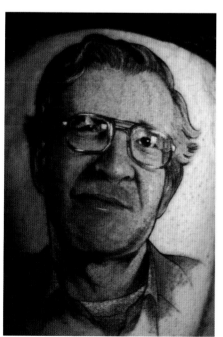

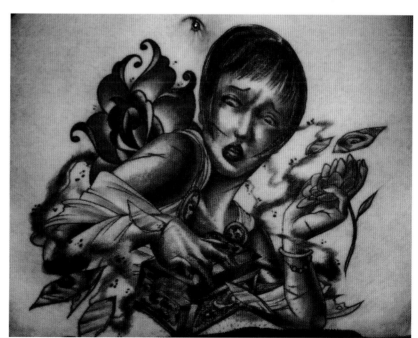

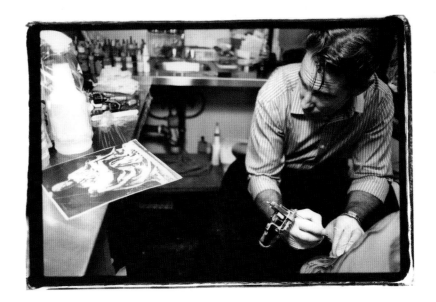

MARK MAHONEY

Mark Mahoney grew up in the suburbs of Boston, Massachusetts. "I remember watching the JFK funeral, lying on the floor, while my dad taught me how to draw ships and bi-planes," he says. Years later, in 1976, Mahoney started tattooing under the guidance of his greaser gang leader, Mark Herlihy. After moving west, Mahoney began working at the Original Good Time Charlie's in East L.A. "That is where it all began," he says, "and only a few can trace their pedigree to that sacred shrine." Six years ago, he opened the Shamrock Social Club in West Hollywood, where he works six nights a week. Since becoming a tattoo artist, he has had a number of memorable experiences–tattooing Johnny Thunders in Sid Vicious' room at the Chelsea Hotel, flying in Suge Knight's private jet and working on Brad and Angelina. But most influential of all was the first time he saw the black-and-gray lowrider tattoos of Freddy Negrete, Jack Rudy and Boy Loco. "That was like the Harlem Renaissance, Westside-style," he says. "That stuff drives me to this day." Along the way, Mahoney has done commercial work, designing fabric for Betsey Johnson in the '80s, which was one of the first times the worlds of tattooing and fashion intermingled, but prefers the serene nature of working in the shop on a client. "I love the act of tattooing," he says. "I can be in pain, depressed or whatever and I can get lost in the tattoo and the conversation with the client. I love that."

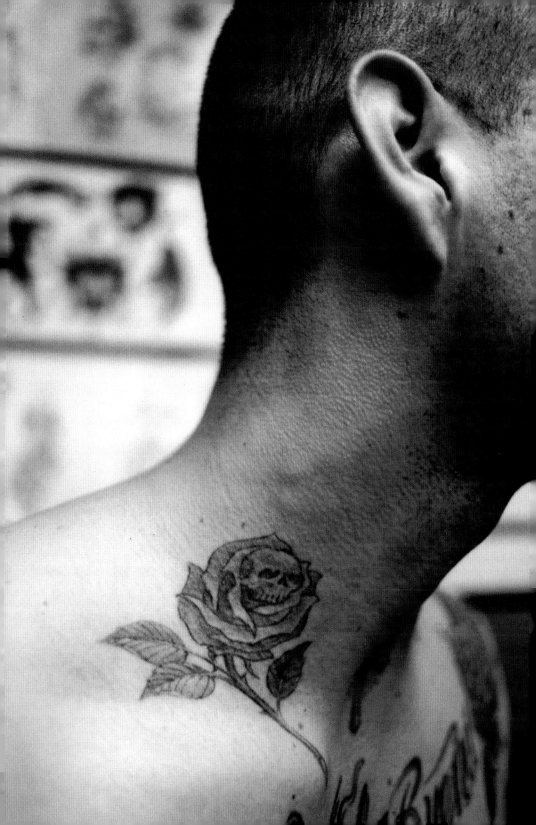

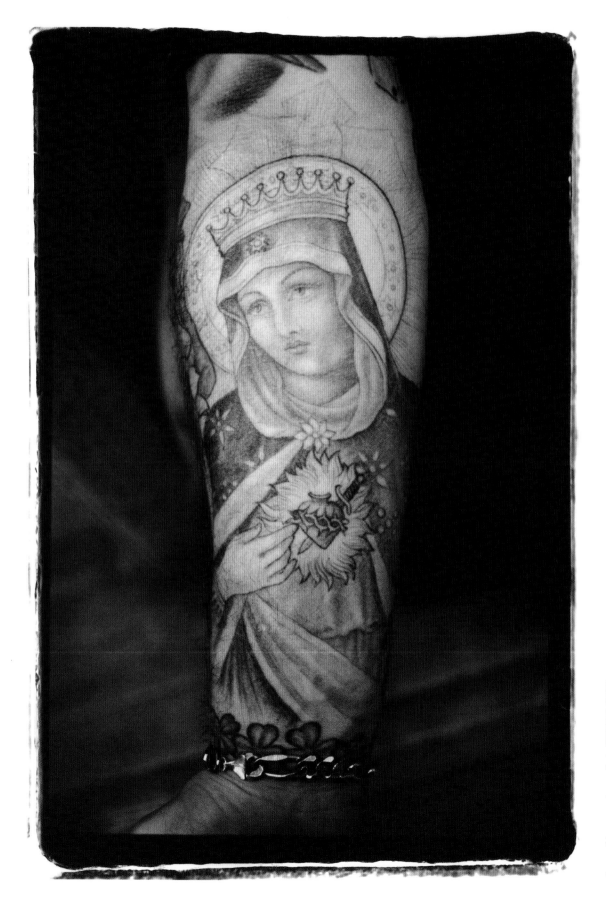

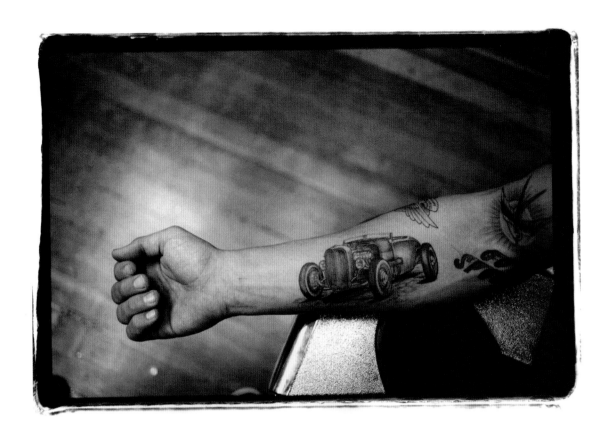

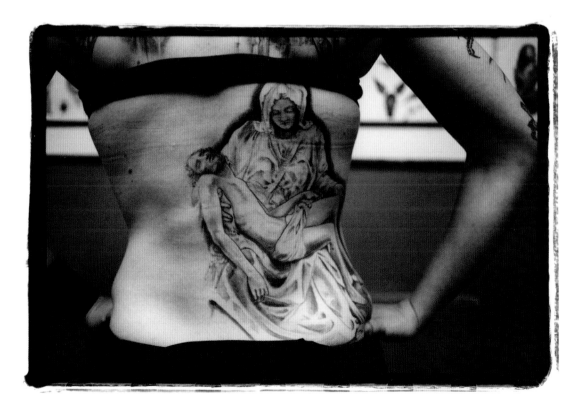

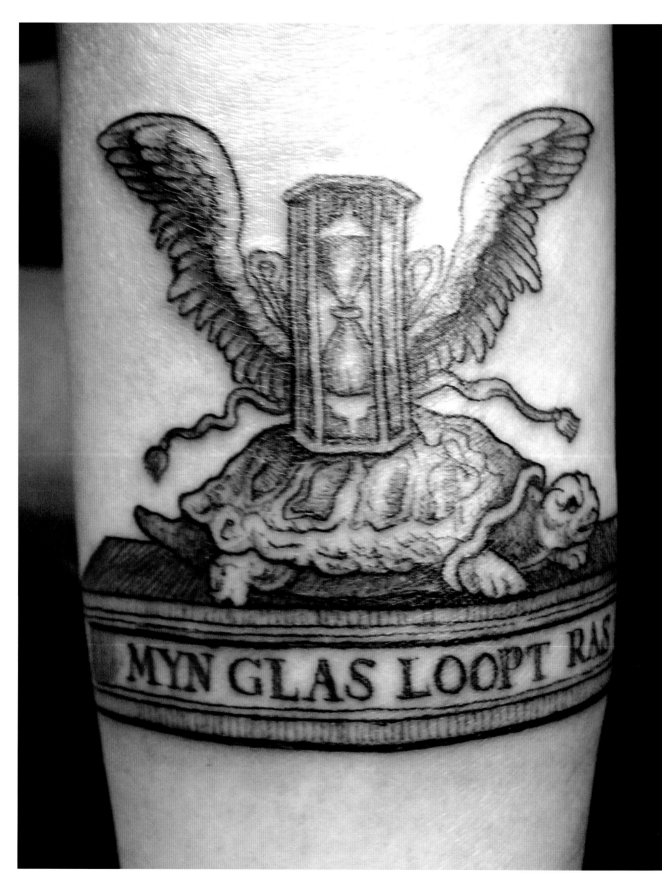

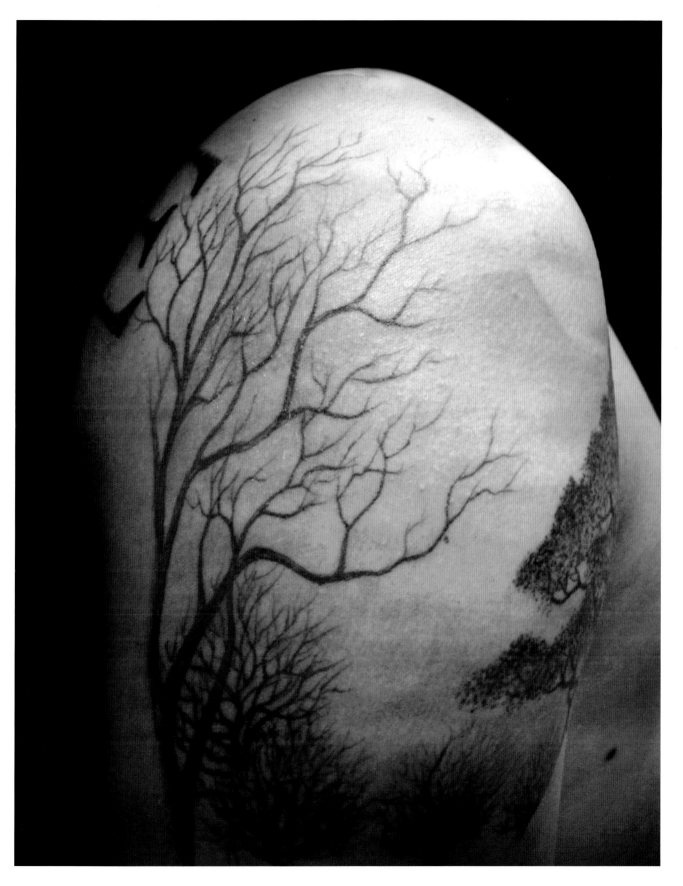

ALEX MCWATT

Alex McWatt started out working behind the counter at Fly Rite Studios in New York. "I was doing a lot of graff at the time so I was always drawing stuff," he explains. "Elio [Espana] must have seen something in me because he asked me if I wanted to be his first-ever apprentice." McWatt apprenticed for two years, and then began tattooing in '01. He continues to tattoo at his alma mater, as well as at True Blue Tattoo. "One thing I really try to achieve in my work is to not become repetitive and monotonous," he says. "I enjoy trying to meld the boldness of classic American tattoos with the complexity and subtlety of Asian art." Tattooing has allowed McWatt to travel the globe. "I love the freedom that tattooing has afforded me," he explains. "I can travel all over the world and work. I've met so many different people from Japan to Australia, Brazil to Montreal, and had the opportunity to tattoo them and exchange ideas with them." Recently, McWatt compiled a flash calendar featuring the work of international tattoo artists Dave Cummings, Bas Kahle and Sento, among others. McWatt explains: "There are so many people doing so much amazing stuff that I am constantly seeing something new and exciting coming from everywhere."

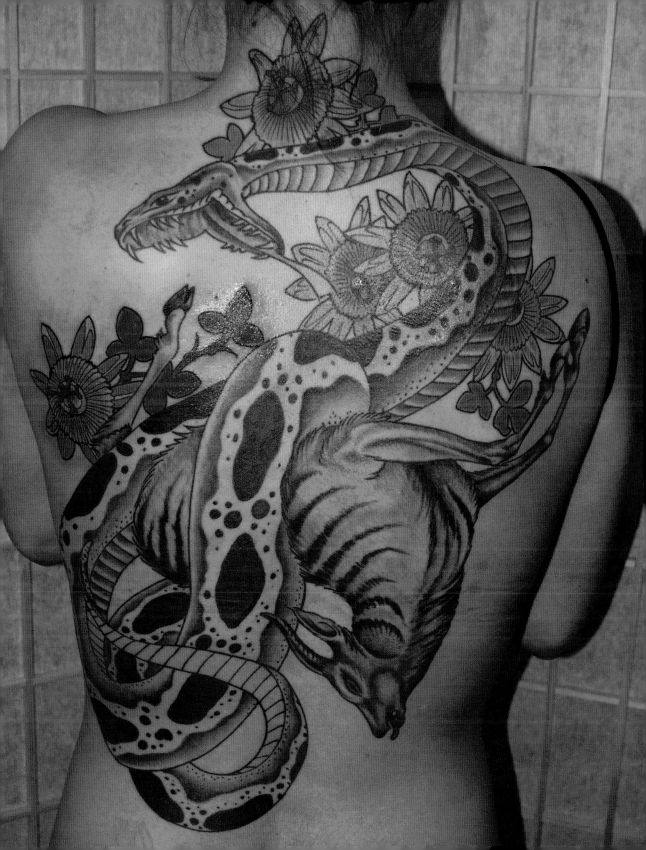

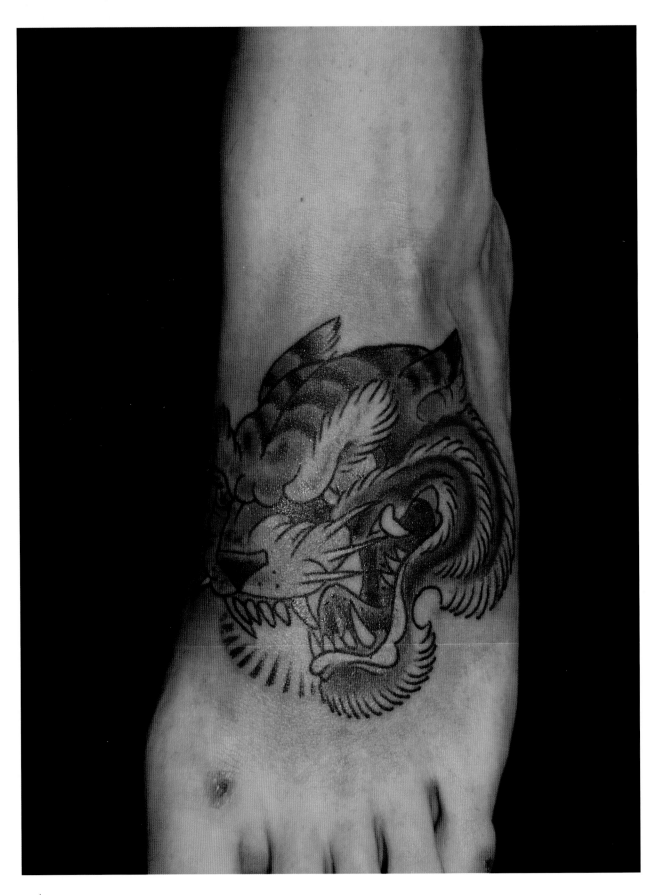

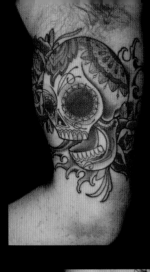
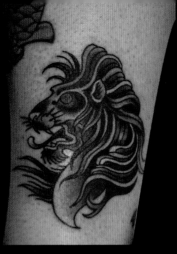
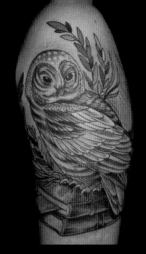
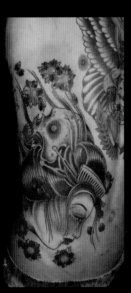
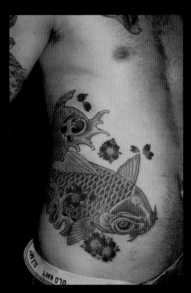
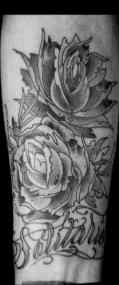

CHRIS O'DONNELL

Chris O'Donnell specializes in large-scale Japanese tattoos and vintage Americana. "I just gravitated to what I consider the best styles of tattooing," he says, "kind of a slow awakening." O'Donnell began tattooing as a senior in high school and apprenticed at Creative Designs in Richmond, VA. "It seemed like the perfect profession at the time," he says. "It was a much more romantic ideal back then." In 2000, he started tattooing at New York Adorned, where he remains today. His work is distinct: strong colors and graphic images wrap around arms, legs and backs. He has been inspired by world travel—particularly in Europe and Japan—and the art books that he has collected along the way. O'Donnell also paints in oils and watercolors, and sometimes creates large drawings in ink, graphite and colored pencil. "I try to work in other mediums in order to break out of the style confinement that comes hand in hand with tattooing a living person with their own ideas about how the end result should look," he explains. Both his tattoos and fine art have appeared in a handful of gallery shows. "Tattooing has been very good to me," he says. "I can't complain. If I branch out a bit it's just to try to develop other aspects of whatever artistic identity I might have in my head."

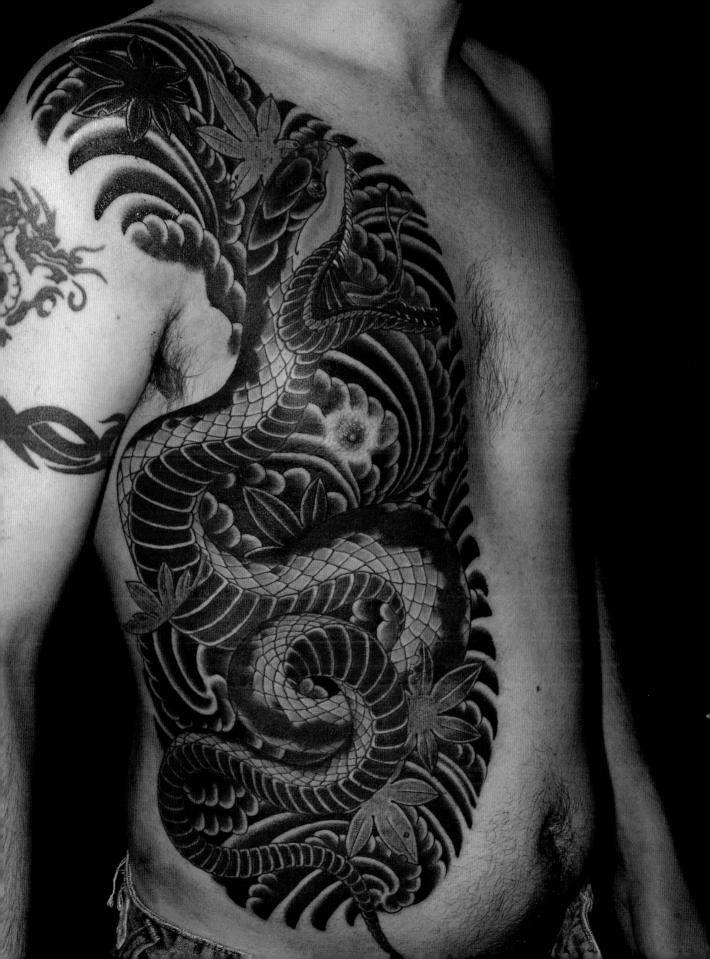

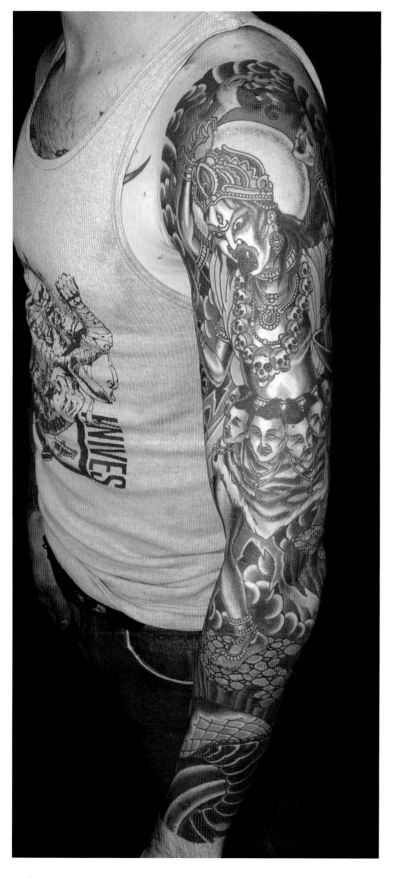
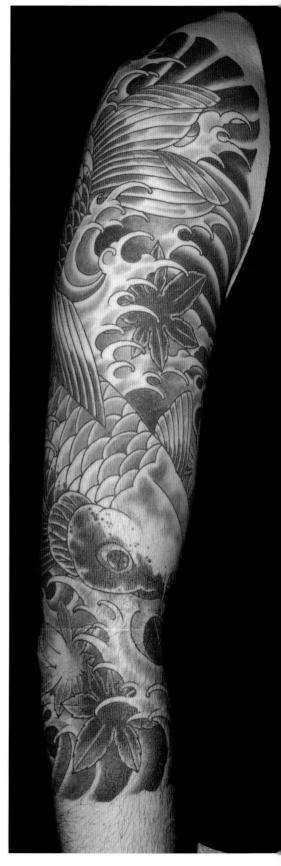

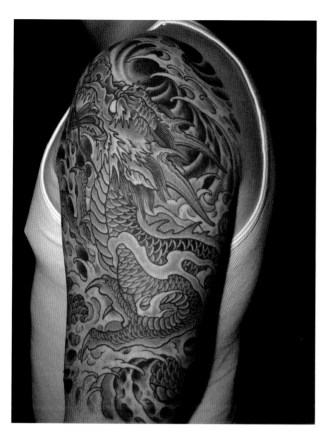
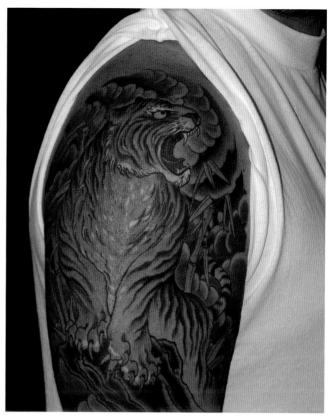
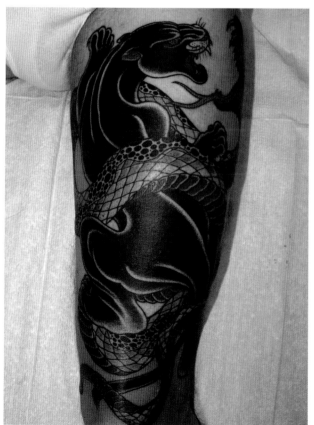
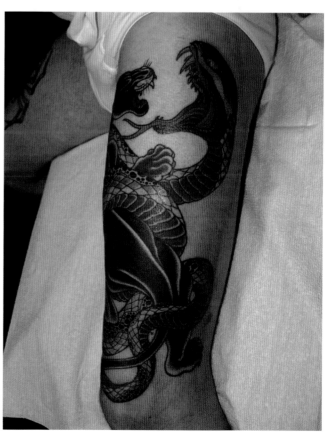

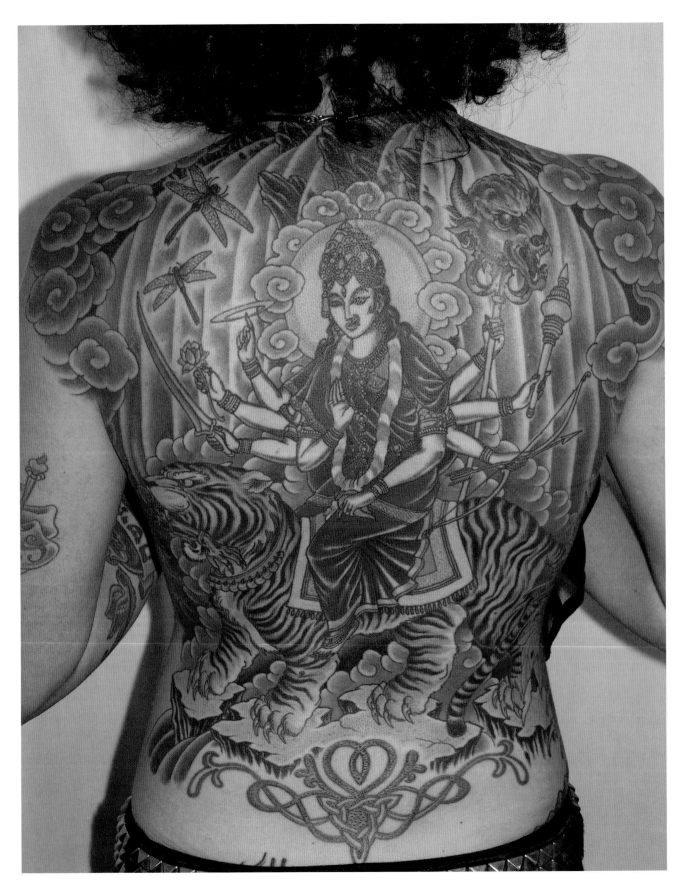

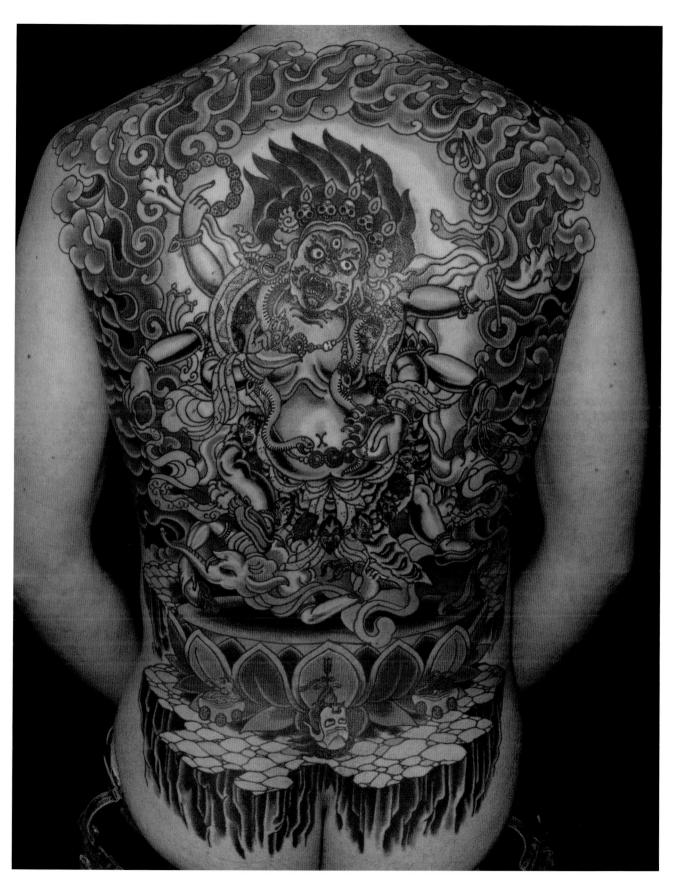

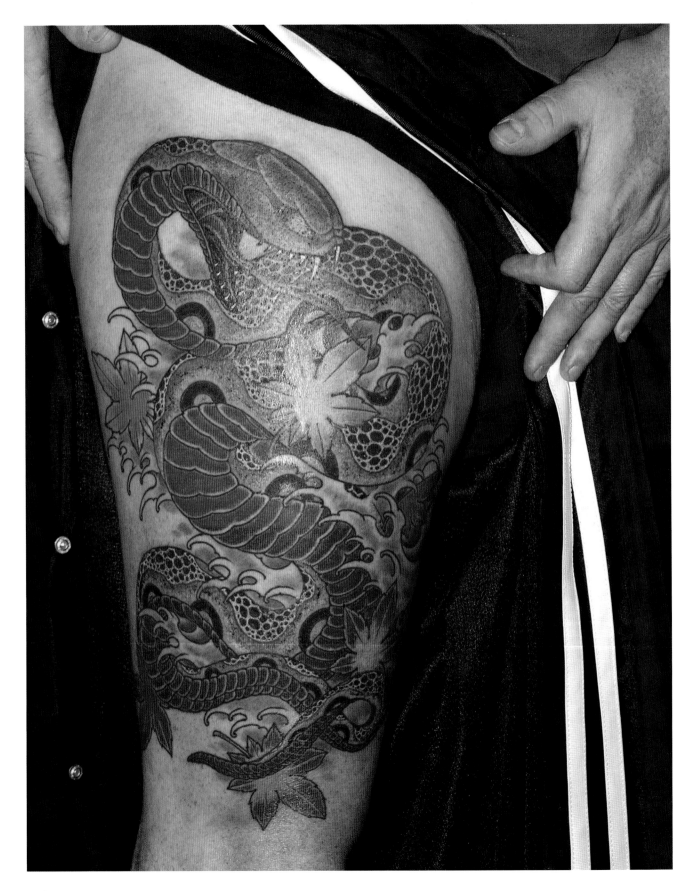

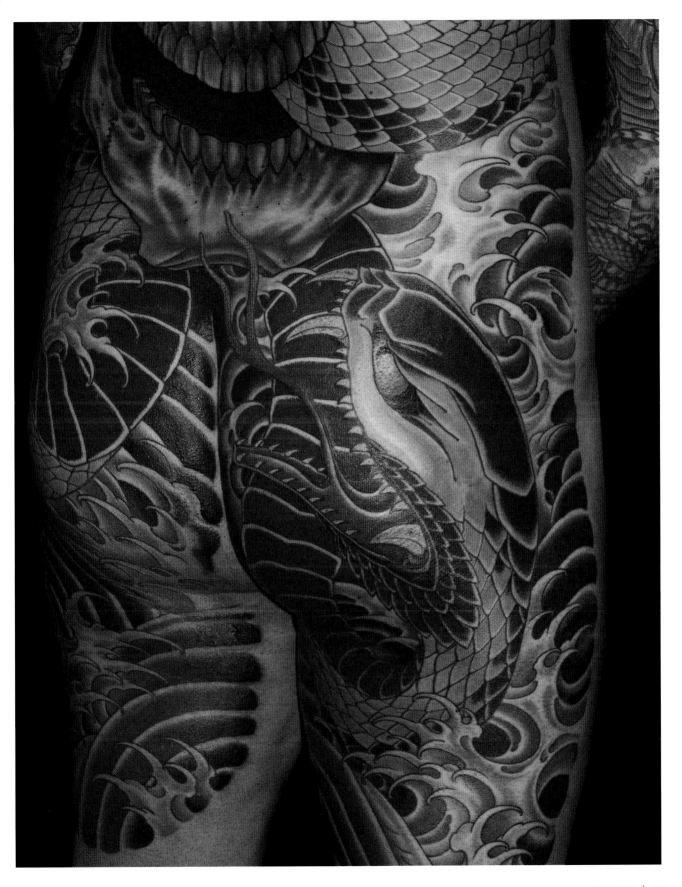

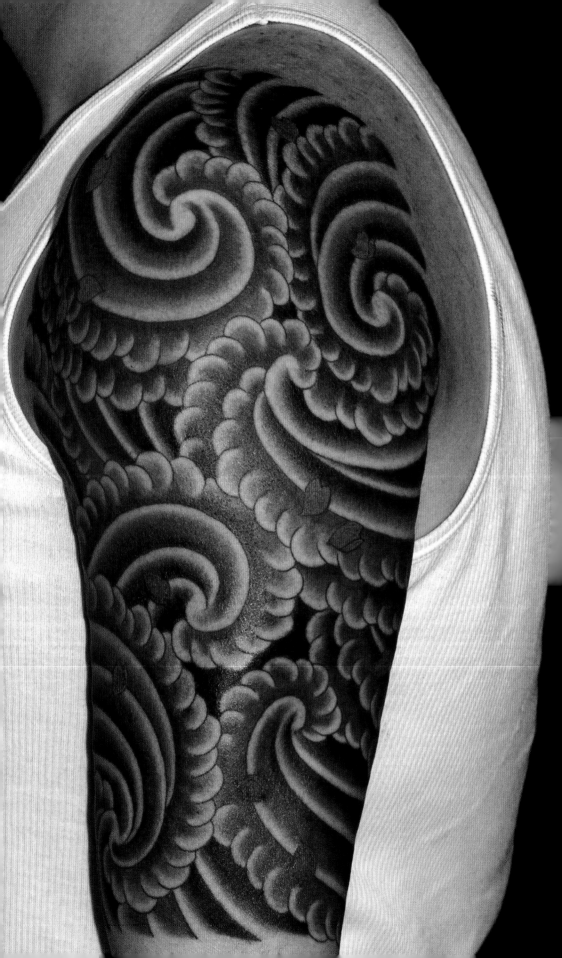

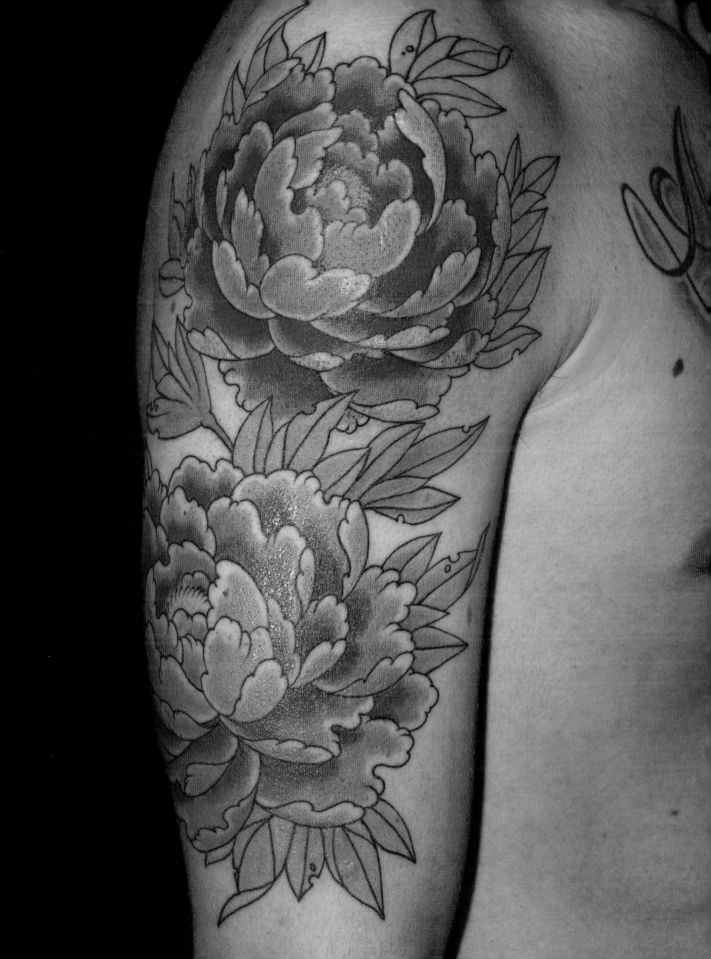

JUAN PUENTE

Juan Puente feels fortunate to be a tattoo artist. "I consider myself blessed to be doing this, and to be doing this for 16-plus years is even more amazing." He became interested in tattooing in the early '90s, after getting a tattoo of his own. "As soon as I got my first one I knew I wanted more but never really thought about doing them," he explains. "Finally, it just sort of hit me and I started paying attention and asking questions and went from there." He started working with Corey Miller, who taught him the technical application of single needle, fine line work. Then, when he went to work with the late Eric Maaske, Puente studied traditional tattooing and its broad color palette. Now he utilizes both styles, "and everything in between." For the last five years he has been working at Spotlight Tattoo for Bob Roberts. Puente says everyone he works with at Spotlight, as well as Ed Hardy and Japanese tattooist Horiyoshi 3, inspires him. "I like to work hard, and to be in touch and see what everyone is doing out there, and learn and grow at the same time." Last year he published a book of photos titled "Legacy: The Horiyoshi III Tradition." The book came about after Puente's photos were displayed in a traveling exhibit. "I love tattooing because of everything it has given to me, my friends and family," he says. "This has given me so much, someday I hope to give back what it has given me, and then some."

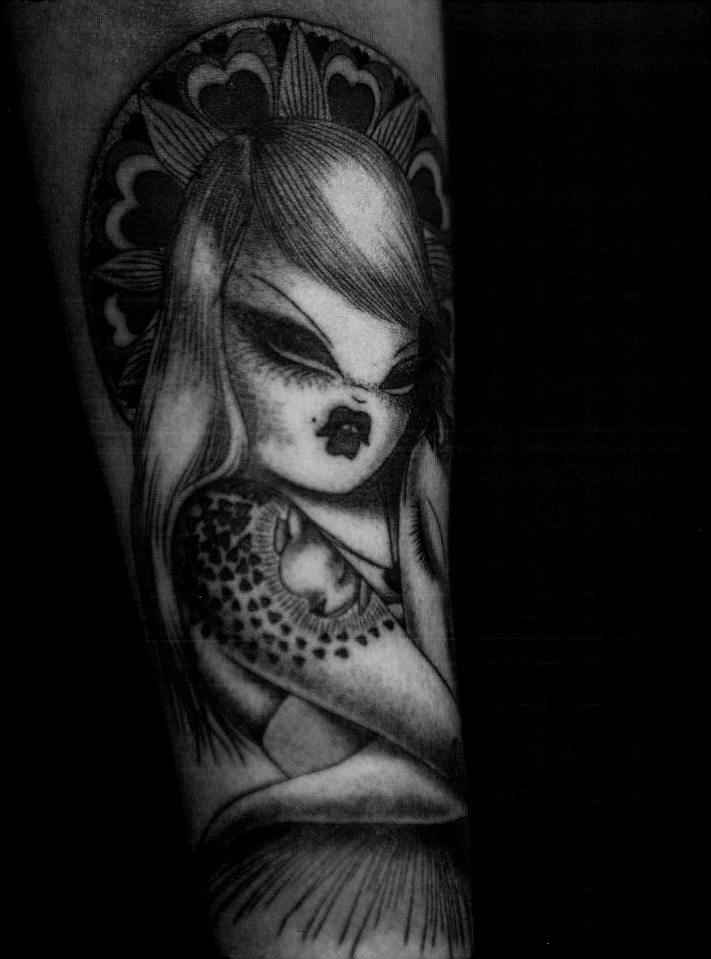

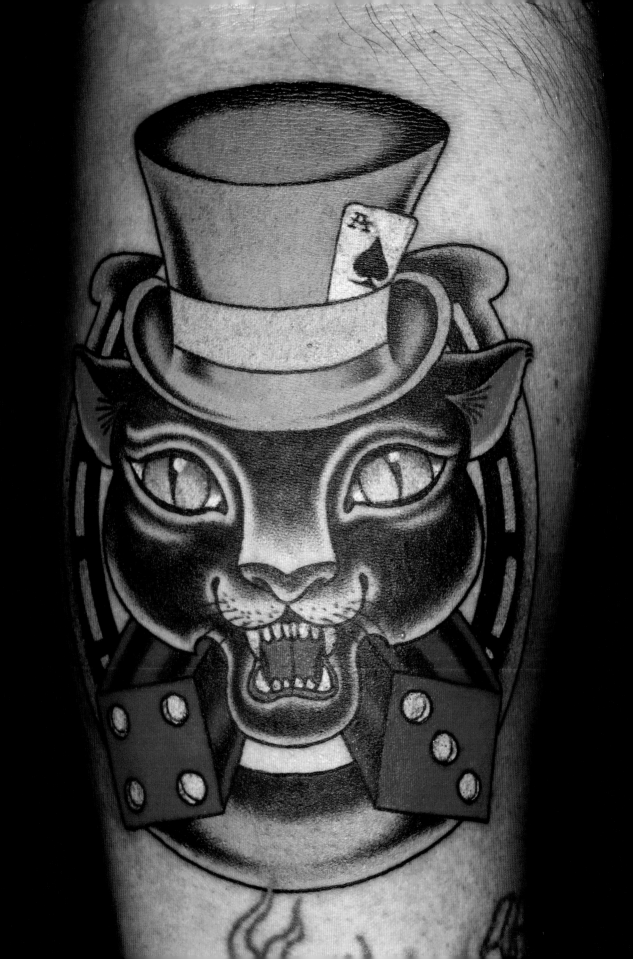

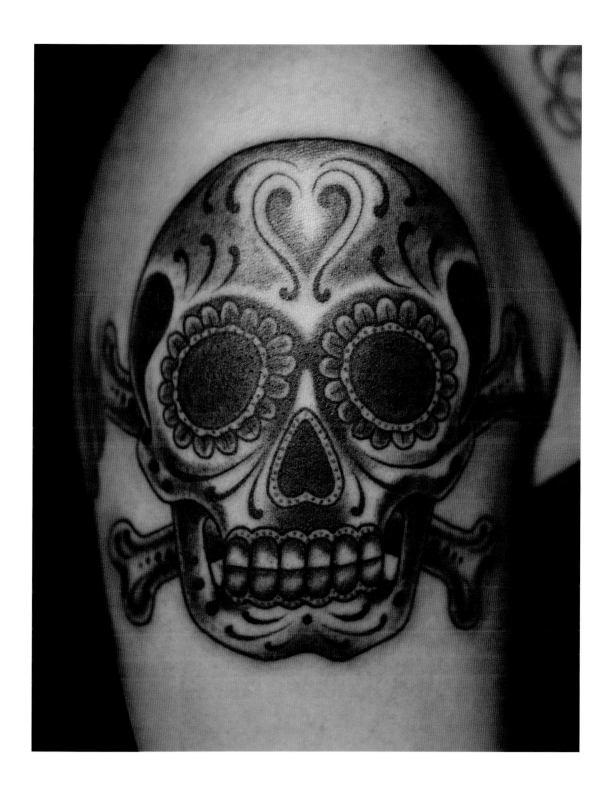

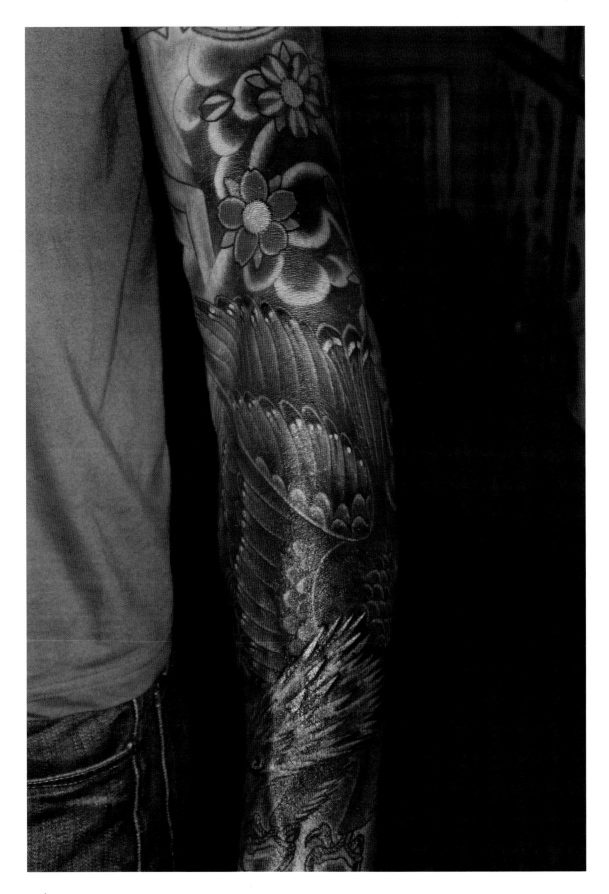

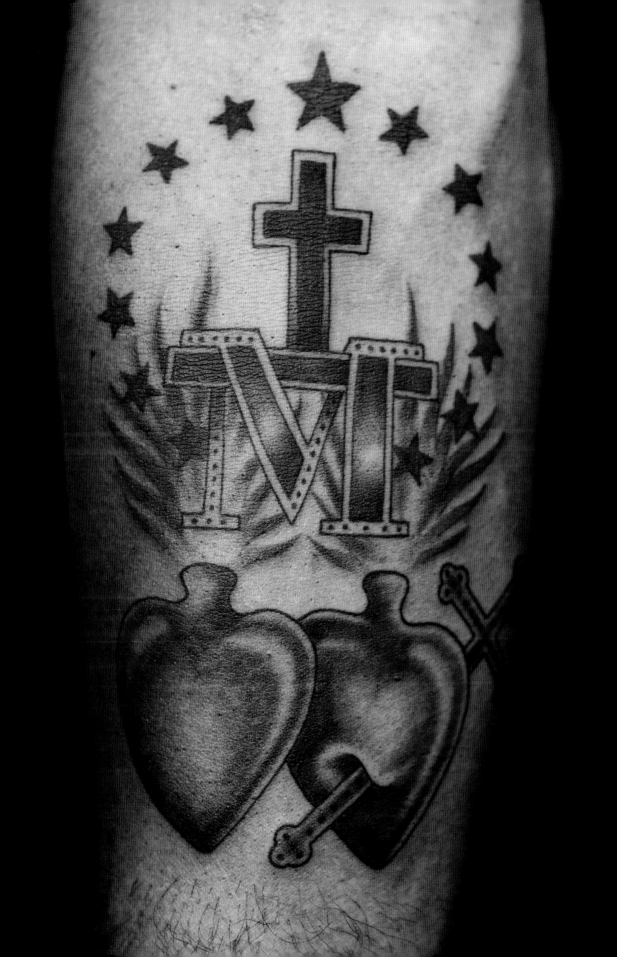

ELI QUINTERS

Eli Quinters was born and raised in a small town in Utah. In '97, he moved to New York to attend Pratt Institute. While there, he met John Reardon, who taught him how to tattoo in his dorm room. "Tattooing just seemed like the coolest way to make a living," he says. "I was impressed with what a cool job tattooing seemed to be. I always loved drawing, and that was such a big part of tattooing, it seemed like a perfect fit." In '99, he started an apprenticeship at Medusa Tattoo in Manhattan. Last year, he opened up his own tattoo studio in Bushwick, N.Y., and still spends his weekends working at Saved Tattoo. Quinters is inspired by Mexican folk art, prison tattoos, turn-of-the-century vignettes and advertising. He infuses his work with a traditional feel and applies a limited color pallet. "If it's up to me, I'll use two to three colors besides black," he says. He favors old-fashioned sailor tattoos that are both attractive and tough. "Old sailor tattoos look like tattoos," he says. "They will always look good even when they're old and faded. They're classic."

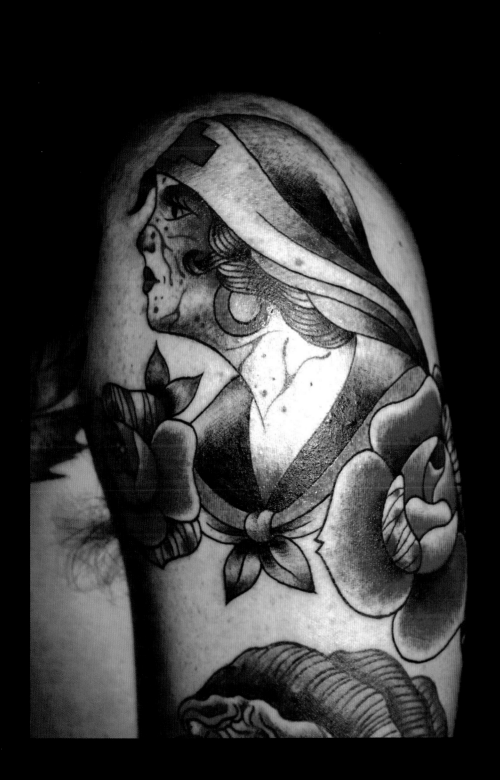

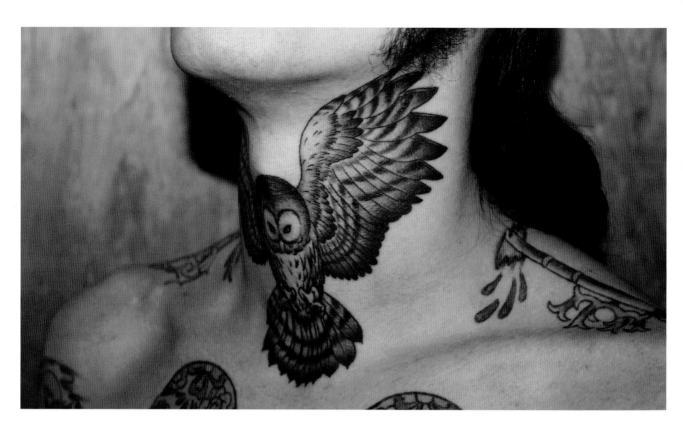

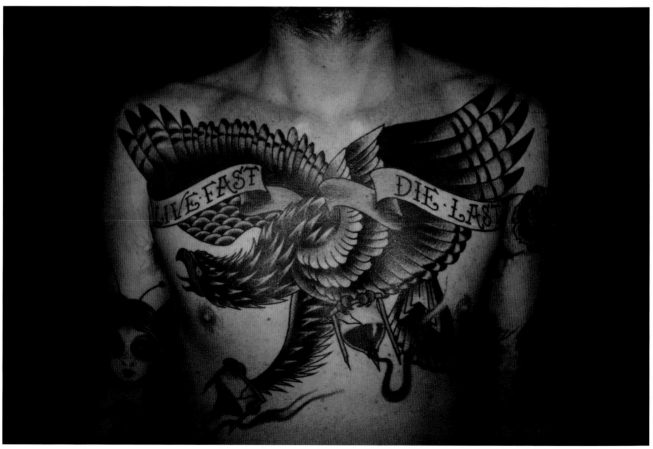

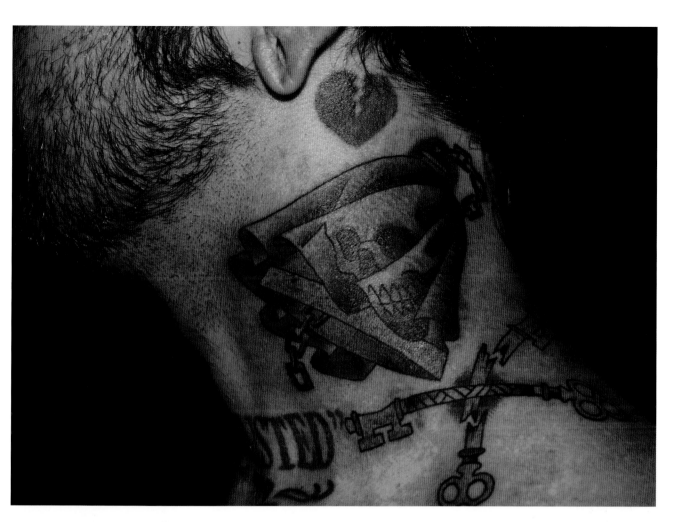

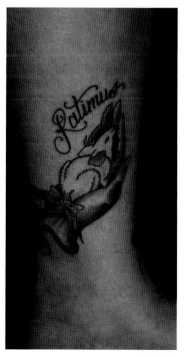

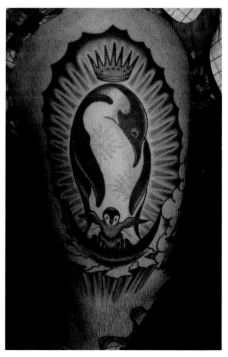

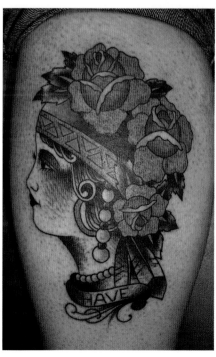

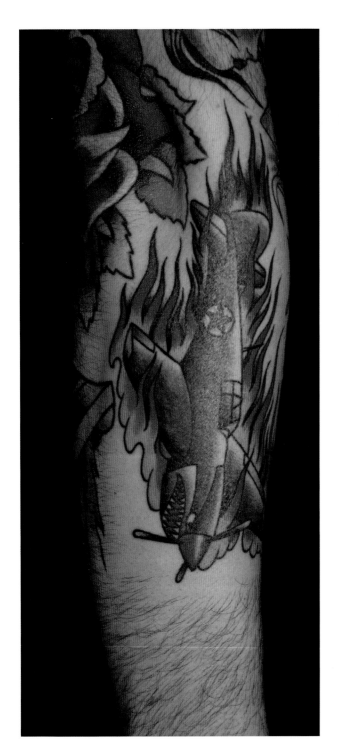
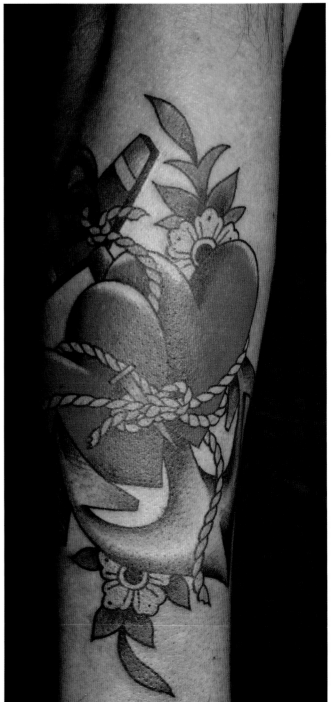

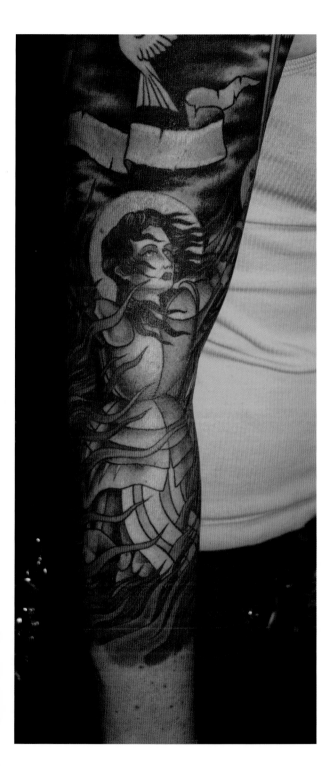

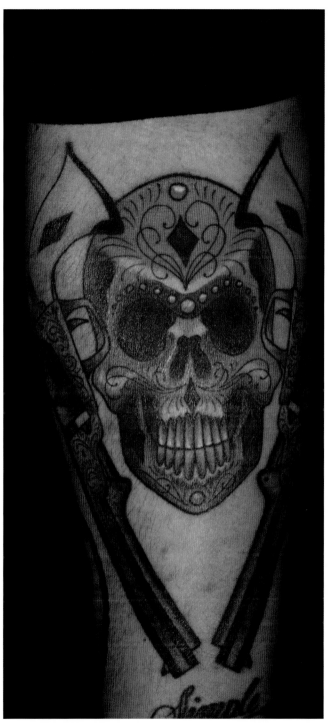

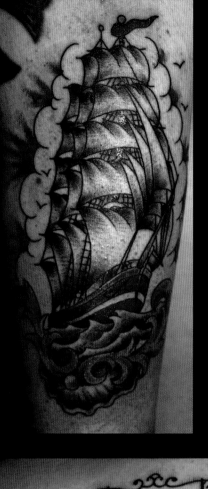
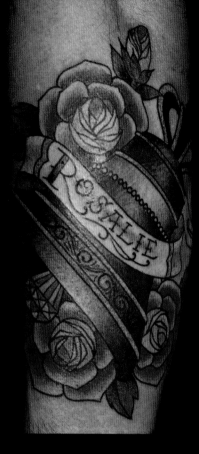
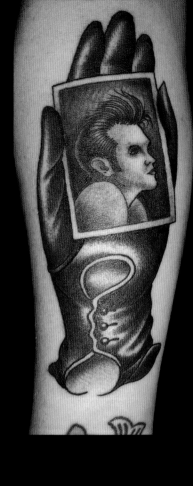
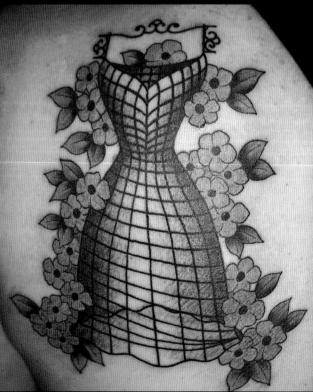

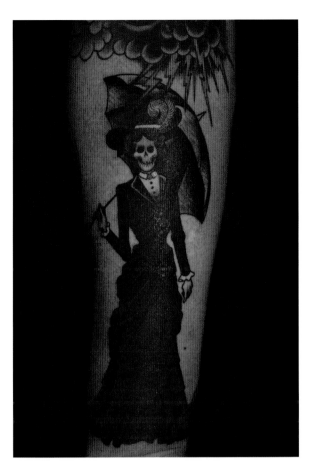

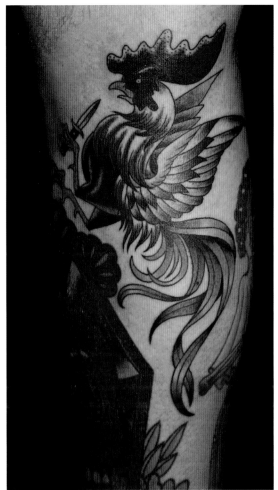

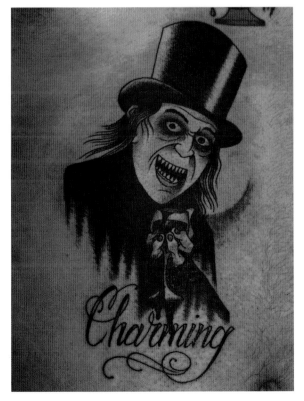

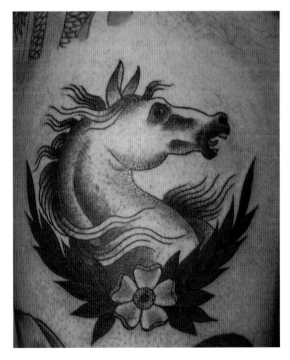

JEFF RASSIER

After 17 years of tattooing, Jeff Rassier has doled out enough ink to cover every crevice of the population of his birthplace—population 427. That town couldn't hold him, so he headed to California, landing in Santa Barbara where he began tattooing at a little biker shop. Rassier eventually found a home in San Francisco, where he opened the Blackheart Tattoo Shop with co-owners Tim Lehi and Scott Sylvia. While it has afforded him time to experiment with other media, he's quick to qualify that he has "no ambitions of being a fine artist." His proudest accomplishment is "doing big tattoos that people actually finish and I don't fuck up at all." He is not interested in the celebrity market for his work. "No famous people," he declares. "They get stupid tattoos and act like dicks. I prefer plumbers. The only customers worse than famous people are people trying to be famous." Fortunately, good customers abound, and Rassier loves his job all the more for it. "For the most part I like everything about tattooing," he says. "It's just plain cool, it's fun to do, it's challenging, the history of it is so vast that it could take a lifetime to learn it all, and the chicks dig it. Who wouldn't want to tattoo?"

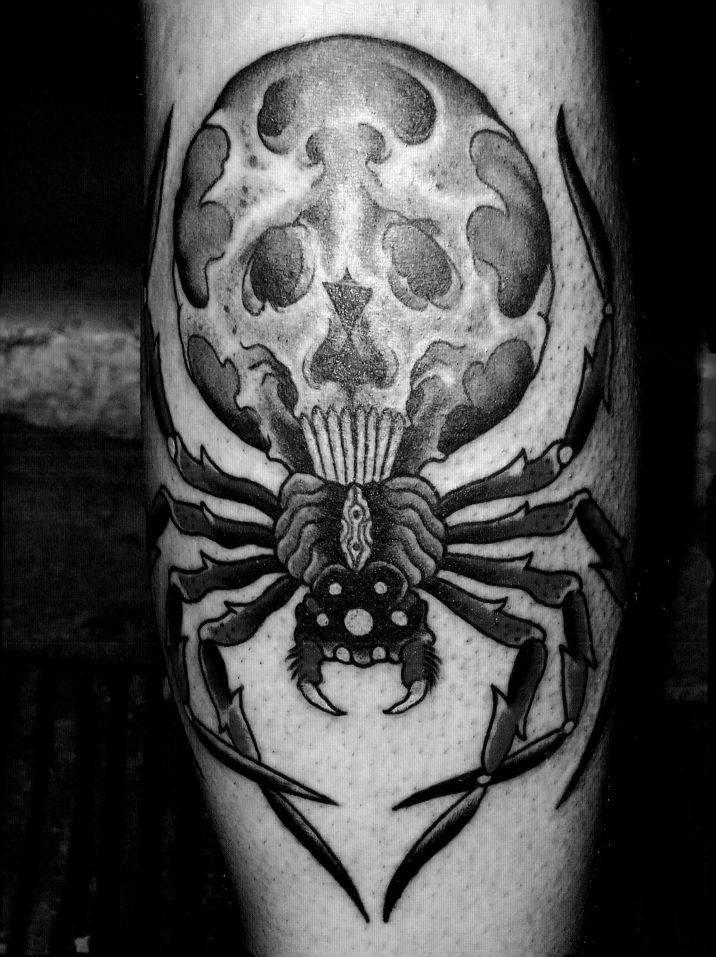

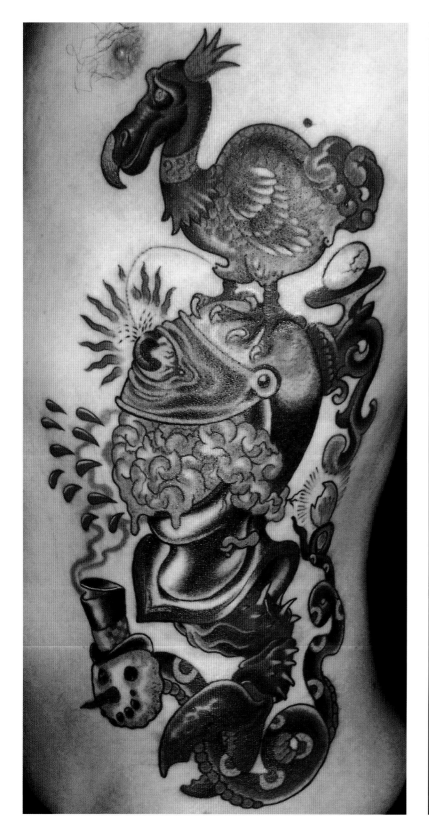

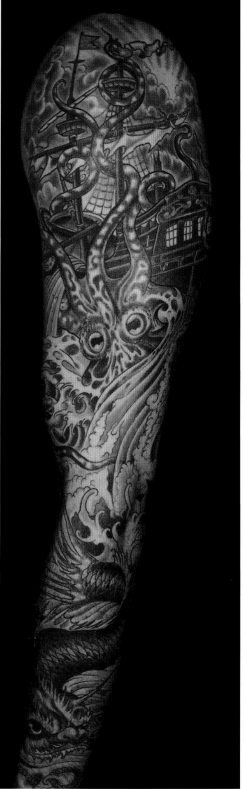

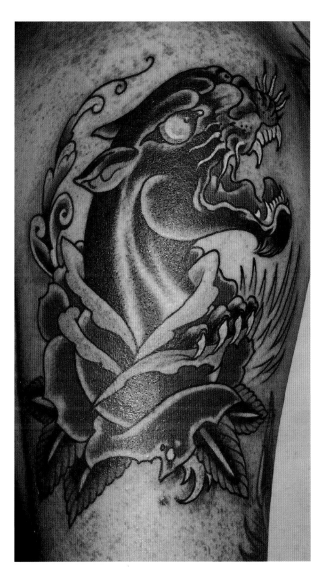

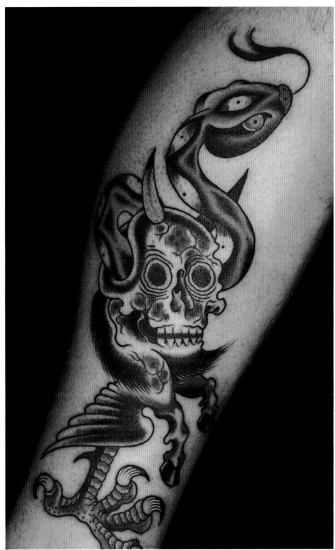

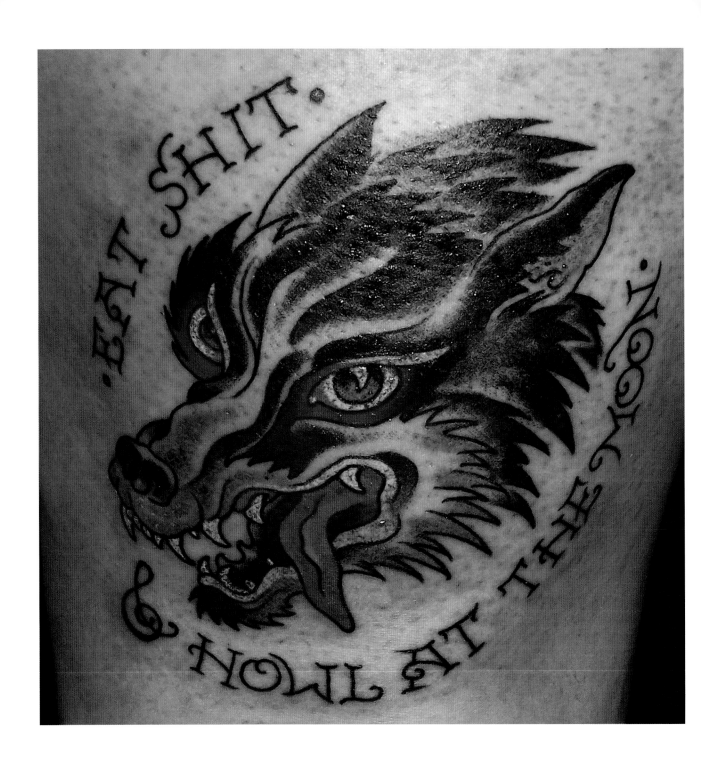

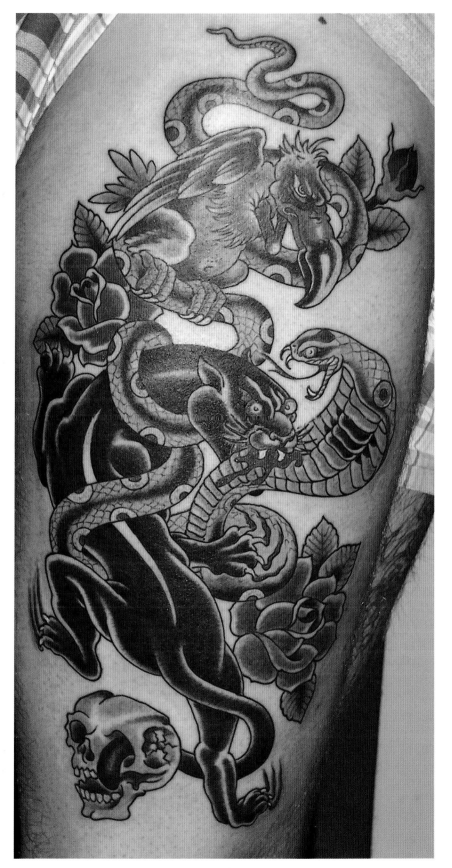

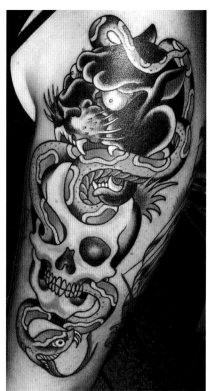

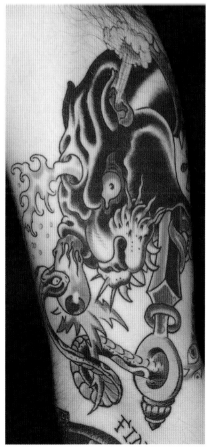

GREG ROJAS

Born in Downtown L.A. and raised in East L.A., Greg Rojas has been tattooing for 16 years, and building handmade tattoo machines for 10 years. Although his favorite things to tattoo are script letters and birdcages, Rojas doesn't place himself in one specific style camp. Instead, he describes his own style as "one-third outline, one-third shading and one-third color." Sixteen years ago, he was introduced to tattooing by way of punk rock music. Not long after, he began to apprentice at a shop in West L.A. Now operating out of Everlasting Tattoo in San Francisco—alongside artists such as Patrick Conlon, Mike Davis and Henry Lewis—he's happy to be in the city that he lovingly refers to as "the land of milk and honey." Rojas has had other jobs along the way, but he's not bashing any of them. "I can't say that I've ever had a worst job, I've always gained experience points wherever I've been." Beyond the art itself, Rojas' favorite aspect of tattooing is the storytelling and constant banter between the artists. What's the worst part? "Having to tattoo people that are totally insane and annoying," he explains. "I must have a million stories about that!"

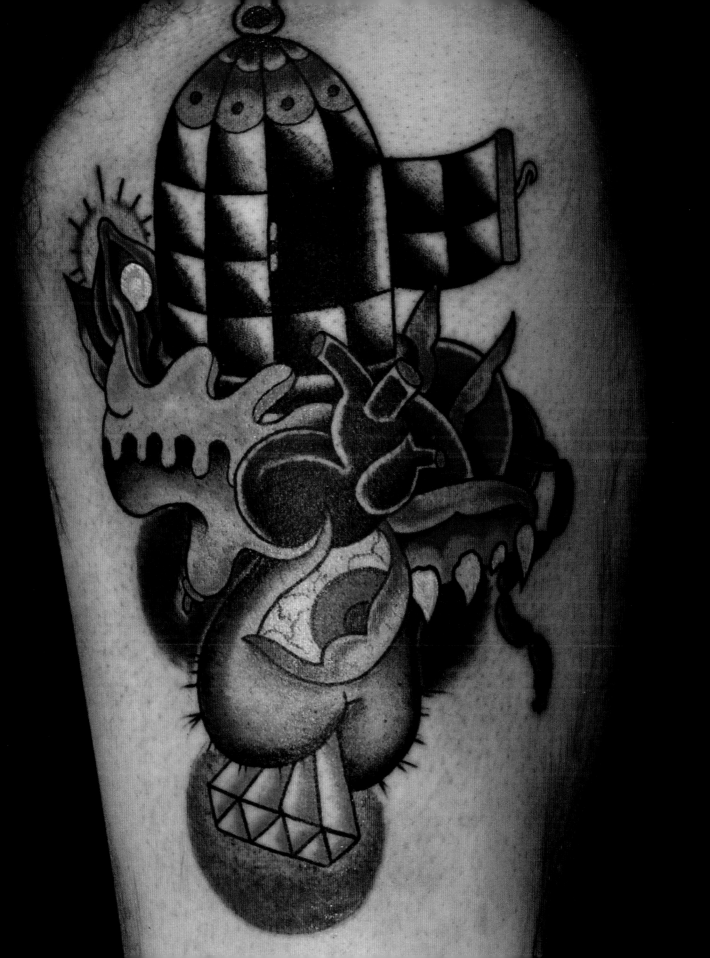

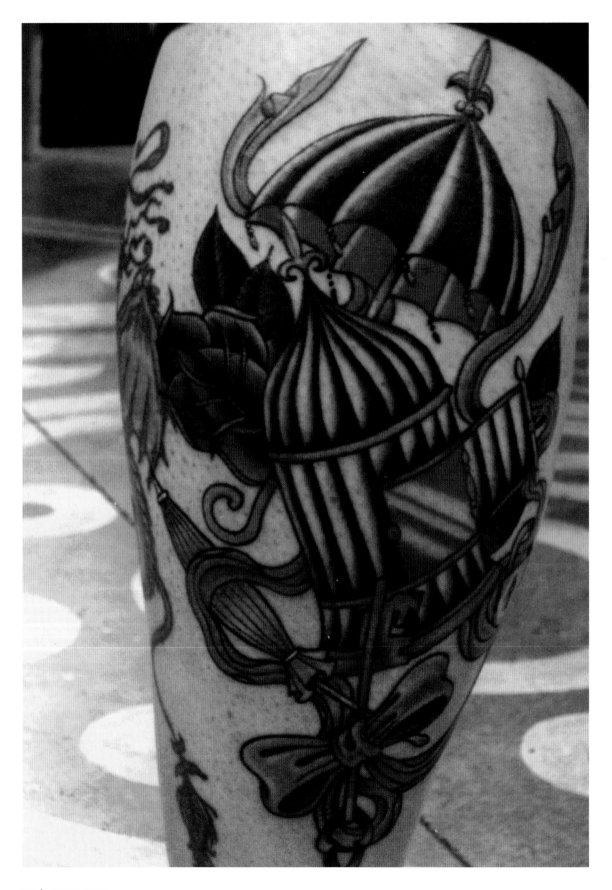

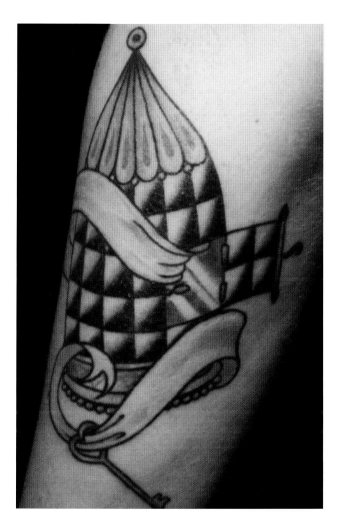
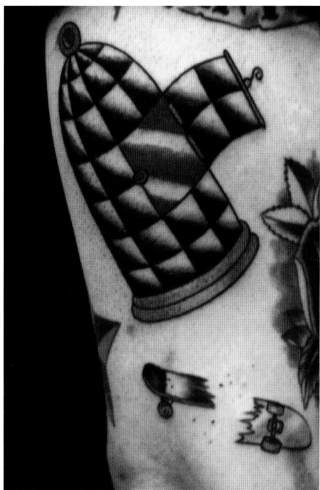
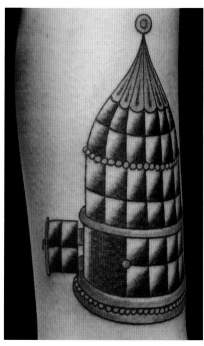
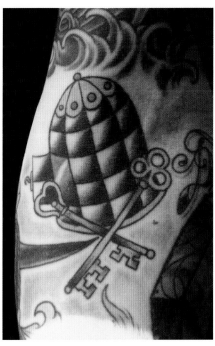
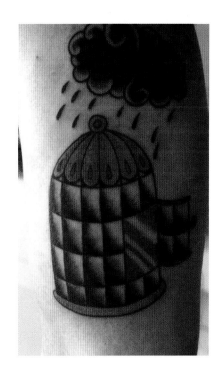

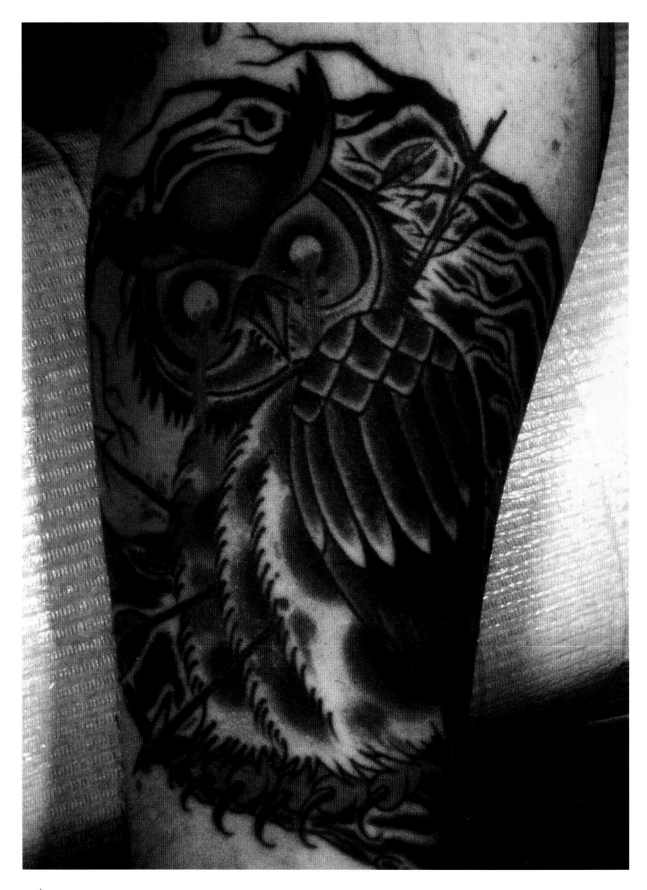

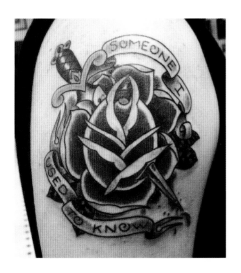

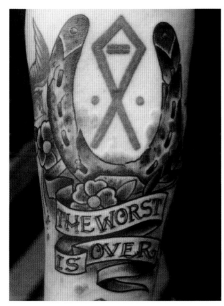

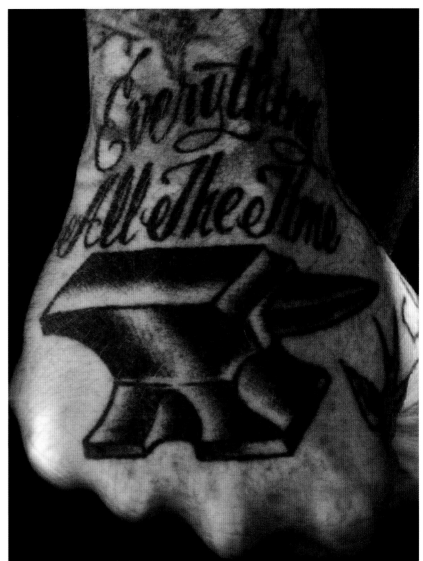

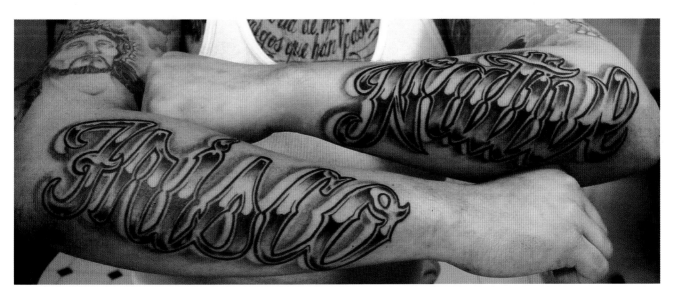

MIKE RUBENDALL

Mike Rubendall specializes in Japanese tattooing. "Its timelessness lends itself to the tattoo style," he explains, "and it captures the art of simplicity." Drawing from Japanese traditions, he alternates between simple black and grays and a shockingly bright palette—a sunset-colored koi fish swims up the back as a turquoise dragon entwines a leg. "I think people come to me for my work because it's clean, readable and stands the test of time," he says. "With each tattoo I do, I give it its own life and people recognize that." Rubendall began tattooing in '96 at Da Vinci in Long Island, New York. He now owns and operates Kings Avenue Tattoo in his hometown of Massapequa, N.Y. "Through hard work, dedication and traveling, I got to where I am today in my career," he explains. "I am inspired when I see exceptional work being done by my colleagues. That pushes me to work harder." With a deep respect for the tattoo trade and its history, Rubendall is spearheading the field's new movement. He travels internationally attending tattoo conventions and guest spotting at shops around the globe. Of his craft, he says, "I love the different people and good friends I have made through the years of tattooing."

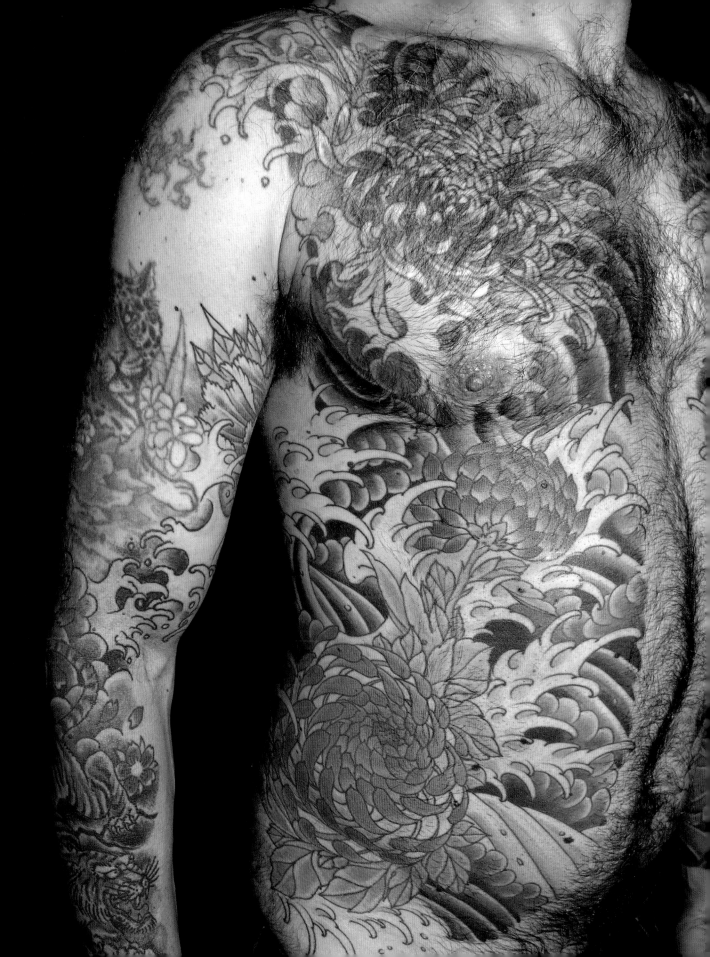

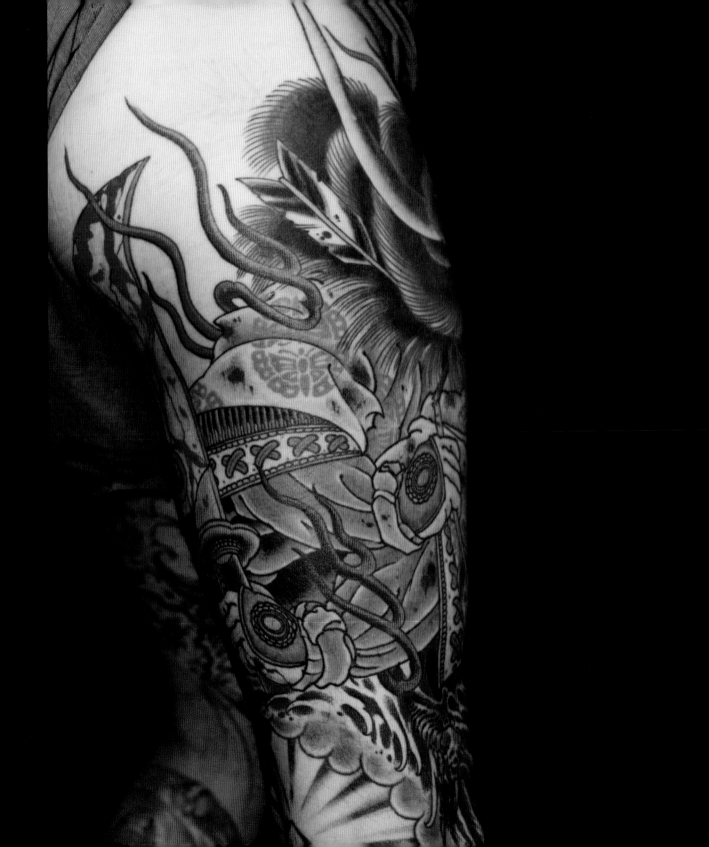

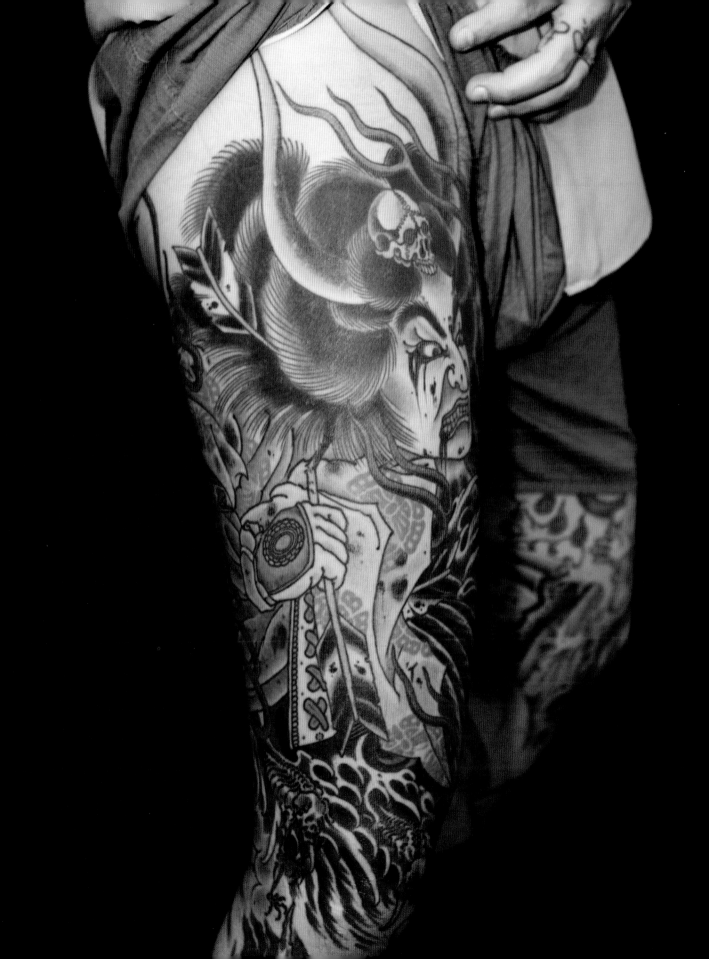

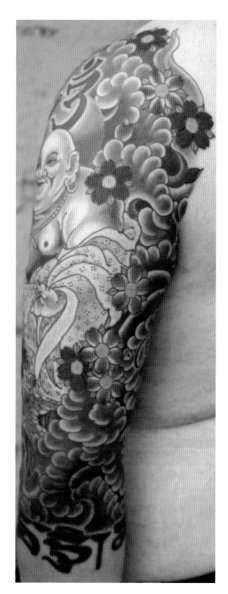
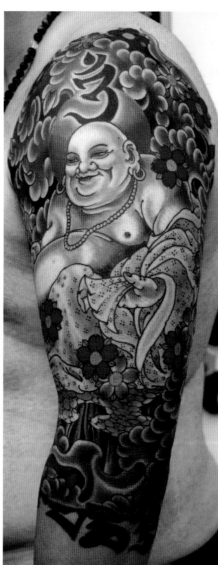
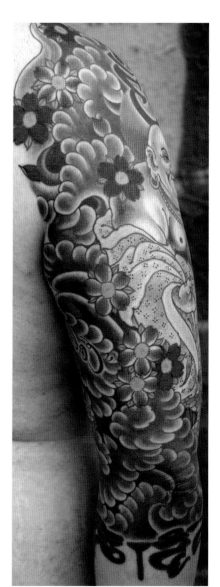

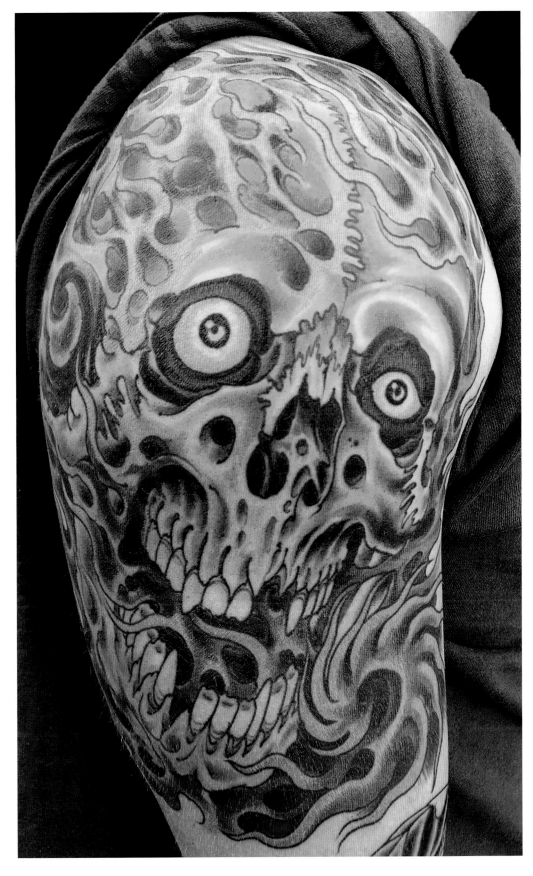

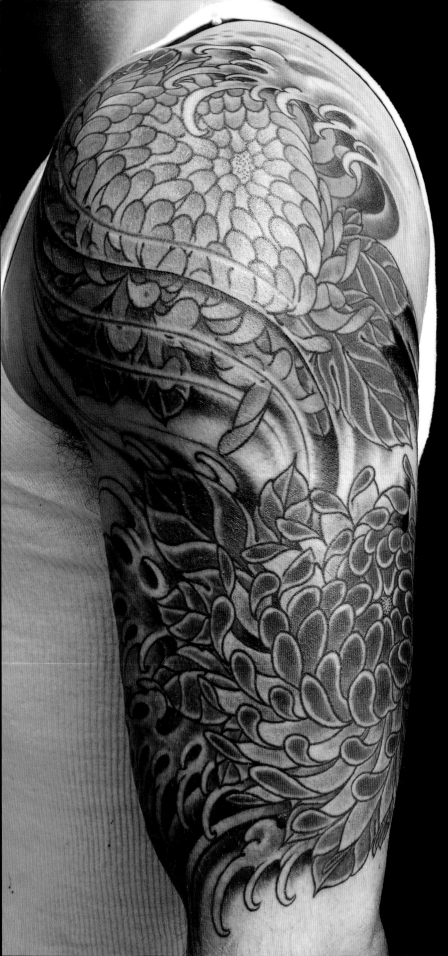

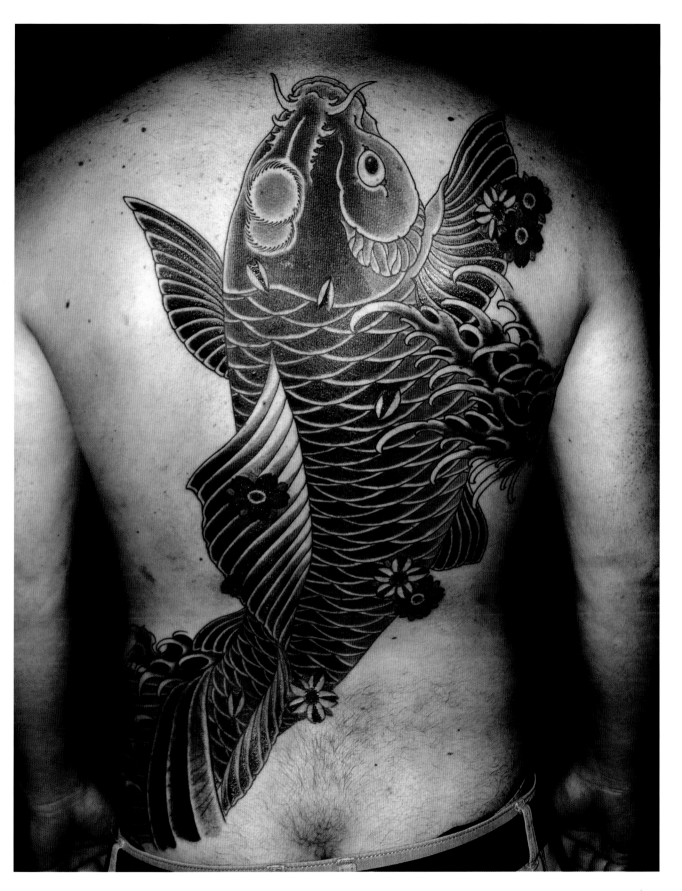

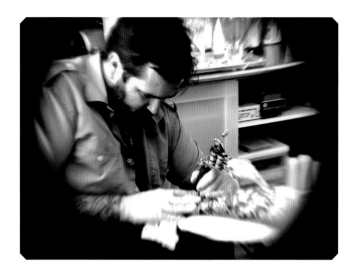

JASON SCHRODER

The first time Jason Schroder tattooed someone he almost puked. "Despite the tension," he told Bodyartweb.com, "the tattoo itself healed up nicely." Schroder began tattooing straight out of high school. "Tattooing created its own appeal, there were no other reasons than we seemed to fit well together." In the early '90s, he tattooed out of a kitchen on Romaine Street in Hollywood. Schroder's work is based on classical themes—art with a timeless appeal—and he employs a straight-to-the-point aesthetic. "The most common thread in my tattooing is a certain directness to the subject matter," he explains. In '93 he opened Incognito Tattoo in Pasadena, which is the city's oldest tattoo shop. "I got where I am through hard work and a certain lack of talent," he explains. Schroder thinks that people come to the shop to see his "awesome beard and turquoise ring collection." Recently, he founded Incognito Irons. "I manufacture tattoo machines for the elite of the tattoo business," he says, "and the regular schmoes too." Also an illustrator and designer, Schroder has collaborated with Camel Cigarettes and SpitfireGirl.com, among others. What makes his work original? "I make myself unique," Schroder answers, "with an extra 'Q.'"

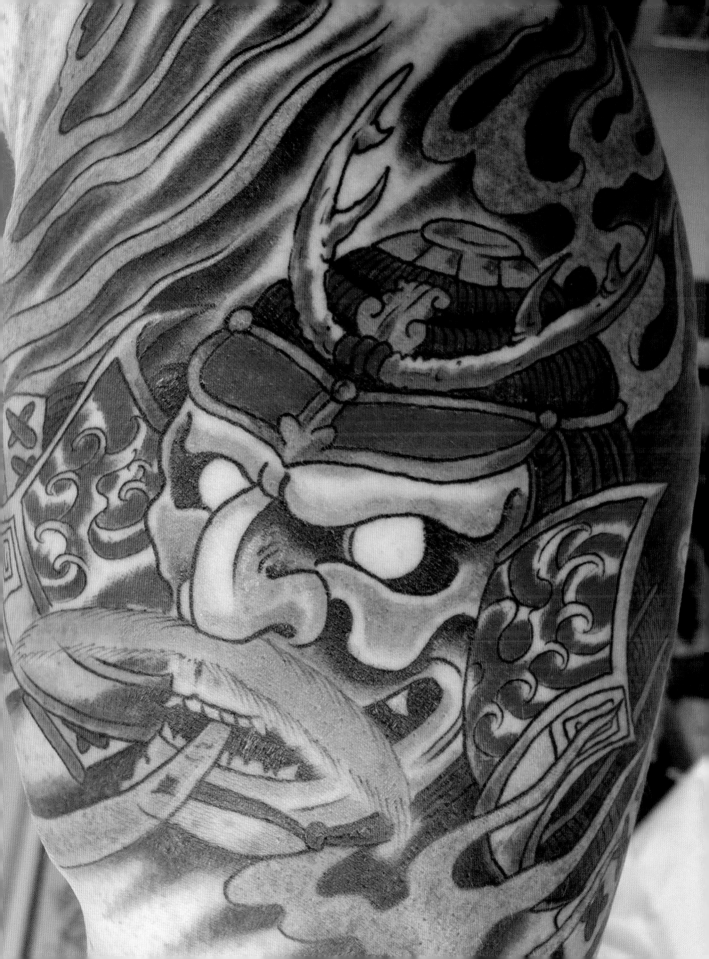

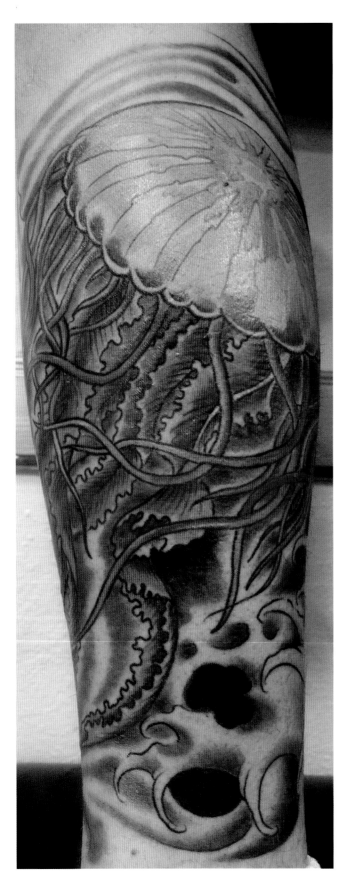
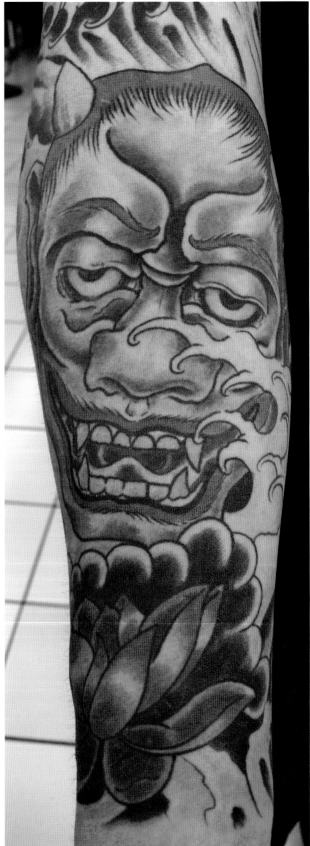

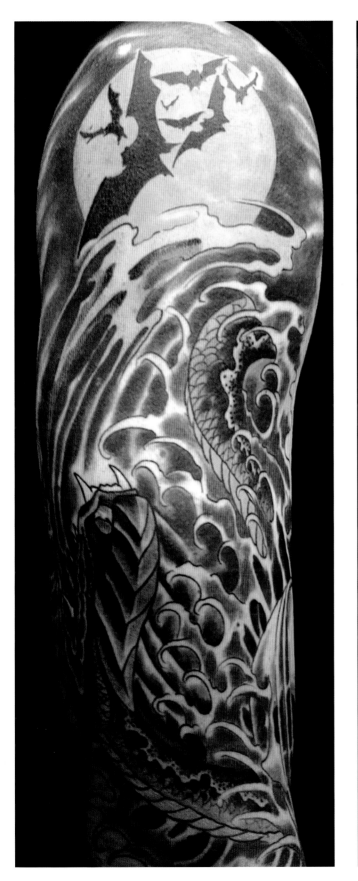
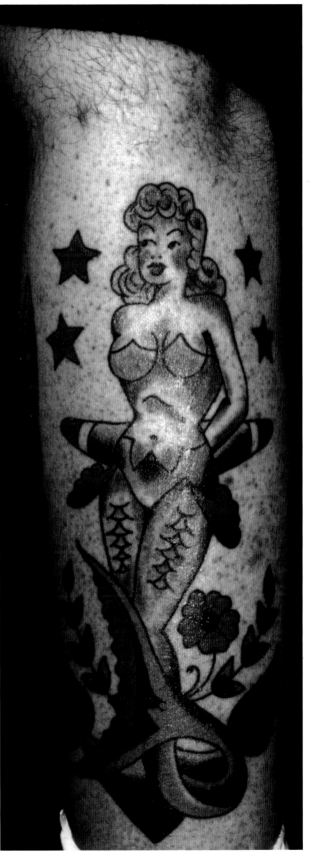

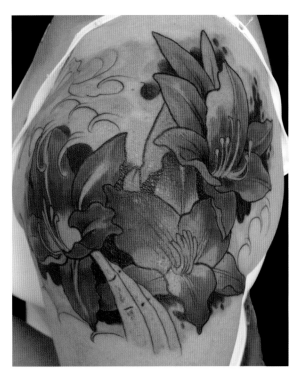
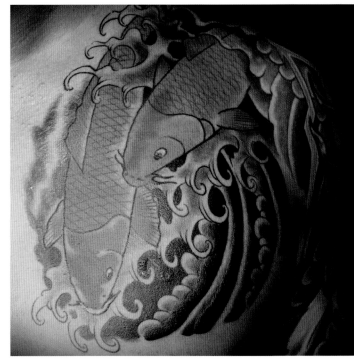
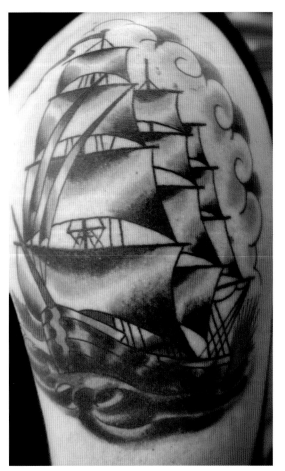
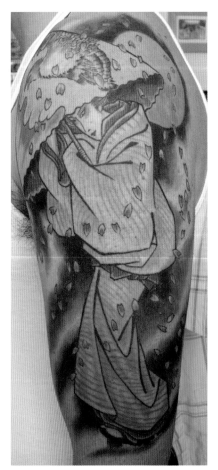
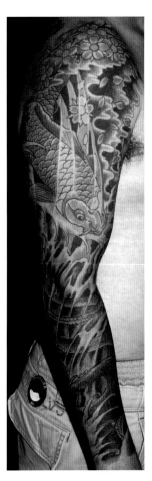

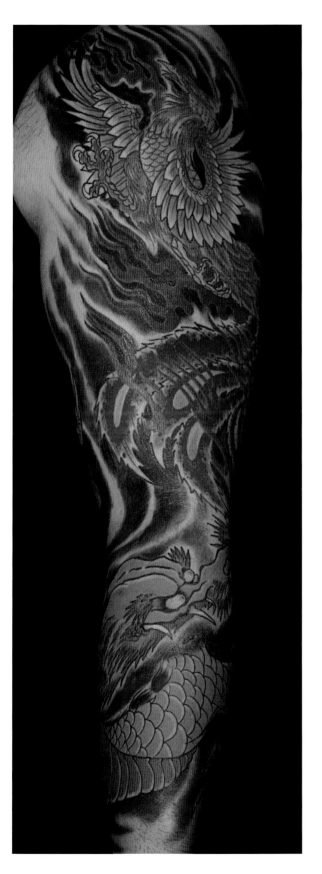

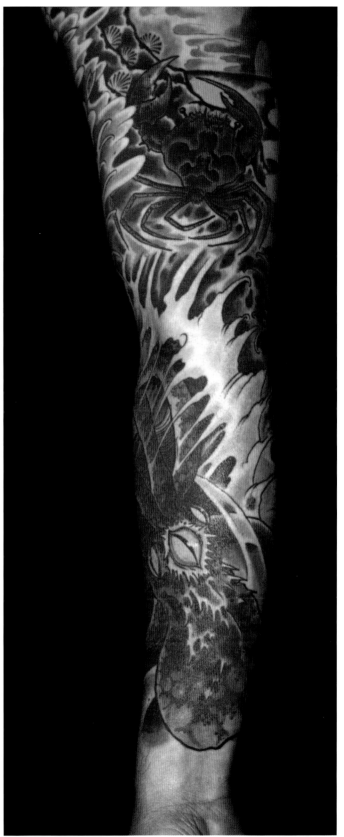

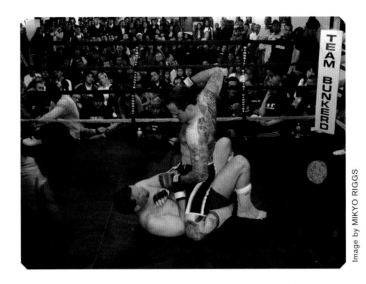

Image by MIKYO RIGGS

LUKE STEWART

"I knew I wanted to have tattoos, mostly because I thought the guys that had them were really tough and scary looking," Luke Stewart remembers. At the age of 17, he began to train in Brazilian jiu jitsu under Ralph Gracie in San Francisco, and through training he met Sean Perkinson and Troy Denning. "Sean got me started with some equipment," he recalls, "and I began working out of my house in San Francisco." A more formal education came later as an apprenticeship under Henry Goldfield at the well-known Goldfield Tattoo Studio. "Working for Henry taught me so much about tradition and tattoo history," Stewart says, "and also what it means to pay your dues as a tattooer–like scrubbing floors and picking up your boss' Hawaiian shirts at the dry cleaners." In 2006, Stewart, Erik Rieth and Jason Kundell opened Seventh Son Tattoo in San Francisco. "While tattooing is a huge part of my life," he qualifies, "it doesn't completely define who I am." He recently received his black belt in Brazilian jiu jitsu, and has since become a professional Mixed Martial Arts fighter with a 3-0 record. "After sitting on my ass tattooing all day, training is the balance I need," he says.

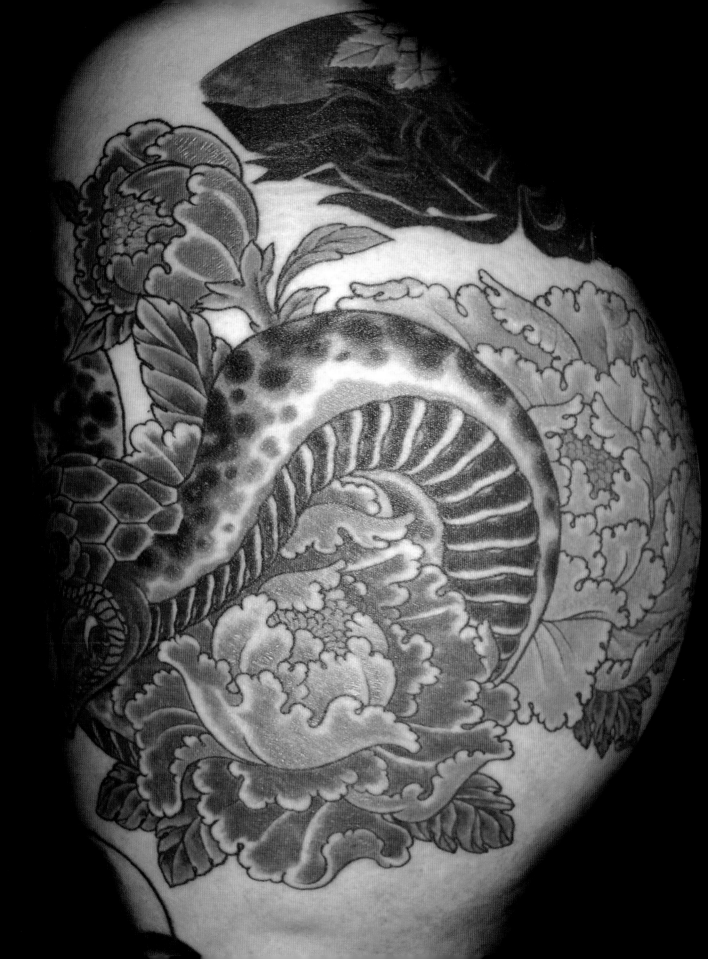

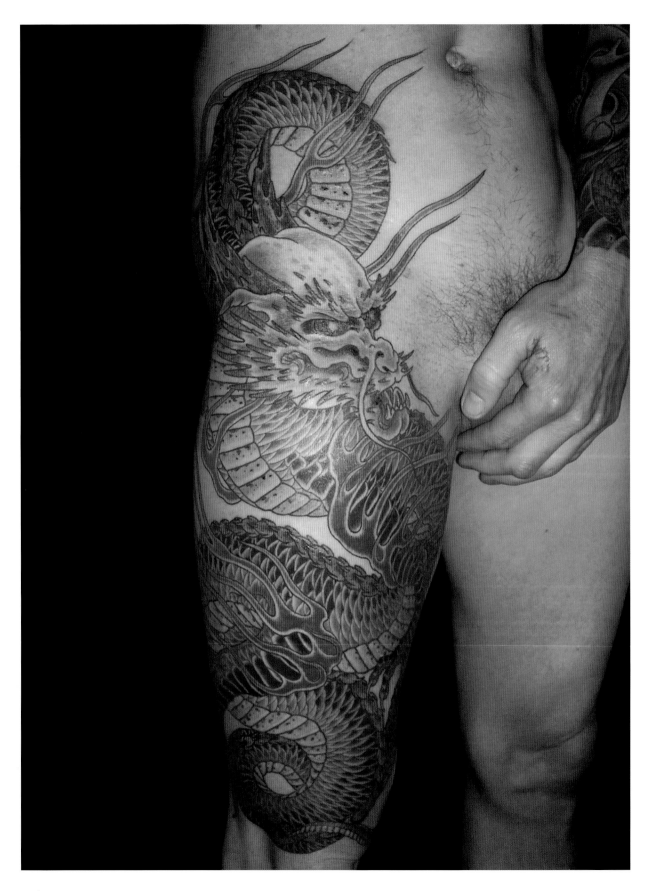

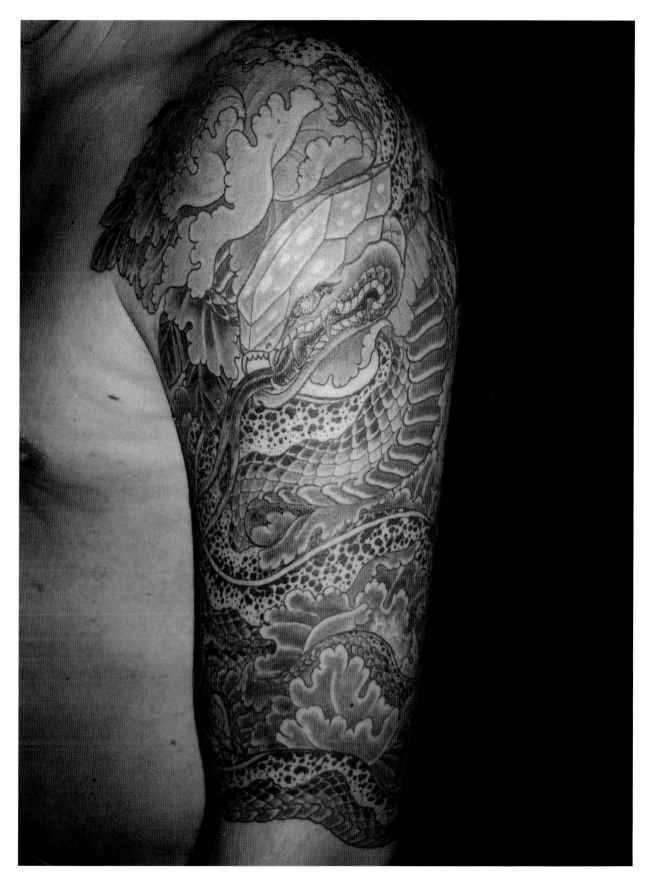

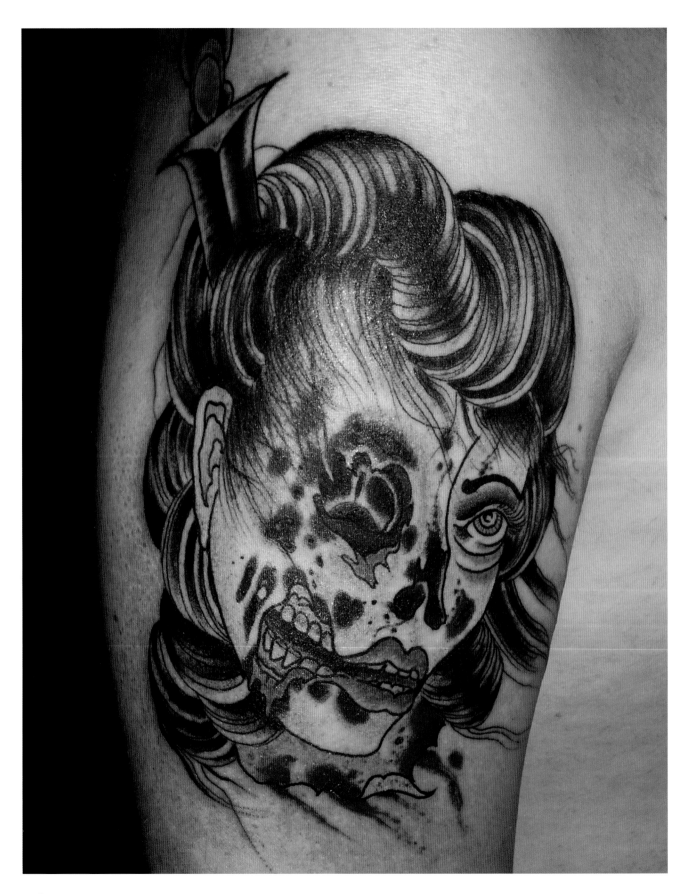

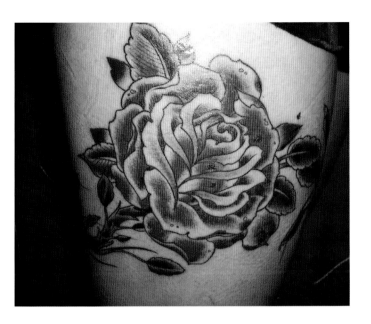

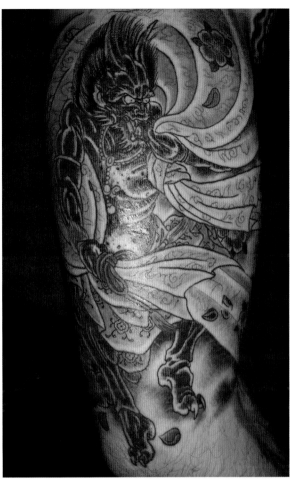

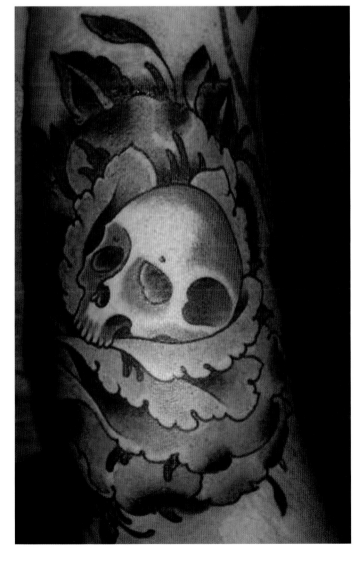

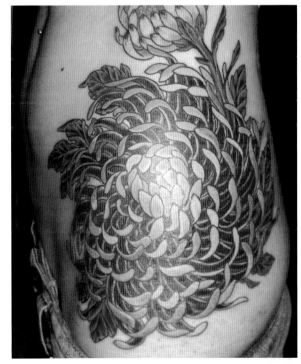

DANIEL TROCCHIO

Wisconsin-bred Daniel Trocchio started tattooing in '94 at Steve's in Madison, but art has always been a mainstay. "I've been drawing and painting my whole life," he says. "I've tried my hand at most things. It's always been what I do." Trocchio began tattooing because he was intrigued by the medium, wanting to make a living doing something he enjoyed. He tattooed in Scandinavia for some time, and then moved to New York in 2000. He currently works at Saved Tattoo in Brooklyn, New York. Inspired by "relentless original creation," Trocchio prefers a clean illustrative or traditional Japanese style. "I go with [what has] an appealing aesthetic to me," he explains. However, he says, "People come to me because no matter what class of tattoo I end up putting on, I always try my best." In '07, Trocchio showed his work alongside friend and fellow tattoo artist Joseph Ari Aloi. "I love the instant reward of doing a little drawing and getting praise and money to feed my artistic ego," Trocchio explains. "And sometimes, it's very rewarding to have the connection with so many human beings."

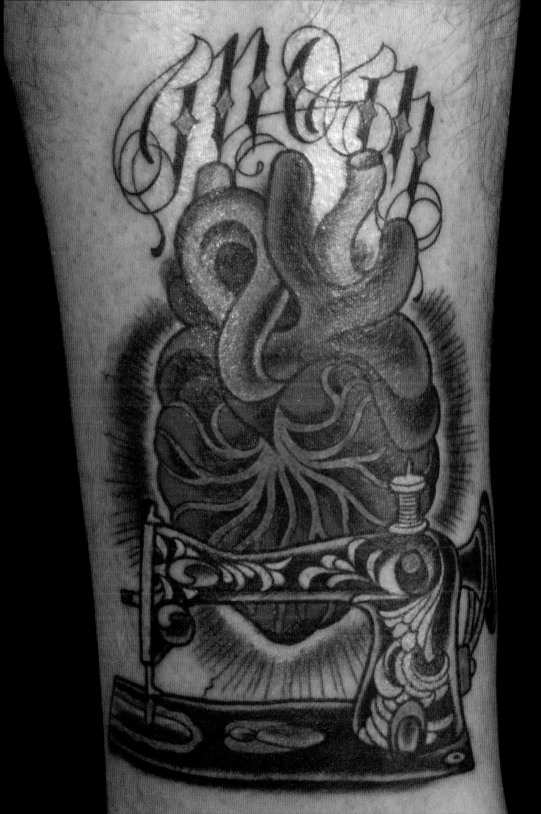

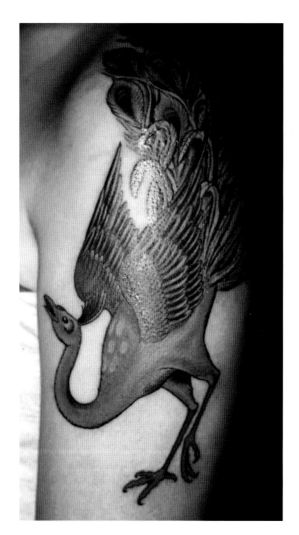

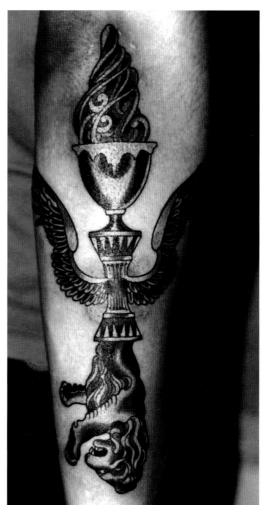

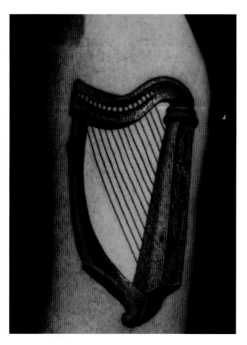

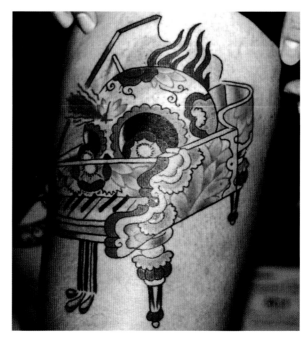

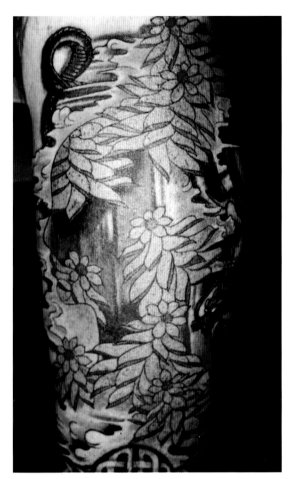

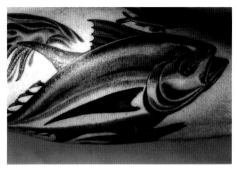

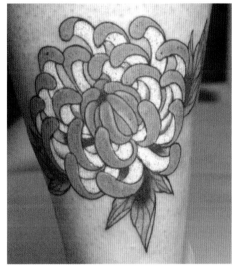

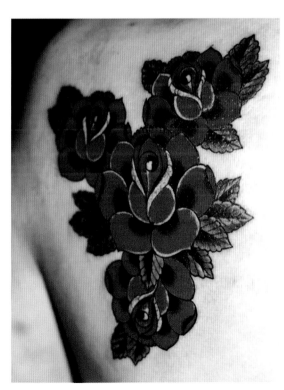

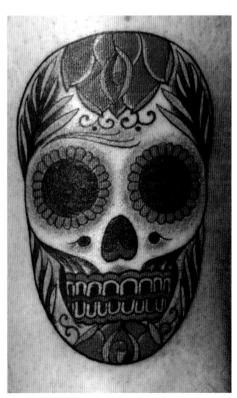

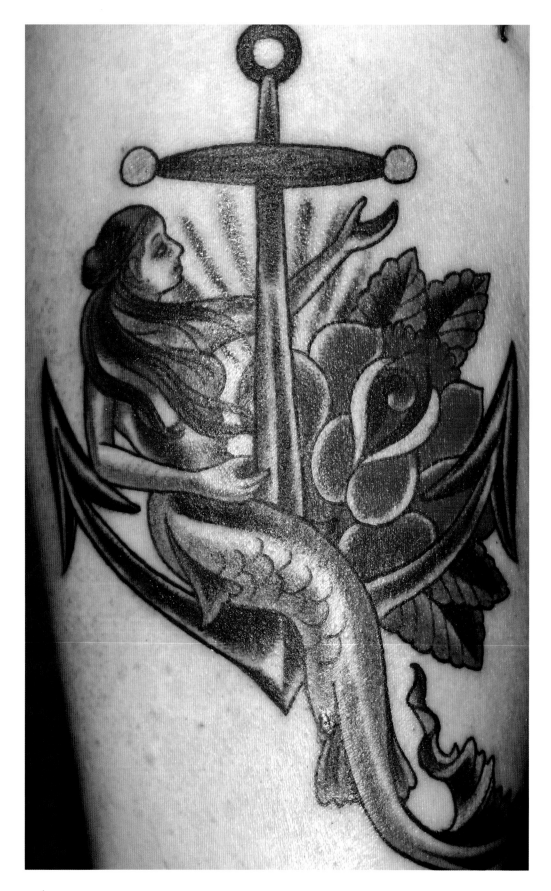

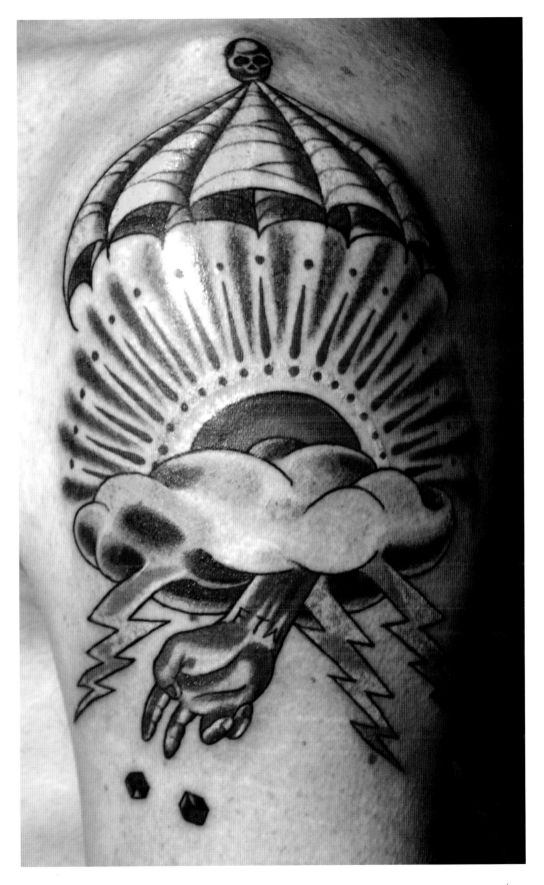

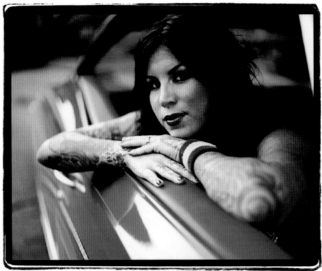

Portrait by ESTEVAN ORIOL

KAT VON D

The child of Argentinean missionaries, Kat Von D was born in Mexico and moved to Southern California at 4 years of age. As a kid she constantly drew while her mother saved every doodle, and at just 14, she inked her first tattoo. "One day, a friend, who had rigged up a shitty tattoo machine out of a Walkman motor, some guitar string and a 9-volt battery, asked me to tattoo a Misfits skull on him," she explains. By 16 she was tattooing in a professional shop, although, she admits, her skills were unpolished at the time, having never had a formal apprenticeship. "All of my artistic abilities have been acquired via trial and error," she says. Kat also learned from the masters, collecting tattoos from all of her "tattoo heroes" along the way. (She also collects tattoos from her inartistic friends whom she peer pressures into tattooing her at parties.) Recently, Kat opened her shop High Voltage Tattoo in Hollywood, which is the subject of the TLC show "LA Ink." Inspired by Los Angeles, Mexico, sex, drugs and rock 'n' roll, Kat specializes in "gangster shit," fine, black-and-gray tattoos and photorealistic portraiture. What keeps people coming back? Steve-O, of Jackass, answers: "Everyone she's worked on has been overjoyed. Her work stands out because it fuckin' rules, and people come to her because she is so overwhelmingly gorgeous that a mere glimpse of her is enough to instantly make any heterosexual man half hard as a goddamned rock."

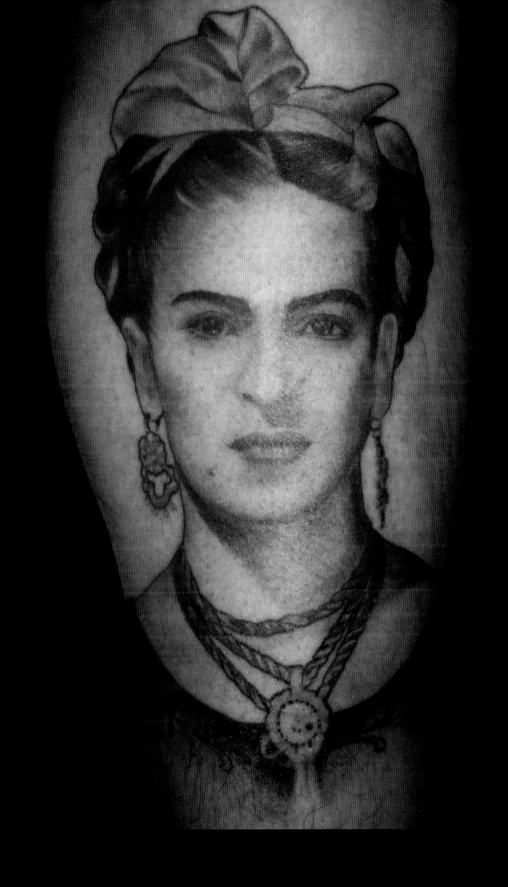

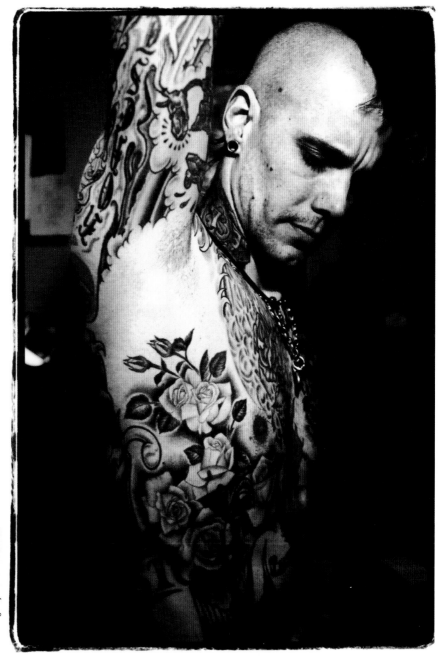

Image by ESTEVAN ORIOL

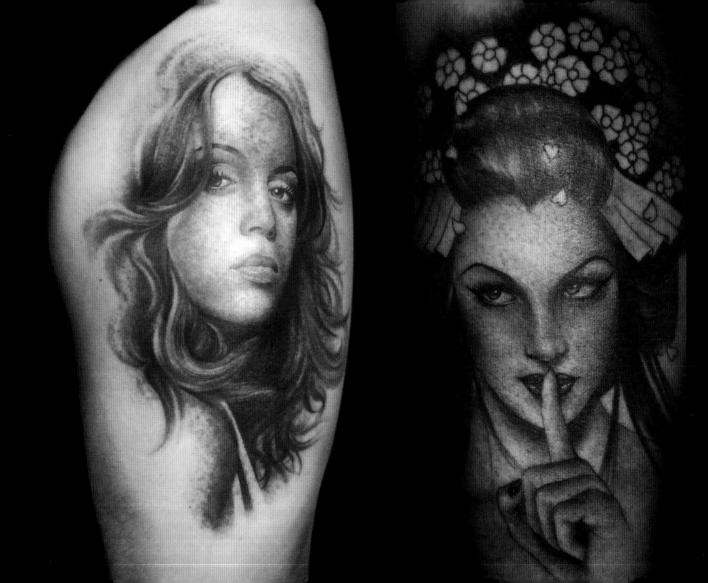

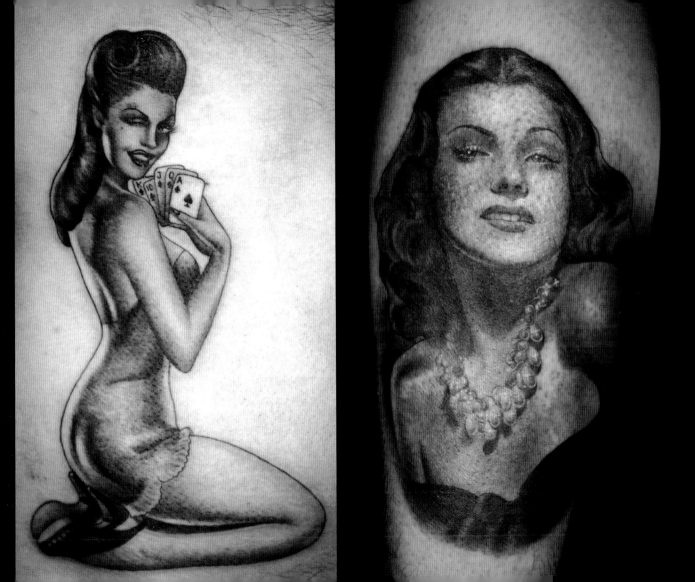

JIRO YAGUCHI

Growing up in Tokyo, Jiro Yaguchi's exposure to tattooing wasn't as broad as it might have been in the United States. "There weren't too many styles to choose from, like in the U.S.," he explains. When he began tattooing in '91, Jiro naturally gravitated toward the traditional Japanese style of full-body designs, even though by then he had already moved across the Pacific to Costa Mesa, California. In fact, being away from Japan made the stylistic draw even stronger. "Not until then did I get to see the beauty of my country," he remembers, adding that "it's kind of weird, but we notice what we have when it isn't there in our face." "In '93, he apprenticed with a Japanese tattoo artist for five years. "I knew I needed to learn a skill," says Jiro. "I really wanted to do something art related and I found that with tattooing." Like so many artists, Jiro dodged a nine-to-five job. As a result, he says, "This job is definitely one of the biggest luxuries a person can have." Having lived and tattooed in Los Angeles for the past 14 years—working the past four in a private studio in Little Tokyo—he finds himself happily busy and constantly working. "There's little time for hobbies," he laments, adding that he'll surf and paint for fun whenever he can. "I'm a quiet, reserved guy that is just about working hard and doing better. I don't party, drink, or do drugs. I just tattoo and hang out with my cats and my old lady." It's not a bad life, as he concedes, "I create permanent art everyday. That is my biggest accomplishment by far."

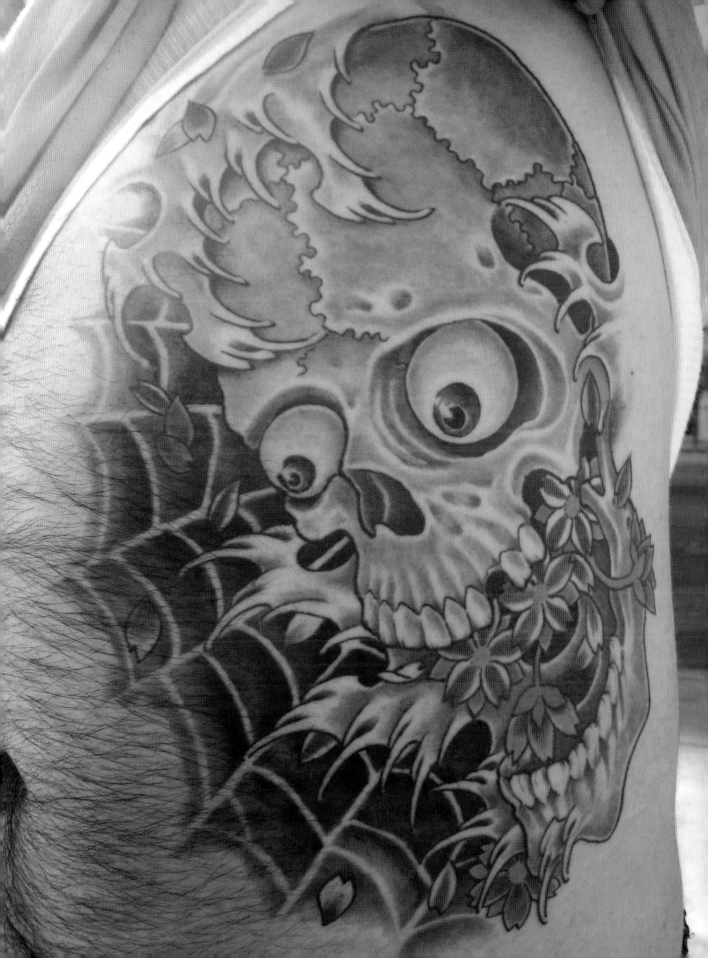

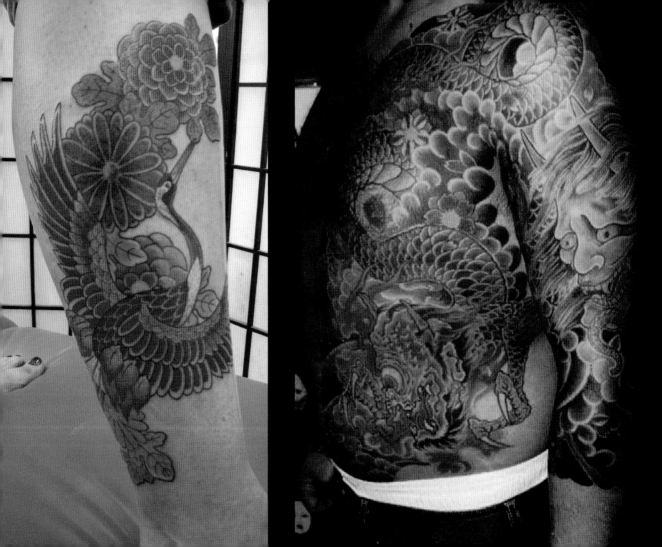

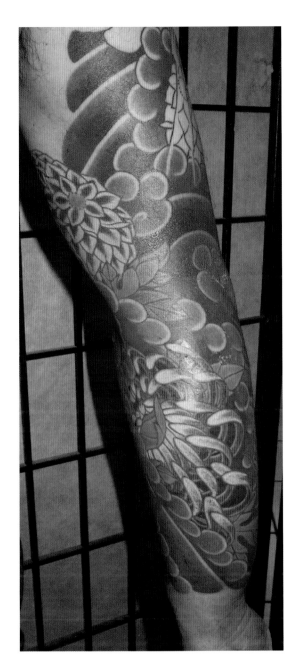
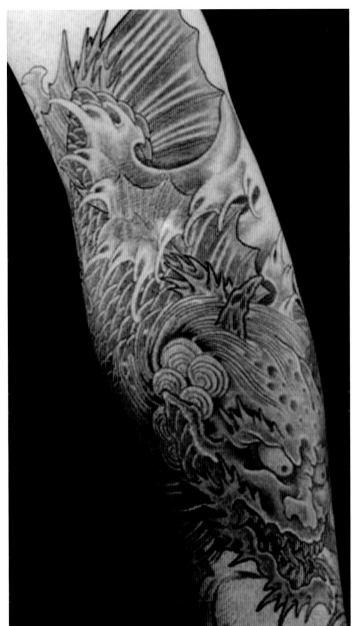

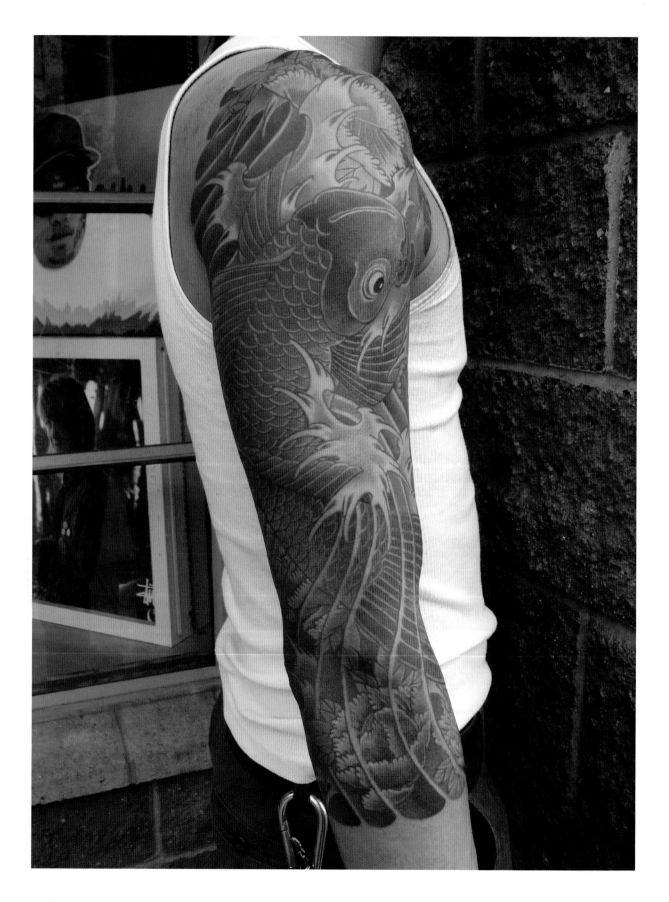

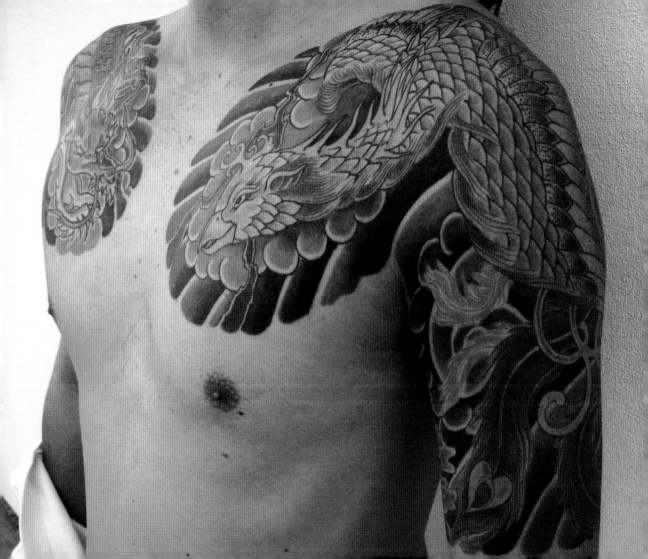

JEFF ZUCK

While he traveled here and there, Jeff Zuck didn't stray far from his birthplace outside of Flint, Michigan, which he describes as an "ever-growing ghost town." Since an apprenticeship wasn't really an option, he used a guitar string and a tape recorder motor and got started. Soon, he got his first shop job in nearby Lansing, cracking out several tattoos a day under the watchful eyes of a half-dozen novice tattoo artists and one biker mentor. "I could go on in detail about the environment and experiences working there," he reveals, "but my family may have to read this," so the rest is left to imagination. Eight years ago, Zuck opened his own shop, Name Brand, in Ann Arbor, Michigan. His own work largely falls into two styles, each with its own role in his development as an artist. "Japanese is a window for growth, and traditional American is an exercise in foundation for me. I stick with these styles and try to allow them to be my focus without remaining too pigeon holed. My work is not visionary at this point, I am just putting together the pieces of the puzzle that others have put together a million times before." He enjoys expanding his work with larger pieces and "studying and executing Japanese folklore on full backs, torsos, arms, legs, along with this large-scale traditional American body work." Nevertheless, he says, "I still love when someone just wants a job I can finish in one setting."

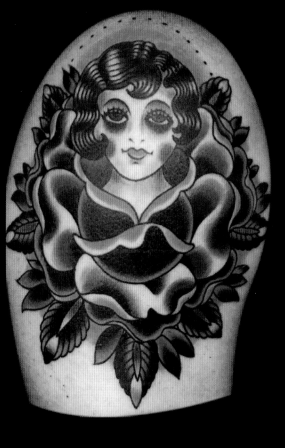
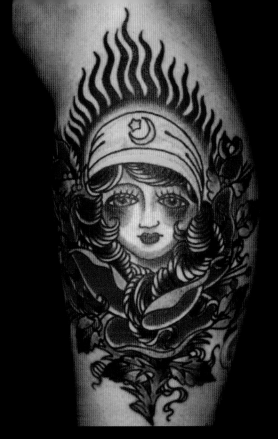
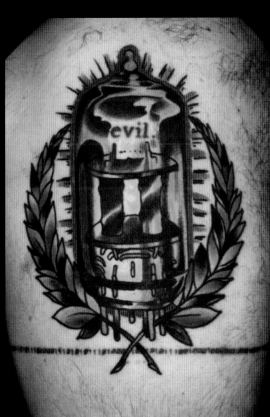
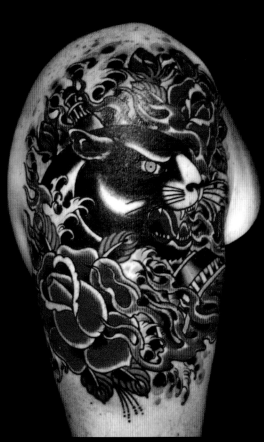

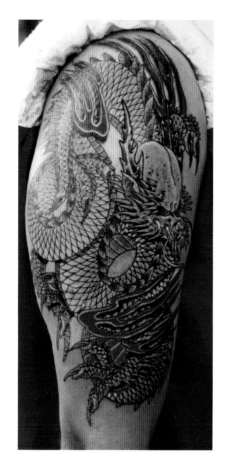

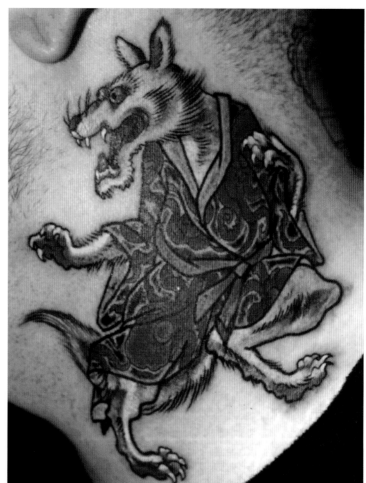

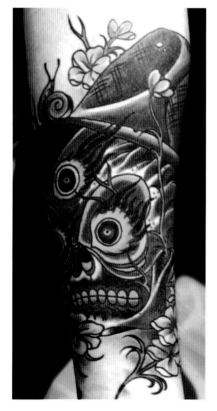

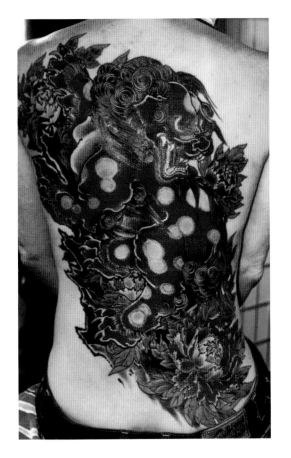

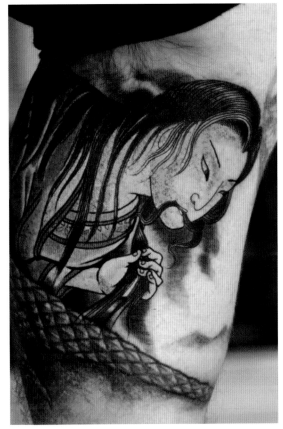

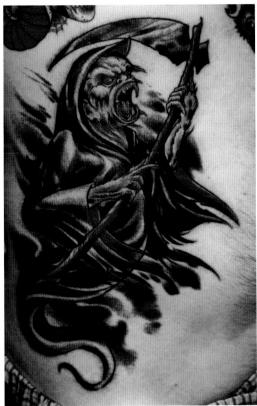

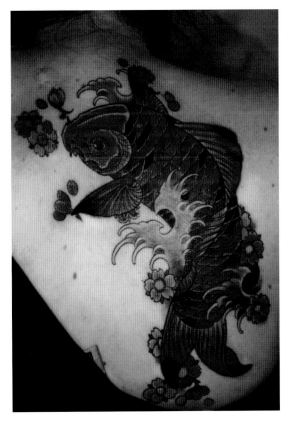

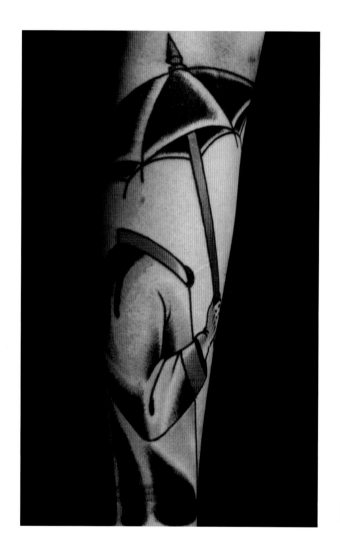

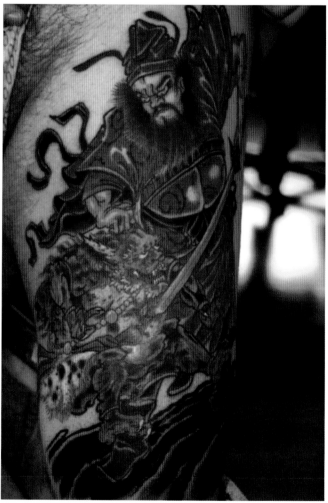

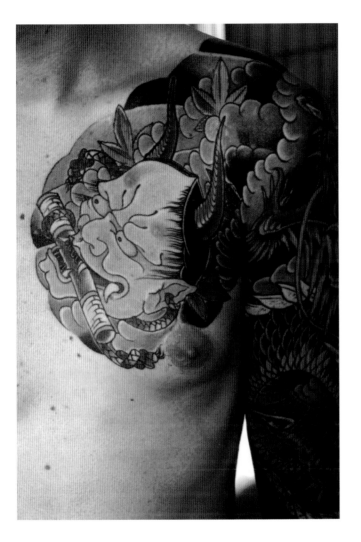
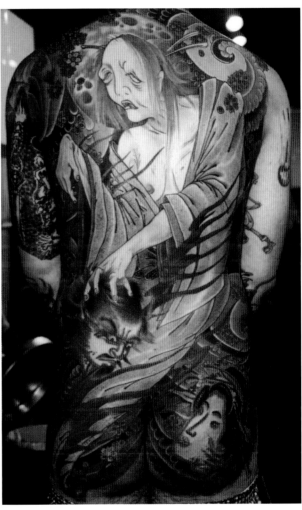

ARTIST INDEX

JOSEPH ARI ALOI
www.jk5nyc.com

JULIE BECKER
www.juliebeckerink.com

STEVE BOLTZ
www.steveboltz.com

SCOTT CAMPBELL
www.scottcampbelltattoo.com

MISTER CARTOON
www.mistercartoon.com

MIKE DAVIS
www.everlastingtattoo.com

TROY DENNING
www.troydenningtattoo.com

MARIO DESA
www.mariodesa.com

KORE FLATMO
www.plurabella.com

ADAM FOREMAN
www.highvoltagetattoo.com/adam.htm

JASON GOLDBERG
www.oldecitytattoo.com

REGINO GONZALES
www.regnyc.com

DENNIS HALBRITTER
www.dhalbritter.com

BERT KRAK
www.bertkrak.com

TIM LEHI
www.blackhearttattoosf.com

HENRY LEWIS
www.everlastingtattoo.com

MARK MAHONEY
www.shamrocktattoo.com

ALEX MCWATT
www.alexmcwatt.com

CHRIS O'DONNELL
www.nyadorned.com/tattoo/artists/
chris/index.htm

JUAN PUENTE
www.juanpuente.com

ELI QUINTERS
www.tattoosfortheunloved.com

JEFF RASSIER
www.blackhearttattoosf.com

MIKE RUBENDALL
www.mikerubendalltattoo.com

JASON SCHRODER
www.jtstattoo.com

LUKE STEWART
lukestewarttattoo@yahoo.com

DANIEL TROCCHIO
www.danieltrocchio.com

KAT VON D
www.katvond.net

JIRO YAGUCHI
www.jirotat.com

JEFF ZUCK
www.jeffzuck.com

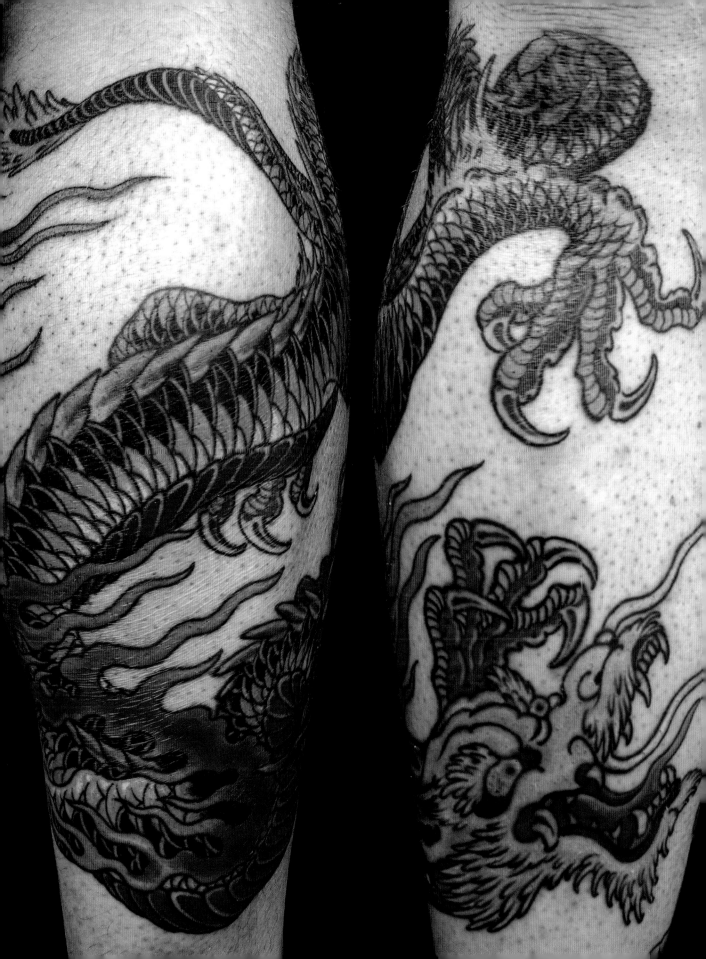

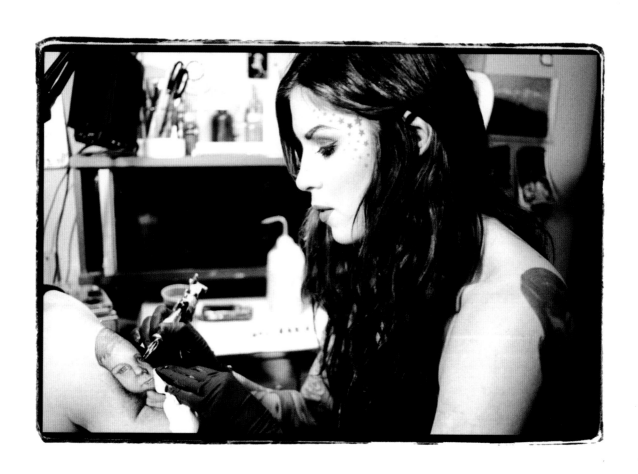

Image above: Kat Von D by ESTEVAN ORIOL